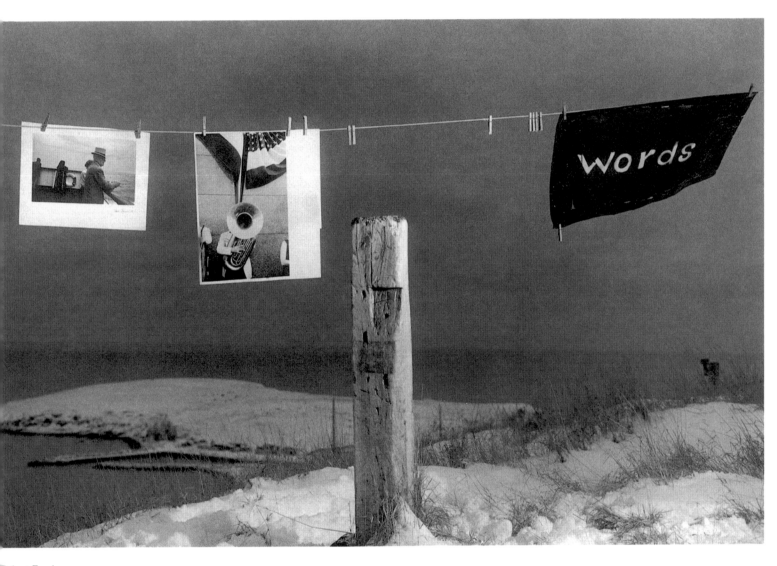

Robert Frank
Words, Nova Scotia, 1977

CONTENTS

Robert Frank: New York to Nova Scotia is one of four books on Robert Frank being published in 1986. There has been a collaborative effort to avoid duplication. Each publication contains information and images unavailable to the others. The other publications include a new edition of *The Americans,* which is being published in three languages. The Center for Creative Photography and the Museum of Fine Arts, Houston are copublishing Stuart Alexander's comprehensive *Robert Frank: A Bibliography, Filmography, and Exhibition Chronology, 1946 - 1985.* In conjunction with a retrospective exhibition in Paris, Robert Delpire has edited *Robert Frank* by Robert Frank.

The Museum of Fine Arts, Houston has also coproduced with Houston Public Television (KUHT) a video documentary titled *Fire in the East: A Portrait of Robert Frank.* Directed by Amy Brookman and Philip Brookman, it offers yet another view of Frank, an artist whose photographs and films have influenced artists on both sides of the Atlantic and in Asia and whose images still have the power to provoke controversy.

In this catalogue all articles are published without corrections or the use of [sic]. In the letters, some passages have been deleted, and paragraphs have been indented, but grammar and spelling have not been edited unless content was unclear.

INTRODUCTION

by Peter C. Marzio

In one sense Robert Frank's photographs of American life belong to a 400-year tradition of Europeans attempting to capture the uniqueness, the essence, or the meaning of the people who inhabited the New World. A Frenchman in 1782 asked, "What then is the American, this new man?" He was repeating a query which artists and writers first asked about the Indians in the sixteenth century and then broadened to include European and African settlers after 1607. The idea of being an American, distinct from an Englishman or German, for example, was not developed fully even at the time of the ratification of the Constitution. We must remember that the United States was the first country to be defined as a political entity before its character as a nation was clear. This historical reversal, becoming a state before being a nation, sent nineteenth-century Americans and European visitors scurrying in a frenzied search for the new nation's identity.

Important home-grown writers and poets like Emerson, Whitman, and Twain tried to tell us who we were. Brilliant genre painters including William Sydney Mount, Eastman Johnson, and Winslow Homer looked for American "types" to portray American character. Photographers, too, joined the search. Although their techniques and equipment did not permit them to capture an instant or candid picture in the early years, photographs from the Civil War and afterward show an aggressive people forging the character of the nation. At a popular level, every drawing-room periodical carried commentary about the unique quality of American life, and lavish pictorials like *Harper's Weekly* minted hundreds of woodcuts revealing the American style.

This self-search was more than matched in energy by foreign travelers to America who felt compelled to analyze everything from the nation's psyche to its unique railway system. Hundreds of books were published by foreign observers trying to define America. Alexis de Tocqueville, Charles Dickens, and Josiah Royce were some of the most famous visitors, but the ranks included writers, soldiers, diplomats, artists, and philosophers.

Some accounts were complimentary, but many were not. The lack of American traditions, the constant mobility of the American people, the wide-open spaces, and the polyglot populace seemed to threaten the order and refinement Europeans saw as basic requirements for sophisticated civilization.

This desire to know America was inexhaustible. The millions of immigrants who entered the nation in the nineteenth and early twentieth centuries kept changing America. Waves of Irish, Germans, Italians, Poles, and Chinese altered the look and character of entire American cities. The newcomers needed to be educated, so the public school systems were organized to teach basic skills and to Americanize the immigrant. But what did Americanize mean? And if more and more Germans and Italians and Poles were pouring in every day, didn't it mean that the definition of American was changing? Examination and reexamination of the nation's character was a perpetual necessity.

The tradition has persisted until the present day. In painting, sculpture, literature, poetry, photography, journalism, and film, creative people continually find new cadences and points of view rooted in American life. Robert Frank is a clear example. By the time he wrote to the Guggenheim Foundation in 1954, he had been photographing everyday life in Europe, Peru, and America for eleven years. When he came to the United States in 1947, his goal was to record the "kind of civilization born here and spreading elsewhere." How reminiscent of what observers wrote more than 200 years ago! And yet, despite all who came before him, Robert Frank found an America all his own.

Robert Frank took a cliché and turned it inside out. Mobility is a word which seems to appear most often in foreigners' accounts of American life. The westward movement, the constant churning of peoples in the cities, the great railway and canal and highway systems—all were seen as basic facts of American life. An American was someone who couldn't sit still. But mobility also had a second meaning. The promise of an American life was the opportunity to move upward on the social and economic ladders. Observers continually viewed the American entrepreneurial spirit as a free-for-all, a "great barbecue" where the toughest and hungriest ate the most. To be American was to be ambitious.

Robert Frank saw the flip side. He photographed the nonmobile American, the working classes who live the life of a specific place. Frank's people appear to have an organic connection with their environment and to be oblivious to the whirligig of a mobile society. This sense of small communities and low horizons is reinforced by Frank's photographs of jukeboxes, radios, and televisions which bring popular culture *to* the people. This immobility gives a scary feeling of isolation, insecurity, and futility. The people we see in Frank's photographs never leave their meager environments, their expectations of moving up in society appear to have died generations ago.

The only mobile person in Robert Frank's *The Americans* is the artist himself. By using the technology that made American mobility possible—highways, gasoline stations, telephones, motels, and automobiles—Frank penetrated a sector of American life which eluded many of those who preceded him. Frank's contribution is a dispassionate portfolio of images with a stark honesty, beauty, and coherence which demand our attention and interpretation.

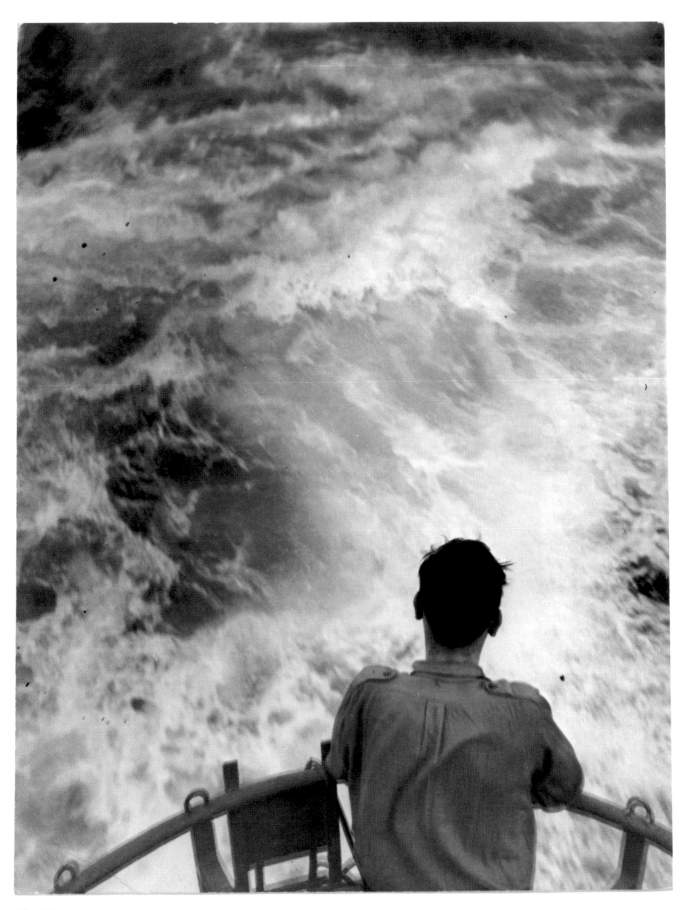

Robert Frank
On Boat to USA, March 1947

CHRONOLOGY

by Anne W. Tucker and Stuart Alexander

For complete references to titles in brackets, see bibliography.

1924 — *November 9*, born, Zurich, Switzerland.

1941 — *January – April 1942*, apprentices to photographer H. Segesser, Zurich, to avoid going into his father's business.

1942 — *May – July*, works as still photographer for Gloriafilm, Zurich, on *Steinbruc*, starring Maria Schell.

— *August – March* 1944, works at Michael Wolgensinger's photography and film studio.

1944 — *December – July 1945*, works as assistant for Victor Bouverat, Geneva.

1945 — Serves in military in Switzerland.

1946 — *May 1 – August 31*, works for Hermann Eidenbenz studio, Basel.

— Makes first of four books binding original photographs in book format.

1947 — *March*, immigrates to United States. Hired by Alexey Brodovitch to work for *Harper's Bazaar*.

1948 — Meets Louis Faurer in *Harper's* studio.

— *July – November*, photographs fashion, primarily for *Harper's Bazaar's* Shopping Bazaar section.

— "I was lucky in meeting the right people. In New York. That's what New York is great

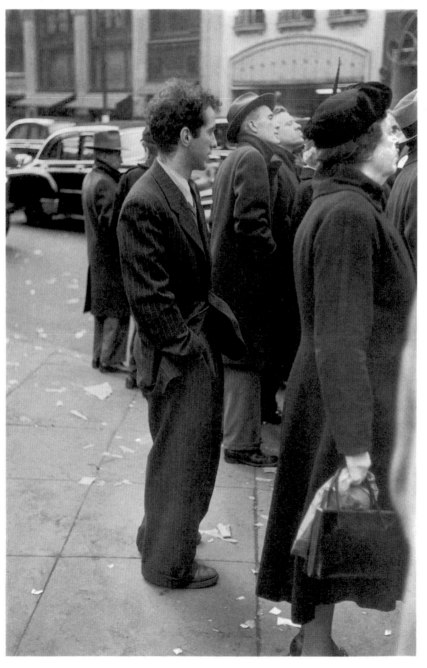

Louis Faurer (American, b. 1916)
Robert Frank, New York City, 1947

8

for. You really meet the people you need. You choose them." [*Photography Within the Humanities*]

— Takes brief trip to Europe.

— *June – December*, travels in Peru and Bolivia. Makes unique book with thirty-eight photographs, which he presents to Brodovitch. Photographs first published in *Neuf* (1952) and later (1956) in book form as *Indiens pas morts* with additional photographs by Werner Bischof and Pierre Verger and text by Georges Arnaud. Subsequent editions (some with different text) in Great Britain, Italy, Spain, Switzerland, and United States.

1949 — Travels to Europe. Meets Robert Delpire in Paris. Over next thirty-seven years, Delpire publishes four books of Frank's photographs.

— Travels to Italy with Elliott Erwitt.

— Makes unique book of photographs of Paris for Mary Lockspeiser.

1950 — Marries artist Mary Lockspeiser. Lives at 53 E. 11th Street in New York.

— *August 2 – September 17*, included by Edward Steichen in *51 American Photographers* at the Museum of Modern Art. First of twenty-seven group exhibitions at the Modern which contain Frank's work, including *Post-War European Photography* (1953), *The Family of Man* (1955), *Photographs by Harry Callahan and Robert Frank* (1962), and *The Photographer's Eye* (1964).

1951 — *February 7*, son Pablo born.

— *April 29 – May 9*, exhibition at Tibor de Nagy Gallery, New York, with W. Eugene Smith and Ben Schultz.

— *August*, Mary and Pablo travel to Switzerland. Frank completes entries for *Life* magazine's Young Photographers Contest. Enters photo essay category with "People You Don't See," fifteen photographs of six people on 11th Street, chosen "because they are typical of people I had seen before, almost anywhere in the city." [text for essay, unpublished] Also submits photographs in individual pictures category in which he wins second prize ($1,250).

— *Summer – March 1953*, lives and works in Europe with Mary and Pablo.

1952 — Lives in Paris. *Summer*, travels to Spain, is based in Valencia.

— *October*, meets Edward Steichen in Zurich, Switzerland; helps Steichen survey photographs for *Post-War European Photography* and *The Family of Man*.

— Makes four copies of *Black, White and Things*, a book of thirty-four photographs designed by Werner Zryd. Gives copies to his parents, Edward Steichen, and Zryd and keeps one for himself.

— *December*, travels to London.

1953 — *March 8 – 16*, photographs miners in Caerau, Wales.

— *March 17*, sails from Southampton, England, to New York on *Mauretania*.

— Rents apartment on 130 W. 23rd Street.

— Gives up fashion photography; works as freelance photojournalist with some advertising assignments. "I did illustration work for magazines: bad women, good men, old people, lonely people. That was my thing." [unpublished] Subsequently publishes in *Life*, *The New York Times*, *Fortune*, *Look*, *Esquire*, *Glamour*, and *Harper's Bazaar*.

— Meets Walker Evans.

— *December*, wins fourth prize in black-and-white category in *Popular Photography*'s 1953 Photography International Pictures Contest.

1954 — *April 21*, daughter Andrea born.

— *October*, applies for Guggenheim Fellowship. Alexey Brodovitch (art director, *Harper's Bazaar*), Walker Evans (photographer and editor, *Fortune*), Alexander Lieberman (art director, *Vogue*), Meyer Schapiro (professor, Columbia University), and Edward Steichen (curator, the Museum of Modern Art) serve as references. Awarded $3,000 for June 1955 to June 1956, becoming first European photographer to receive Guggenheim Fellowship.

1955 — Purchases 1950 Ford from Ben Schultz. Begins fellowship by photographing in New York and environs. Photographs in Savannah, Georgia, and along coasts of South and North Carolina. *July*, photographs in Detroit and at Ford's River Rouge plant in Dearborn, Michigan. Stopped by Detroit police, searched, and arrested for possessing two license plates. (Had tossed expired plate in trunk when he purchased car.) Released after one night in jail.

— *October*, drives down East Coast to Florida, up through Atlanta, across northern Georgia, Alabama, and Mississippi to Memphis. Drives south along Mississippi River, first in Arkansas, then through Mississippi to New Orleans. Joined in Houston by Mary and children. Drives across southern Texas, up to Santa Fe, New Mexico, across Arizona and Nevada on Route 66 to Los Angeles. Stays for a month; processes film in Wayne Miller's darkroom. Mary and children return to New York.

1956 — Seeks and receives renewal of Guggenheim Fellowship.

— Drives to San Francisco, across Nevada and Utah, up to Idaho and Montana, down through

Nebraska, east to Chicago, Indianapolis, back to New York. Photographs the Democratic National Convention in Chicago.

— "I think that trip was almost pure intuition—I just kept on photographing. I kept on looking. I think that at that time I was compassionate. I had a feeling of compassion for the people on the street. That was the main meat of the book—that gave me the push—that made me work so hard until I knew I had something, but I didn't even know I had America." [*Criteria*]

1956 — Moves to 34 Third Avenue near Tenth Street community of poets, painters, and musicians. Alfred Leslie lives next door and Willem de Kooning across backyard.

1957 — *January*, photographs presidential inauguration in Washington, D.C.

— Prints enlargements, selects and sequences photographs for his book. Publishes portfolios in *U.S. Camera Annual*, *Camera*, and *Pageant* magazines.

1958 — Delpire publishes *Les Américains*, with text selected by Alain Bosquet. Italian edition *Gli Americani* is published by Il Saggiatore, Milan (1959). American edition *The Americans*, with added introduction by Jack Kerouac, published by Grove Press (1959). Reprinted by Aperture and the Museum of Modern Art (1968); Aperture, distributed by Grossman Publishers (1969); enlarged Aperture edition (1978); revised Delpire (France) and Pantheon (U.S.A.) editions (1986).

— *January*, works for *The New York Times* Promotion Department under Louis Silverstein. First in series of ads appears in *Advertising Age* (continues roughly biweekly through 1961). Also appears in other trade journals and *The New York Times*. Series also published as a book titled *New York Is*, c. 1959. Ad campaign continues as double-image series and finally as filmstrip series in July and August 1963.

— *April*, travels to Florida with Jack Kerouac.

— *July 4*, photographs at Coney Island.

— *Summer*, begins filmmaking with a home movie with friends in Provincetown, Massachusetts.

— Rides 42nd Street bus and photographs from window. Dedicates photographs "to the people who walk and dream on the Streets of New York." Declares this to be his last personal project in still photography. "When I selected the pictures and put them together I knew and I felt that I had come to the 'end' of a chapter. And in it was already the beginning of something new." [*The Lines of My Hand*]

1959 — Makes *Pull My Daisy*, codirected with Alfred Leslie. Produced by Walter Gutman. Narrated by Jack Kerouac. Cast includes Allen Ginsberg, Gregory Corso, Peter Orlovsky, Alice Neel, Larry Rivers, Richard Bellamy, and Delphine Seyrig. (35mm, black/white, 29 minutes)

1960 — Films *The Sin of Jesus*, script based on story by Isaac Babel. Produced by Walter Gutman. (35mm, black/white, 40 minutes) Shown in 1961 at Spoleto Film Festival.

1961 — Travels to Europe. Photographs Venice Film Festival.

— *Pull My Daisy*, with complete improvised narration by Jack Kerouac and still photographs by John Cohen, published by Grove Press, New York, and Evergreen Books, Ltd., London.

— *Spring*, exhibition at the Art Institute of Chicago curated by Hugh Edwards. First one-man exhibition.

1962 — *January 29 – April 1, Photographs by Harry Callahan and Robert Frank* curated by Edward Steichen at the Museum of Modern Art.

— *January*, *Du* (Switzerland) devotes issue to Callahan's and Frank's photographs.

— Moves to Sixth Avenue and Spring Street.

1963 — *September*, directs *OK End Here*, film based on an original story by Marion Magid. (35mm, black/white, 35 minutes) Wins grand prize at Bergamo Film Festival. Also shown at New York Film Festival.

— *June*, The New York Times publishes *Zero Mostel Reads a Book* with photographs by Frank.

1964 — Works and travels with Conrad Rooks (producer, director, and scriptwriter), filming *Chappaqua. Through April 1966*, films in France, United States, Mexico, England, India, Ceylon, and Jamaica. Film released in 1967. (35mm, color and black/white, 92 minutes) Wins Silver Lion (second prize) at 27th Annual Venice Film Festival. First of at least six films on which Frank is employed as cameraman or editor without artistic control. Others include *Home Is Where the Heart Is* (c. 1971), *Let the Good Times Roll* (1973), *Sunseed* (1973), and *No Second Chances* (1974).

— Beaumont Newhall includes Frank in fourth revised edition of *The History of Photography: From 1839 to Present Day*. Few histories of twentieth-century photography subsequently published have excluded Frank's work.

— Moves to 86th Street and Broadway.

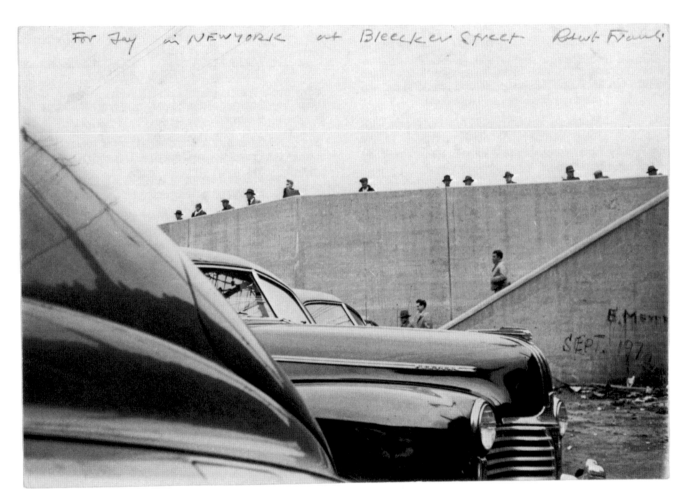

Robert Frank
New York, 1947
Jay Manis, New York

1965 — George Eastman House purchases twenty-five photographs from *The Americans* for traveling exhibition in exchange for 35mm, black/white movie film.

— Meets Sid Kaplan, printer.

— *Through 1968*, directs, photographs, and edits *Me and My Brother*, film "about a silent man and an actor who becomes silent." Produced by Helen Silverstein. Cast includes Allen Ginsberg, Julius and Peter Orlovsky, and Joseph Chaikin. (35mm, color and black/white, 91 minutes)

1969 — Separates from Mary.

— *Winter*, moves to 184 Bowery. Lives with artist June Leaf.

— Produces, directs, and edits *Conversations in Vermont*, a film about Pablo and Andrea, on grant from Dilexi Foundation. Cameraman is Ralph Gibson. (16mm, black/white, 26 minutes)

— Makes documentary film, *Life-raft Earth*, with Hugh Romney and Stewart Brand. Danny Lyon is assistant. (16mm, black/white, 30 minutes)

— Travels to Nashville, Tennessee, to work on Danny Seymour film about singer Tracy Nelson.

— *May 26 – June 29*, one-man exhibition curated by Michael Hoffman at Philadelphia Museum of Art, from which museum purchases forty-four photographs.

— *June – December*, publishes five monthly columns in *Creative Camera* (London).

— *Summer*, buys land in Nova Scotia with June Leaf. "We build a building, overlooking the sea. I spend a lot of time looking out the window. Camera still in closet. I wait." [*Robert Frank*, Aperture]

1970 — Receives grant from American Film Institute to make *About Me . . . A Musical.* (16mm, black/white, 35 minutes) Released in 1971.

— Lectures in colleges across country.

— Danny Seymour visits Nova Scotia.

1971 — Begins to use Super 8 Canon camera that June Leaf brings from Japan.

— Receives New York state grant from Creative Artist Public Service Program for filmmaking.

— *Fall*, teaches at Visual Studies Workshop in Rochester, New York, producing short film with students. Later produces films with students at Nova Scotia College of Art and Design (1973). Through mid seventies, teaches and lectures at other colleges and workshops in United States and Canada.

1972 — Kazuhiko Motomura publishes *The Lines of My Hand* in Tokyo. American edition published by Lustrum Press. Frank's introduction reads: "Twenty-five years of looking for the right road. Post cards from everywhere. If there are any answers I have lost them. The best would be no writing at all."

— Commissioned by Rolling Stones to film 1972 American tour. Film made with Danny Seymour and titled *Cocksucker Blues.* (16mm, color and black/white, 85 minutes) Stones block public release because of explicitness of sexual and drug scenes.

1974 — Begins to use Polaroid black and white positive/negative film to make series of collages with multiple negatives and writing. First picture is *Bonjour Maestro* for Delpire.

— *December 28*, Andrea dies in airplane crash at Tikal National Park in Guatemala.

1975 — Marries June Leaf in Reno on way to California.

— *Spring*, teaches filmmaking for two months at University of California, Davis.

— Makes a series of collages with multiple color prints and writing using $5 Lurecamera.

— Makes film *Keep Busy* with Rudy Wurlitzer, writer, who also lives in Nova Scotia and New York City. (16mm, black/white, 38 minutes)

1976 — *Robert Frank* published as part of book series, *Aperture History of Photography Monographs*. Foreword by Rudy Wurlitzer.

— *February 29 – April 25*, retrospective exhibition at the Kunsthaus, Zurich, curated by Rosselina Bischof.

1978 — *January 20 – March 26*, retrospective exhibition curated by Lorraine Monk at Stills Division, National Film Board of Canada, Ottawa. Exhibition travels to Fogg Museum, Harvard University, Cambridge, Massachusetts.

— *February 15 – March 25*, retrospective exhibition curated by Philip Brookman at Mary Porter Sesnon Art Gallery, University of California, Santa Cruz.

1979 — *March 25 – May 6*, retrospective exhibition curated by Philip Brookman at Long Beach Museum of Art, California.

1980 — Makes film, *Life Dances On . . .*, dedicated to Andrea and Danny Seymour. (16mm, color and black/white, 30 minutes)

— *September 16 – 28*, film retrospective curated by John Hanhardt at Whitney Museum of American Art, New York.

1981 — Makes *Energy and How to Get It* with Gary Hill and Rudy Wurlitzer. Funded by Corporation for Public Broadcasting. (16mm, black/white, 28 minutes)

— *February*, films shown at Rotterdam Film Festival. From Rotterdam, travels to Israel. Teaches three week course at Camera Obscura school.

1982 — *This Song for Jack* filmed at Naropa Institute in Boulder, Colorado, during twenty-fifth anniversary celebration of Jack Kerouac's book *On the Road*. Film completed in 1983. (16mm, black/white, 30 minutes)

— *Summer*, Kazuhiko Motomura visits Mabou preparing book titled *Flower is Paris; Ford is Detroit; Mabou is Waiting*.

— Works with Robert Delpire on retrospective exhibition to open in Paris in 1986.

— *December*, Robert Delpire edits *Robert Frank*, with introduction by Rudy Wurlitzer, published by Photo Poche, Paris. Reprinted in America by Pantheon (1985).

— *December*, special issue of *Les Cahiers de la Photographie*, edited by Gilles Mora, devoted to Frank.

1983 — *November – March 1984*, makes *Home Improvements*, video about Robert Frank, June Leaf, and Pablo Frank in Canada and in New York. Edited in 1985. (color, 26 minutes)

1984 — Photographs Democratic National Convention in San Francisco for *California Magazine*.

1984-85 — Works with Robert Heinecken, Dave Heath, and John Wood on Polaroid Project curated by William Johnson.

1985 — *March 29 – May 10, Robert Frank: Fotografias/Films 1948-1984* exhibition and catalogue, curated by Vicent Todoli, produced by Sala Parpallo, Valencia, Spain.

— *June*, awarded Erich Saloman Prize by Deutsche Gesellschaft für Photographie in Berlin.

— Prepares feature length film script with Rudy Wurlitzer, titled *There Ain't No Candy Mountain*.

1986 — Republishes *The Americans*.

— *February 15, Robert Frank: New York to Nova Scotia* opens at the Museum of Fine Arts, Houston.

March 1947

Dear Parents,

Never have I experienced so much in one week as here. I feel as if I'm in a film. Life here is very different than in Europe. Only the moment counts, nobody seems to care about what he'll do tomorrow. Now you want to know what I've been doing. For the past five days, I have been looking for a job and have not found one yet. The situation is not very favorable, because business has not been doing well. This country is really a free country. A person can do what he wants. Nobody asks to see your identification or your papers. The people here have representatives from every race and every nation. Whether you've been here for eight days or eight years, you are always treated like an American! There is only one thing you should not do, criticize anything. The Americans are extremely proud of their country! The whole way of life here is based on saving time. Only fast and as simple as possible. Bus, streetcar, and subway all cost the same amount, and tickets are not necessary. Doors open by themselves, newspapers are read and thrown away and then are immediately burned by street cleaners, on the open street in giant wastebaskets. There are no garbage cans, everything goes down an individual chute and is burned directly. Mailboxes are too small, so you have to place packages by the side of the street and they are picked up every 10 minutes, etc., etc. Nothing is impossible. They have electric toothbrushes and nail clippers, etc. In 10 minutes, you have eaten and there are three men standing behind you, waiting for you to leave. (Not in the expensive restaurants). I can only tell you this: you have to see for yourself. I would not want to live here forever. For older people who do not have much $, it is terrible here. Nobody has any consideration for anybody else. Old or young, man or woman, here it is everyone for himself. It is inconceivable, the tempo at which life takes place. And nevertheless, the people are much nicer and kinder than in Switzerland. For example, today I went to an address I got from Wechsler. The man was not home, only his wife. The door opened, I said who I am, and suddenly I was seated at the table and drinking coffee with the woman. By the way, they are very rich people with a giant apartment and a few servants. In New York, only millionaires could afford an apartment like ours [in Switzerland].

I must have had unbelievably good luck with my room. Very cheap (7 dollars a week) and right in the heart of the city, directly opposite of Rockefeller Center! Unfortunately, I can only stay until April 31. In fact, I owe this to my visit in Bern to the photographer Laubli. In addition, I have been invited to Matter's. Life here is expensive. Just to eat normally costs a dollar. Last week, I took a bus or subway at least eight times a day. Cost: 40 cents! I need a new shirt every two or three days and laundry costs about 3 dollars each time. It costs 70 cents for a haircut. Only that you should know that the dollar is not even worth four francs. In order to live in New York, you have to earn 50 dollars a week. Theater, etc., is very expensive. Movies on Broadway are, too. The city is monstrously big and, for example, when I go to Roger's I need half a day to get there. I will write again next week, I am tired from all the living and riding around in New York. Please send me the tripod and all of my negatives (in the wooden case) in my room.

Love, Robert

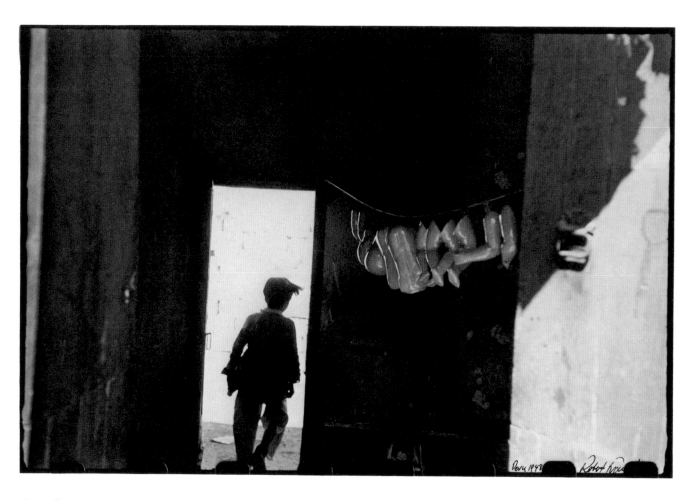

Robert Frank
Peru, 1948
Weston Gallery, Carmel, California

R. Frank — 33 Eugenia Vines
Gano de Valencia
Valencia, Spain
June 3rd, 1952

Dear Eugene [Smith] —

My answer to your letter comes late—but it is better late than not at all. Again I want to thank you for writing me such a fine letter. Meantime I have seen the issue with your Chaplin Story. By the little experience I had with *Life* I can understand how you must feel working with and for them for so long. But no matter how you (or one in general) feels about that magazine—it is a great compliment to be their most capable photographer. You had the best photographic story's known published in *Life* and with that reached a great audience, no other publication could have done as much for you as they did. (OR??) The only question for me would be how long do I need to stay with them. (Unfortunately one has to make a living) In Spain, *Life*—thanks to your Spanish Village Story—is known as a communist Paper!! By Police I was more than once asked if I work for *Life* and if I would know E. Smith. I like Spain very much—especially the people who are so friendly and sympathetic—it is too bad that they can't get rid of Franco. I plan to stay here for at least another month. Maybe by the end of this year we will be back in N.Y. (Let's hope you'll be there and we can get to know each other) If you would come to Europe, please let me know.

Good luck to you Robert

November 1952

Dear Lou [Faurer]

This is the best postcard from Paris. We heard Gaby's coming here. We soon will see you. We go to England this month and from there back to Times Square. Keep the dryer warm as I have a lot of glossy prints.
Happy Weekend and Christmas. Sammy

We saw a big parade, November Armistice, from our hotel window. Pablo thought it was very fine. Lots of horses, feathers, and music. Mary

Robert Frank
Valencia, 1952

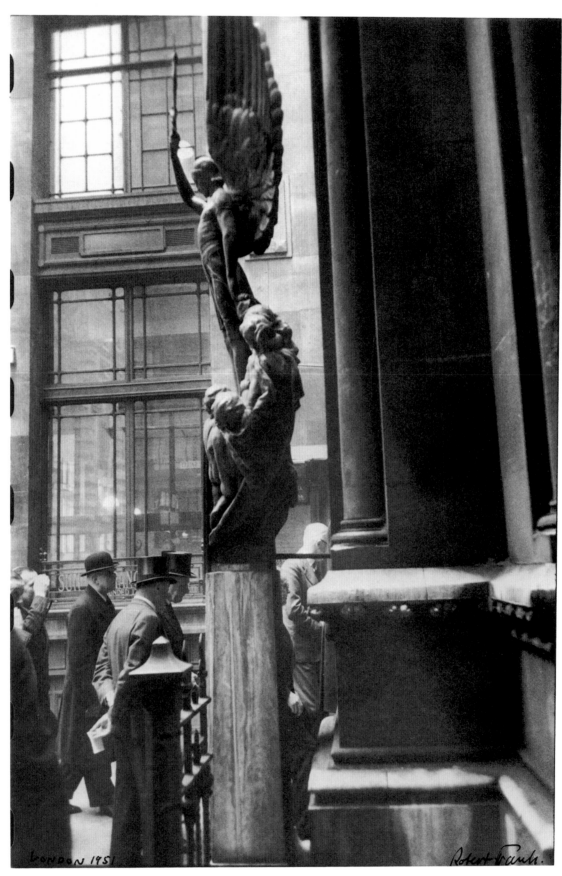

Robert Frank
London, 1952

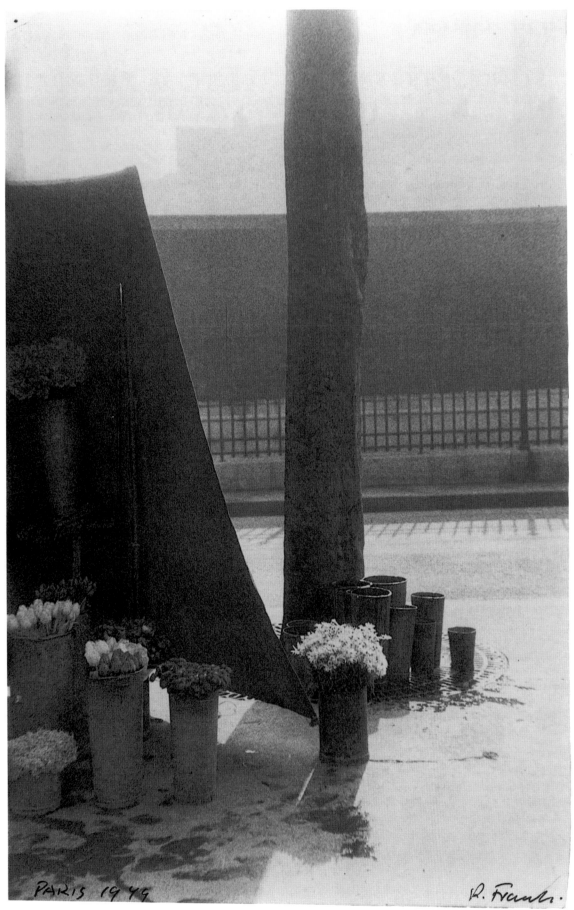

PARIS 1949

R. Frank.

Robert Frank
Paris, 1949
The J. Paul Getty Museum

FELLOWSHIP APPLICATION FORM

JOHN SIMON GUGGENHEIM MEMORIAL FOUNDATION
551 FIFTH AVENUE · NEW YORK 17 · N · Y ·

RECEIVED
OCT
21
1954

APPLICATIONS and accompanying documents should reach the office of the Foundation not later than October 15 of each year.

In what field of learning, or of art, does your project lie?..............Photography..............

Concise statement of project To photograph freely throughout the United States, using the miniature camera exclusively. The making of a broad, voluminous picture record of things American, past and present. This project is essentially the visual study of a civilisation and will include caption notes; but it is only partly documentary in nature: one of its aims is more artistic than the word documentary implies. Applicant elaborates this matter in seperate accompanying statement of plans.

I am applying for a Fellowship with a very simple intention: I wish to continue, develop, and widen the kind of work I already do, and have been doing for some ten years, and apply it to the American nation in general. I am submitting work that will be seen to be documentation—most broadly speaking. Work of this kind is, I believe, to be found carrying its own visual impact without much work explanation. The project I have in mind is one that will shape itself as it proceeds, and is essentially elastic. The material is there; the practice will be in the photographer's hand, the vision in his mind. One says this with some embarrassment but one cannot do less than claim vision if one is to ask for consideration.

"The photographing of America" is a large order— read at all literally, the phrase would be an absurdity. What I have in mind, then, is observation and record of what one naturalized American finds to see in the United States that signifies the kind of civilization born here and spreading elsewhere. Incidentally, it is fair to assume that when an observant American travels abroad his eye will see freshly; and that the reverse may be true when a European eye looks at the United States. I speak of the things that are there, anywhere and everywhere—easily found, not easily selected and interpreted. A small catalog comes to the mind's eye: a town at night, a parking lot, a supermarket, a highway, the man who owns three cars and the man who owns none, the farmer and his children, a new house and a warped clapboard house, the dictation of taste, the dream of grandeur, advertising, neon lights, the faces of the leaders and the faces of the followers, gas tanks and postoffices and backyards. . .

The uses of my project would be sociological, historical and aesthetic. My total production will be voluminous, as is usually the case when the photographer works with miniature film. I intend to classify and annotate my work on the spot, as I proceed. Ultimately the file I shall make should be deposited in a collection such as the one in the Library of Congress. A more immediate use I have in mind is both book and magazine publication. Two European editors who know my work have agreed that they will publish an American project of mine: 1)M. Delpire of "NEUF", Paris, for book form. 2) Mr. Kubler of "DU" for an entire issue of his magazine.

STUDIES PROPOSED DURING 1956:

A photographic record of:
Northwestern Coastal Cities- Montana- Kansas (farming region) University-Town in the Midwest-Chicago-

Together with New York, Detroit, Houston, and Los Angeles these big cities will form the main structure of my proposed project.

Of the Work I have accomplished since receiving the Fellowship only about one fourth has been printed and edited, due to constant travelling. Beginning march 15th I will be able to print all of the negatives exposed since october 1955.

In collaboration with Mr.R.Delpire of Editions "NEUF" Paris I plan to have a book published.

I feel the request for a renewal of my fellowship can be justified by the significance and vision of its theme. To terminate at this point would mean incompletion and failure of my study.

Detroit Wednesday
July 1955

Dear Mary.

 I have just returned from Ford I have gone to the Post Office and read your letter and then I went to the Hotel and I took a shower and now—I think—for the first time since I came to Detroit I am quiet and peacful and not too tired to write to you. I am sitting in an airconditioned luncheonette and sweat like hell.

 Your letter is not cheerful but your letters are often sad. I would like to write to you something nice and maybe something nice will come out—eventually.

 It was good that I got so worked-up about that Guggenheim - because if I would not have been so determined about going to Detroit by now I would call it a game and lie down anywhere where it is nice and not think about photographs.

 Detroit is all right—just the way I thought an American city looks. But then, when you have to photograph you watch so closely and there is all the time to watch finally you don't want to see any-more and certain things cannot be photographed. My night in jail was not so funny as it might have sounded. It was depressing and I got scared. I was ready to give up when they let me out and maybe it is my Swiss-Background that helps. (Don't laugh)

 Ford is an absolutely fantastic place. Every factory is really the same but this one is God's factory and if there is such a thing—I am sure that the devil gave him a helping hand to build up what is called Ford's River Rouge Plant. But all the cars come out at one end. . . . At the other end, the beginning of the Plant, ships bring Iron-ore and from then on the whole car is built.

 It is slow to get permission to photograph and especially the way I want to photograph. Today I photographed where they make the motor (about 8,000 people work in this bldg.) Accompanying me—always: a man from Ford.

 I might come back to N.Y. the middle of next week (around July 16th) As soon as I know I'll let you know.

Robert

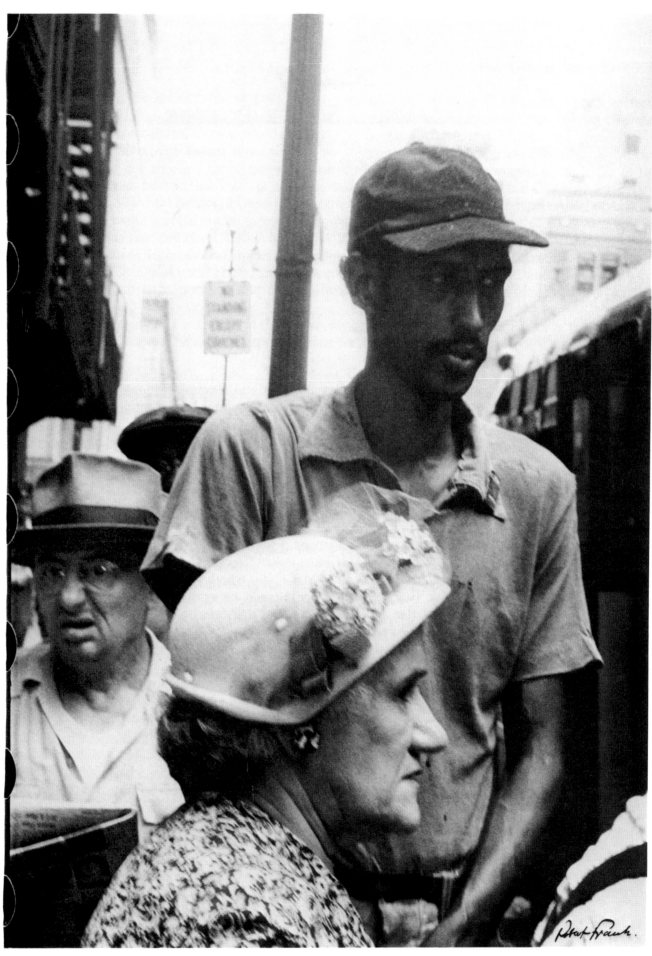

Robert Frank
Dearborn, Michigan, July 1955

Department of
ARKANSAS STATE POLICE

P. O. BOX 1189

Little Rock, Arkansas

HERMAN E. LINDSEY
DIRECTOR

PHONE
MOHAWK 3-4115

December 19. 1955

Alan R. Templeton, Captain
Criminal Investigation Division
Arkansas State Police
Little Rock, Arkansas

Dear Captain Templeton:

On or about November 7, I was enroute to Dermott to attend to some business and about 2 o'clock I observed a 1950 or 1951 Ford with New York license, driven by a subject later identified as Robert Frank of New York City.

After stopping the car I noticed that he was shabbily dressed, needed a shave and a haircut, also a bath. Subject talked with a foreign accent. I talked to the subject a few minutes and looked into the car where I noticed it was heavily loaded with suitcases, trunks and a number of cameras.

Due to the fact that it was necessary for me to report to Dermott immediately, I placed the subject in the City Jail in McGehee until such time that I could return and check him out.

After returning from Dermott I questioned this subject. He was very uncooperative and had a tendency to be "smart-elecky" in answering the questions. Present during the questioning was Trooper Buren Jackson and Officer Ernest Crook of the McGehee Police Department.

We were advised that a Mr. Mercer Woolf of McGehee, who had some experience in counter-intelligence work during World War II and could read and speak several foreign languages, would be available to assist us in checking out this subject. Subject had numerous papers in foreign languages, including a passport that did not include his picture.

This officer investigated this subject due to the man's appearance, the fact that he was a foreigner and had in his possession cameras and felt that the subject should be checked out as we are continually being advised to watch out for any persons illegally in this country possibly in the employ of some unfriendly foreign power and the possibility of Communist affiliations.

Subject was fingerprinted in the normal routine of police investigation; one card being sent to Arkansas State Police Headquarters and one card to the Federal Bureau of Investigation in Washington.

Respectfully submitted,
R. E. Brown, Lieutenant
Commanding
Troop #5
ARKANSAS STATE POLICE
Warren, Arkansas

REB:dlg

Walker [Evans]—

 I am writing you this because I want your opinion or advice. Nov. 7th I planned to drive from Marianna Ark. to Greenfield Miss. I came as far as McGehee Ark, outside this little town on Highway U.S. 65 two Highway-Patrol-Cars stopped me. I had to show my license, registration, passport etc. The lieutenant of the patrol-car looked at my papers, went through all my luggage inspected the whole car, asked me what I do, where I came from where I am going etc. After showing him the letter of the Guggenheim Found. he said that I was going to be detained. They drove me to the City Jail—locked me up. That was 12:30 P.M. I did ask, if I could have some coffee (I had nothing to eat since 6AM that day) but the answer was that if I would not be quiet they would teach me how to be quiet.

 I stayed in that cell untill 7:30 P.M. At 7 PM I got something to eat. At 7:30 P.M. that same lieutenant that stopped me came to my cell accompanied by a uniformed Highway-Patrolman plus a regular policeman. From 7:30 PM untill 11:30 P.M. I was cross-examined by those 3 men who, at halftime were joined by apperently an inspector of that county. I will discribe to you this cross-examination which was the most humiliating experience I had so far.

 The lieutenant was in charge of the whole thing, the policeman and the Highway patrolman had minor roles. That is untill the special inspector arrived at about 9 P.M. who then took charge of the cross examination.

 Again the same questions: where I came from, why, where I am going, why etc. I said I was going to photograph at Baton Rouge-Refinerys for that Guggenheim project. They took me to the car, I brought up all my luggage except one big suitcase where I could not find the key to open it. Also in my car in the glove compartment they found 1/5 bottle of Hennessey-Brandy which I bought in Wash. D.C. and the bottle was 2/3 empty. Now they had all my papers in front of them. Why the Guggenheim F. gives me money, how old is Mr. Mathias? (he signed the letters—I had that whole correspondence with me) if I am jewish why I went back to Europe? If it would not have been better to stay in America and not to loaf in Europe. I had to translate for 10 Min an intire page of the Swiss Army booklet which I had with me. (This is the equivalent of an american draft information) Why I photographed in Detroit at Ford? The patrolman got all exited—because he visited Ford and was not allowed to photograph there. For 15 Min. he questioned me on that subject, it is impossible to repeat all the questions asked—but at the end he stated that it is damned funny that I was allowed to photograph at all and if he would go to Switzerland he certainly could not photograph there. About every hour I had to go back to my cell, while they discussed the matter and made telephone calls. I was questioned about that 1/5 bottle of Hennessey (foreign whiskey) My cufflinks etc. where in a metal box where english licorice used to be (foreign box.) On my road map the AAA marked the direct route to New Orleans in green. But on your advice (you remember) I made a red marking from Chattanooga Tenn. across Alabama into Miss. to Memphis, Tenn. About that, great questioning. Then the special Inspector arrived. He immediately started to ask me a question in jewish, I said that I did not speak jewish. He asked about the Oil Refinery's Pictures that I where going to take and I gave him the two Names of the people in Baton Rouge who were informed about my arrival by Standard Oil in N.Y. (And I had cleareance to photograph there) I had a list of addresses in Calif. and I was questioned about all of them. All the rolls of Films that I had shot so far, I had marked by location where I took them. I was questioned at length about some rolls which I took in Scottsboro Ala. I denied knowing about that case (all the pict. that I took in Scottsboro show Farmers going to shop at the stores, as it was Satuarday.) I was asked if I took a pict. of the bridge at Memphis. I did not. etc. etc. Then the inspector asked what seemed to me a vital question. He said who do you know, anywhere, that has a high position in public affairs, police etc.

 I mentioned Steichen and Mary's Uncle whom I said is a personal friend of Mayor Wagner. Then he questioned me about the references on my Guggenheim application (russian name, Brodovitch.) I had to go in my cell again. When I got in again, the lieutenant leaned back and said: "Now we are going to ask you a question: Are you a commie? I said no. He said, "Do you know what a commie is? I said yes. Then I

was asked to give them all my exposed films, so they could develop them. I said I would make a big stink if they would do that. I did not tell them what I would do but I said this is the way I make a living and if these films would be developped by someone else they would be ruined. Again I had to go outside. After coming in I was asked to give up voluntarily 3 rolls of film. I was promised, that that would speed up my release. I agreed to that. I was asked about Mary and my children, Pablo and Andrea (foreign Names.) Finally they said they would release me tonight if I would pry open the big suitcase in the trunk of the car. I did that and they came across the Congressional Fortune Nov. Issue. Again a conference, and I think on the advice of the inspector they gave me back my 3 rolls of film. Then the inspector left and the lieutenant took over again.

Dear Walker—this letter is written more than 40 hours after these happenings—I am not exited about them any more and I write without that fury that I had in me after I got released. During the examination I was as courteous as I could be—I realized what would happen if I could not do that.

If you think I could do something to get those Fingerprints-Sheets destroyed or annulled please let me know what you think about that. I think in my naturalization process that would hurt me a lot or make it even impossible. I know you have other problems. If necessary I would go to Little Rock Ark. or back to McGehee Ark. Please get in touch with Mary who will know my address.

Sorry to write such a long letter.

A nous la liberté!

Robert

NATHANIEL H. JANES
LAWYER

Dec. 31, 1955

Mr. Robert Frank
6849 Pacific View Drive
Hollywood, Los Angeles,
California.

Dear Robert:

 I am sending you the following:
 (1)Your letter to Walker of Nov. 9th
 (2)Report of the arresting officer
 (3)My bill for legal services.
 I am holding for safe-keeping your fingerprints which I had better turn over to you in person.

 A copy of the fingerprints have been sent to the F.B.I. by Arkansas authorities. These may be recovered, but not without, a great deal of difficulty.

 If you plan to travel around the southern states, you had better be in communication with me so that I can advise you of your risks.

Very truly yours,
Nate

NHJ;ab
Encls.

27

Letter translated from German.

Winter 1955
Los Angeles

Dear Parents,

Yesterday we received your letter with the check. Thank you very much. I was happy to hear from you, we had written two letters with no reply.

Papa always wants to be informed about my plans, my attitude about my work, etc. It is not so easy for me to describe this. Since I have been working on the Guggenheim project, my attitudes about what I am doing have changed. I am working very hard not just to photograph, but to give an opinion in my photos of America. The first half of my project is finished and the few friends who have seen the photos say they are very good. I believe the second half will be better. I am photographing how Americans live, have fun, eat, drive cars, work, etc. America is an interesting country, but there is a lot here that I do not like and that I would never accept. I am also trying to show this in my photos.

LOS ANGELES is a big city, and one can photograph a lot here. I have stayed here because I have better chances of getting assignments in L.A. than in San Franzisco. We will very probably be going to San Franzisco around March. This will depend on whether I can get any assignments. It is more difficult to work here than in New York.

Eleanor is very fond of Pablo and writes him long letters. She wrote me that she has sent you a few letters. She is very nice to us and I am certain that if we were to need anything, she would help us without hesitation.

The children are healthy and they like it here. Mary has it rough—it is too bad, that Mary cannot drive. . . . Sometimes we have babysitters. But this is expensive.

Thank you very much for the 100 dollars.

We have not received any package. To which address did you send it and when? What are Bobby and Fanny doing? I am always pleased to hear from you. Even if we do not write much, it is not as if we do not want to have contact with you. Often it is difficult to work with the children, etc., etc. The life we are living now seems to be wonderful and cozy, from far away. But often this is not the case.

A kiss from
Robert

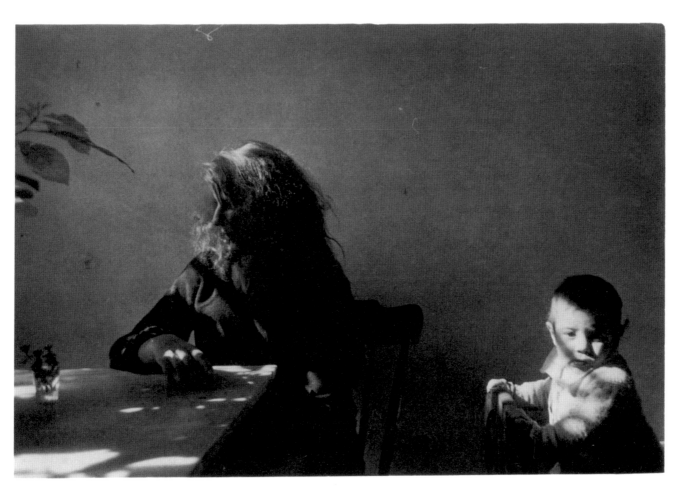

Robert Frank
Mary and Andrea, Third Ave., New York City, 1956

ROBERT FRANK

by Walker Evans

Assuredly the gods who sent Robert Frank, so heavily armed, across the United States did so with a certain smile.

Photographers are often surprised at some of the images they find on their films. But is it an accident that Frank snapped just as those politicians in high silk hats were exuding the utmost fatuity that even a small office-seeker can exhibit. Such strikes are not purely fortuitous. They happen consistently for expert practitioners. Still, there remains something mysterious about their occurrence, for which an analytical onlooker can merely manufacture some such nonsensical phrase as "the artist's crucial choice of action."

But these examples are not the essence of Frank's vision, which is more positive, large, and basically generous. The simple picture of a highway is an instance of Frank's style, which is one of the few clear cut signatures possessed by any of the younger photographers. In this picture, instantly you find the continent. The whole page is haunted with American scale and space, which the mind fills quite automatically—though possibly with memories of negation or violence or of exhaustion with thoughts of bad cooking, extremes of heat and cold, law enforcement, and the chance to work hard in a filling station.

That Frank has responded to America with many tears, some hope, and his own brand of fascination, you can see in looking over the rest of his pictures of people, of roadside landscapes and urban cauldrons and of semi-divine, semi-satanic children. He shows high irony towards a nation that generally speaking has it not; adult detachment towards the more-or-less juvenile section of the population that came into his view. This bracing, almost stinging manner is seldom seen in a sustained collection of photographs. It is a far cry from all the woolly, successful "photo-sentiments" about human familyhood; from the mindless pictorial salestalk around fashionable, guilty and therefore bogus heartfeeling.

Irony and detachment: these are part of the equipment of the critic. Robert Frank, though far, far removed from the arid pretensions of the average sociologist, can say much to the social critic who has not waylaid his imagination among his footnotes and references. Now the United States, be it said, will welcome criticism, and use it. At its worst moments, the U.S.A. today may seem to think that it is literally illuminated by the wide smile of one man, and saved for something-or-other by energy and money alone. But worse moments are the province and the mainstay of the daily newspaper.

For the thousandth time, it must be said that pictures speak for themselves, wordlessly, visually—or they fail. But if those pictures chose to speak, they might well use the words George Santayana once wrote in a small preface about the United States:

". . . the critic and artist too have their rights, . . . Moreover, I suspect that my feelings are secretly shared by many people in America, natives and foreigners, who may not have the courage or the occasion to express them frankly . . . In the classical and romantic tradition of Europe, love, of which there was very little, was supposed to be kindled by beauty, of which there was a great deal; perhaps moral chemistry may be able to reverse this operation, and in the future and in America it may breed beauty out of love."

U.S. Camera Annual 1958, U.S. Camera Publishing Corp., New York, 1957, p. 90

A Statement . . .

I AM GRATEFUL to the Guggenheim Foundation for their confidence and the provisions they made for me to work freely in my medium over a protracted period. When I applied for the Guggenheim Fellowship, I wrote:. . . "To produce an authentic contemporary document, the visual impact should be such as will nullify explanation . . ."

With these photographs, I have attempted to show a cross-section of the American population. My effort was to express it simply and without confusion. The view is personal and, therefore, various facets of American life and society have been ignored. The photographs were taken during 1955 and 1956; for the most part in large cities such as Detroit, Chicago, Los Angeles, New York and in many other places during my journey across the country. My book, containing these photographs, will be published in Paris by Robert Delpire, 1958.

I have been frequently accused of deliberately twisting subject matter to my point of view. Above all, I know that life for a photographer cannot be a matter of indifference. Opinion often consists of a kind of criticism. But criticism can come out of love. It is important to see what is invisible to others. Perhaps the look of hope or the look of sadness. Also, it is always the instantaneous reaction to oneself that produces a photograph.

My photographs are not planned or composed in advance and I do not anticipate that the on-looker will share my viewpoint. However, I feel that if my photograph leaves an image on his mind—something has been accomplished.

It is a different state of affairs for me to be working on assignment for a magazine. It suggests to me the feeling of a hack writer or a commercial illustrator. Since I sense that my ideas, my mind and my eye are not creating the picture but that the editors' minds and eyes will finally determine which of my pictures will be reproduced to suit the magazines' purposes.

I have a genuine distrust and "mefiance" towards all group activities. Mass production of uninspired photo journalism and photography without thought becomes anonymous merchandise. The air becomes infect with the "smell" of photography. If the photographer wants to be an artist, his thoughts cannot be developed overnight at the corner drug store.

I am not a pessimist, but looking at a contemporary picture magazine makes it difficult for me to speak about the advancement of photography, since photography today is accepted without question, and is also presumed to be understood by all—even children. I feel that only the integrity of the individual photographer can raise its level.

The work of two contemporary photographers, Bill Brandt of England and the American, Walker Evans have influenced me. When I first looked at Walker Evans' photographs, I thought of something Malraux wrote: "To transform destiny into awareness." One is embarrassed to want so much for oneself. But, how else are you going to justify your failure and your effort.

Robert Frank

U.S. Camera Annual 1958, U.S. Camera Publishing Corp., New York, 1957, p. 115

Gotthard Schuh (Swiss, 1897-1969)
Robert Frank, 1947

Robert Frank

My dear Robert Frank,
Your new pictures, just received, have left us shocked and haunted. It will take us a considerable time to separate the impression made on us by the world depicted in these photos from our respect for your remarkable performance.

It is eight years since I made your work known here in Switzerland with a page in the 'Neue Zürcher Zeitung'. How well I remember that picture made in the Banlieue, representing suburban children teasing a cart-horse waiting stolidly beneath its blanket. There was also the shy young man with the flower, which he timidly hid from his girl by holding it behind his back. Both pictures combined sharp observation and a fine restraint of expression.

Later on, when we happened to be on exhibition together at the Helmhaus in Zurich at the time of Cartier-Bresson's triumph with his studies in ironic intellectualism, you were showing the sensitive series depicting the expectant mother together with her first-born child. Although you did not regard those tender, touching pictures as a mere matter-of-fact task but as a gift from the heart, your eye nevertheless remained just as accurate, complete master of light effects and forms. And then, in contrast to the human feelings which went into the making of these family pictures full of intimacy and love, there was the set portraying the puritanical London business men—severe and concise in its restriction to black-and-white formality, and the unforgettable view of the silvery monotonous London street with the hearse, and in the background a child. You were never one to lament; you merely observed and remained, almost prudishly, behind your subjects.

Later, there appeared your Welsh miners studies. These pictures were richer in their depth of tone—unusual for you—and they told a story, as did, incidentally, the masterly impression of the nocturnal fiddler shown by Steichen in 'Family of Man'.

Had someone asked me at that time what I thought of you, I should have believed myself capable of drawing a fairly accurate sketch. I would probably have described you as follows: A photographer who is master of forms; an eye sensitive to the delicacy of light and the heaviness of shadows; a man more inclined towards static than dynamic expression, cautious in his restraint, more interested in his fellow-men than in the landscape, and receptive to the personal radiations from any individual.

I should never have thought that I could be so dismayed by your latest achievement, the fruits of your two-year stay in America. I have this work before me as the maquette of your book 'Americans' with the pictures taken during your two years of extensive travels through the States. How little remains in these views of what we knew and loved in your previous work! No smile, no flower, no vegetation, no beauty, but only tormented, stolid human faces set about with machinery, waiting blankly, expressionlessly at filling stations or in buses, or hard and dull at the steering-wheel of their vehicles, bored with the luxury of their super automobiles.

I do not know America, but your pictures frighten me on account of the visionary watchfulness with which you depict things that concern us all. Never have I seen so overpowering an image of humanity become mass, devoid of individuality, each man hardly distinguishable from his neighbour, hopelessly lost in airless space. A dour mass, crafty and aggressive.

Your book is sure to be unfairly judged in that the power of its imagery will be forgotten in the heat of discussion. How far your work lies from complacent irony! You never resorted to the cheap grotesque which would have been all too easy with such material. Your imagery is the fruit of passionate earnestness.

My impression of you has widened, but not changed. Whoever accuses you of arrogance, overlooks your deep love of your fellow-men and your grief at witnessing their transformation into an anonymous welter of mass humanity.

Your sincerely, Gotthard Schuh

Camera, vol. 36, no. 8 (August 1957), pp. 339-40

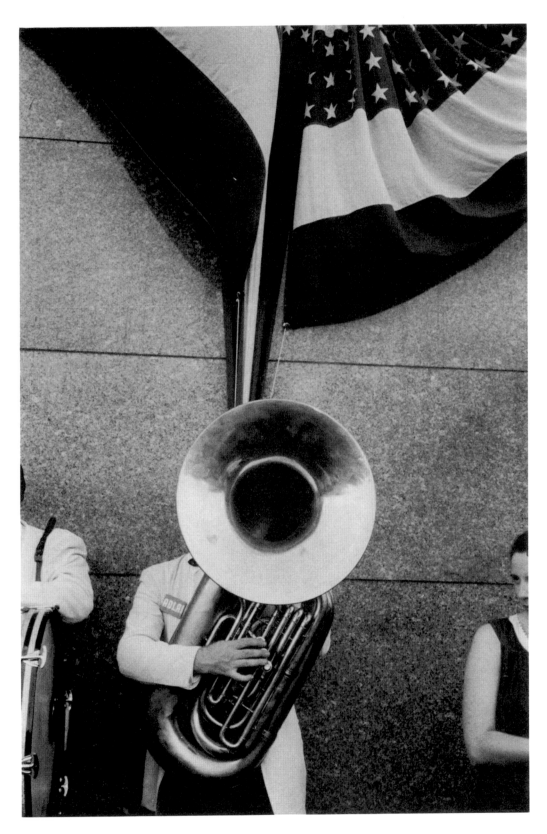

Robert Frank
Political Rally, Chicago, 1956

May 23, 1960.

Mr. Robert Frank,
34 Third Avenue,
New York City, New York.

Dear Mr. Frank: It seems so long since I was in New York and talked with you on the telephone that I am afraid you have forgotten the conversations we had in regard to an exhibition. Since I came back to Chicago, I have been very busy and I knew you had little time to be bothered with correspondence. However, I have not forgotten that you said you might be interested in a show and my experiences with *The Americans* have been so many since my return that I am writing you at last, still with the hope that we may have an exhibition here.

In the last week I have completed an exhibition schedule so that I am able to give you, if you are still interested, some idea of when the show could take place. How would the period from April 28 through June 11 of next year suit you? I remember you said you would like to have some delay and although these dates - almost a year in the future - may seem distant, the time will pass much faster than we think.

I have had the museum store stock the American edition of your book. They have sold a number of copies and there is a steady demand for it. We have both the French and American editions in the print study room and they have been enthusiastically received by the many young photographers who come here to look at the prints in our collection. This pleases me a great deal because no other book, except Walker Evans' *American Photographs*, has given me so much stimulation and reassurance as to what I feel the camera was created for. I hope this does not have too pompous a sound for I feel your work is the most sincere and truthful attention paid the American people for a long time. Although so different and not stemming from them, it may be kept in the company of Frank Norris, Sherwood Anderson, Hart Crane, John Dos Passos and Walker Evans and these are the best in American expression in the time I can remember. It is a real privilege to have known your pictures in their first freshness and newness. Someday they will spread to everyone and even the most sterile and analytical of intellectuals will accept them at last.

I should greatly appreciate hearing from you as soon as possible in regard to what you think about the exhibition so that I may put it definitely in the schedule of exhibitions.

I hope to be in New York again, at least in the early fall, and talk with you again. As typewriters and telephones are instruments of inhibition for me, I regret I could not arrange a meeting during those days I was there this spring.

Yours sincerely,
Hugh Edwards, Curator of Photography.

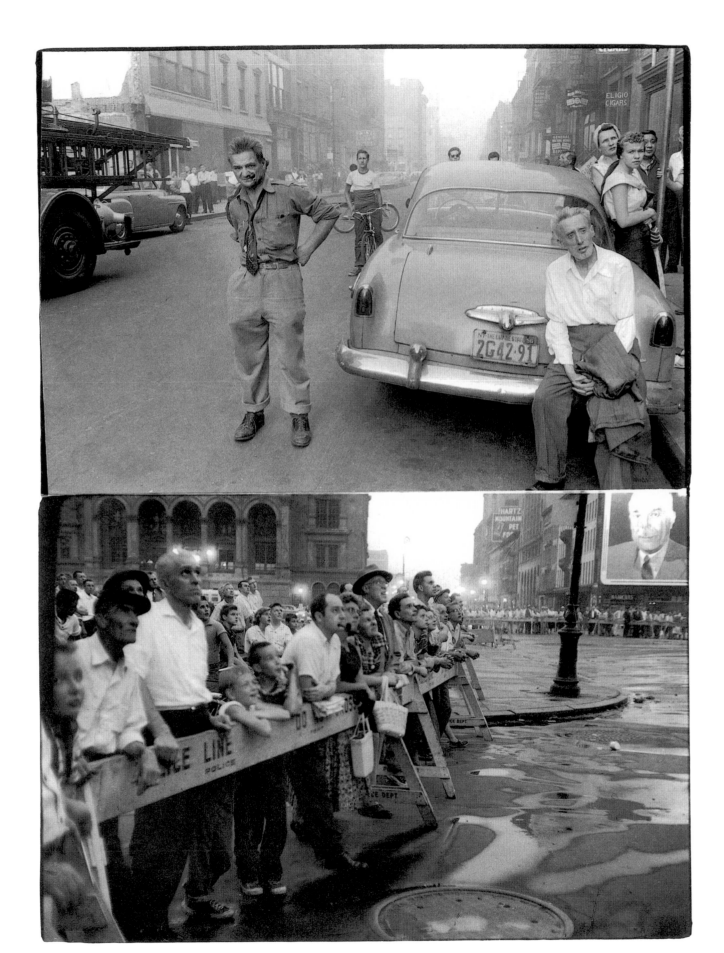

Robert Frank
Wanamaker Fire, East 10th St. and Astor Place, New York City, 1956

AN OFF-BEAT VIEW OF THE U.S.A.

THE AMERICANS POPULAR PHOTOGRAPHY'S editors comment on a controversial new book.

Seldom has a book of photographs aroused as much controversy in the POPULAR PHOTOGRAPHY office as Robert Frank's The Americans (Grove Press, Inc., New York. cloth bound, $7.50). The reactions of the editors ranged from admiration to contempt. Some of these opinions are reported here in the form of individual reviews.

Robert Frank, a mild-mannered Swiss photographer, may have stirred up an Alpine-size avalanche with the publication of this collection of his pictures taken while he toured the United States under a Guggenheim fellowship. Photographically, the pictures are faithful to the school of candid grab-shotism, and show Frank as having a sharp eye and a steady shutter finger. But editorially, the shots he grabbed disclose a warped objectivity that gives this book its major limitation. Although he calls it *The Americans*, Frank's book actually explores a very limited aspect of life in the United States, and it is the least attractive aspect, at that. It's doubtful that he really thinks all Americans are simple beer-drinking, jukebox-playing, pompous, selfish, intolerant, money-worshipping, flag-waving, sacrilegious, insensitive folks. Therefore, it is only logical to conclude that his book is an attack on the United States. As such, it must be considered an overwhelming success, with the vitriolic tone of his photographs increased by the careful selection of his seemingly objective tongue-in-cheek captions. However, there might be people who will be convinced of the straightforwardness of this photo essay, among them being Jack Kerouac, who calls it a sad poem. But Kerouac

even found poetry in Frank's photograph of a row of urinals, which he says is "the loneliest picture ever made."—*Les Barry*

Ugliness can be shocking, it can have impact—like a man spitting in your face: but it can also be given beauty by a sensitive photographer. Frank is sensitive, but apparently he is without love. There is no pity in his images. They are images of hate and hopelessness, of desolation and preoccupation with death. They are images of an America seen by a joyless man who hates the country of his adoption. Is he a poet as Kerouac, his friend, says he is? Maybe. But he is also a liar, perversely basking in the kind of world and the kind of misery he is perpetually seeking and persistently creating. It is a world shrouded in an immense gray tragic boredom. This is Robert Frank's America. God help him. For him there is, there can be, no other. The book seems to me a mean use to put a camera to.
—*Bruce Downes*

Everyone has the right to discover America including Robert Frank, photographer.
The results of his expeditions into the intestines of America (the United States to be exact) are now available in a volume called *The Americans*. Overall, Frank has created many beautiful pictures. Over-all, he has created, also, a wart-covered picture of America. If this is America (the United States) then we should burn it down completely and start all over again. According to Mr. Frank's observa-

tions 200 years of goofing have taken place.
It is obvious that Mr. Frank had 1934 eyes and blinders on when shooting.
The publishers have left a word out of the title. It should read: *Some Americans*. That is exactly what Frank has done, photographed some Americans. But has he photographed what these people really are like? His pictures are unconvincing.
Frank is a great photographer of single pictures but a poor essayist and no convincing story-teller at all. The knowing of America takes a heap of knowing and the shooting of it, a great deal of effort. Frank possibly has done 5 percent of the job, if that.
—*John Durniak*

I wish Robert Frank and/or Grove Press had chosen some less-inflammatory title for this book than *The Americans*, because that choice is going to make many people so damn mad they'll never see the pictures, which for all their faults—I'll enumerate them in a moment—are worth seeing. This book is not about Americans but about a wild, sad, disturbed, adolescent, and largely mythical world, the World of the Beat Generation. As such I found many of the images lovely and evocative: the hunched man striding to God knows what cosmic destiny beneath a neon arrow in Los Angeles: the elongated cowboy so unexpectedly rolling a cigarette on a New York street: the gloom and glare of a New Mexico bar. Frank has managed to express, through the recalcitrant medium of photography, an intense personal vision, and that's

Popular Photography, vol. 46, no. 5 (May 1960), pp. 104-06

nothing to carp at. But as to the nature of that vision I found its purity too often marred by spite, bitterness, and narrow prejudices just as so many of the prints are flawed by meaningless blur, grain, muddy exposure, drunken horizons, and general sloppiness. As a photographer, Frank shows contempt for any standards of quality or discipline in technique: as a poet he is too ready to lapse into the jargon of propaganda. His talent deserves better on both counts. As for Jack Kerouac's introduction, I'm just as glad he didn't, as he promised he could write 30,000 words about the pictures.
—*Arthur Goldsmith*

In *The Americans*, one of our finest photographers has produced a slashing and biting attack on some U. S. institutions, while completely ignoring others. However much one may quarrel with this one-sidedness (which is most assuredly intentional, and not the result of any ignorance of the "better" aspects of our culture), it is impossible to deny the sharp perception and the sheer power of most of the images in the book. It is useless to argue that Robert Frank should have devoted a part of his book to the vast and smiling American middle class, another to the champagne-and-Jaguar stratum, and so on. The fact is simply that he feels strongly about some of the things he sees in his adopted country, and wants to call them to our attention. He does it superbly. As for the title's seeming to imply *all* Americans, it is quite clearly intended as tongue-in-cheek, but the intention was perhaps too subtle.
—*H. M. Kinzer*

Anybody doesn't like pitchers don't like poetry, see?" says Jack Kerouac in his introduction to Robert Frank's new book of photographs. While I think that there is a sort of poetry in Frank's pictures, I also think that Kerouac has almost completely missed the point of the book. While he is "digging" the subjects of Frank's pictures, it is obvious that the photographer meant them in quite another way. Frank's view of America has neither the love nor enthusiasm of his hipster friend. On his Guggenheim-sponsored jaunts across the country, Frank has concentrated almost exclusively on the tawdry, the lonely, and the sad images which are part, but not all, of American life. He has created a powerful and often moving photographic world made up of lonely landscapes, populated by lost and disillusioned people. The only slight vestiges of nobility left in this wasteland of vehicles, jukeboxes, and American flags are possessed by Negroes and small children.

The shortcomings of Robert Frank are those of any artist who is so committed that he is also a propagandist, but an artist with a strong viewpoint, however limited, is better than one with no viewpoint at all.
—*Charles Reynolds*

Robert Frank's book is described in the introduction by Jack Kerouac as a "sad poem." A sad poem for sick people might be more accurate. As a personal statement of Robert Frank's personality, it is unexcelled. The serious question is this: Do such personal statements merit publication?

Anyone could (and many will) dispute Frank's point of view about the cities he has depicted and their citizens. You could contend that Chicago has more valid facets to its personality than harranguing politicians, New York has more than candy stores and homosexuals, Las Vegas more than gaming tables and quick weddings. Yet all photographers are encouraged to make personal statements with their pictures. In the case of Robert Frank, one wonders if his pictures contribute to our knowledge of anything other than the personality of Robert Frank.

As a photographer, Frank uses the same approach that distinguishes Kerouac and his kind in their writing efforts. You will find the same studious inattention to the skills of the craft, the same desire to shock and provide cheap thrills. It seems as if he merely points the camera in the direction he wishes to shoot and doesn't worry about exposure, composition, and lesser considerations. If you dig out-of-focus pictures, intense and unnecessary grain, converging verticals, a total absence of normal composition, and a relaxed, snapshot quality, then Robert Frank is for you. If you don't, you may find *The Americans* one of the most irritating photo books to make the scene.—*James M. Zanutto*

ON THE ROAD TO FLORIDA

by Jack Kerouac, photographs by Robert Frank

Just took a trip by car to Florida with Photographer Robert Frank, Swiss born, to get my mother and cats and typewriter and big suitcase full of original manuscripts, and we took this trip on a kind of provisional assignment from *Life* magazine who gave us a couple of hundred bucks which paid for the gas and oil and chow both ways. But I was amazed to see how a photographic artist does the bit, of catching those things about the American Road writers write about. It's pretty amazing to see a guy, while steering at the wheel, suddenly raise his little 300-dollar German camera with one hand and snap something that's on the move in front of him, and through an unwashed windshield at that. Later on, when developed, the unwashed streaks dont harm the light, composition or detail of the picture at all, seem to enhance it. We started off in N.Y. at noon of a pretty Spring day and didnt take any pictures till we had negotiated the dull but useful stretch of the New Jersey Turnpike and come on down to Highway 40 in Delaware where we stopped for a snack in a roadside diner. I didnt see anything in particular to photograph, or "write about," but suddenly Robert was taking his first snap. From the counter where we sat, he had turned and taken a picture of a big car-trailer with piled cars, two tiers, pulling in the gravel driveyard, but through the window and right over a scene of leftovers and dishes where a family had just vacated a booth and got in their car and driven off, and the waitress not had time yet to clear the dishes. The combination of that, plus the movement outside, and further parked cars, and reflections everywhere in chrome, glass and steel of cars, cars, road, road, I suddenly realized I was taking a trip with a genuine artist and that he was expressing himself in an art-form that was not unlike my own and yet fraught with a thousand difficulties quite unlike those of my own. Contrary to the general belief about photography, you don't need bright sunlights: the best, moodiest pictures are taken in the dim light of almost-dusk, or of rainy days, like it was now in Delaware, late afternoon with rain impending in the sky and lights coming on on the road. Outside the diner, seeing nothing as usual, I walked on, but Robert suddenly stopped and took a picture of a solitary pole with a cluster of silver bulbs way up on top, and behind it a lorn American Landscape so unspeakably indescribable, to make a Marcel Proust shudder . . . how beautiful to be able to detail a scene like that, on a gray day, and show even the mud, abandoned tin cans and old building blocks laid at the foot of it, and in the distance the road, the old going road with its trucks, cars, poles, roadside houses, trees, signs, crossings . . . A truck pulls into the gravel flat, Robert plants himself in front of it and catches the driver in his windshield wild-eyed and grinning mad like an Indian. He catches that glint in his eye . . . He takes a picture of a fantastic truck door announcing all the licenses from Arkansas to Washington, Florida to Illinois, with its confusion of double mirrors arranged so the driver can see to the rear around the body of the trailer . . . little details writers usually forget about. In darkening day, rain coming on the road, lights already on at 3 PM, mist descending on Highway 40, we see the insect swoop of modern sulphur lamps, the distant haze of forgotten trees, the piled cars being tolled into the Baltimore Harbor Tunnel, all of which Robert snaps casually while driving, one eye to the camera, snap. Thence down into Maryland, lights flashing now in a 4 PM rain, the lonely look of a crossroad stoplight, the zing of telephone wires

Evergreen Review, no. 74 (January 1970), pp. 42-47, 64 (originally written after trip in 1958)

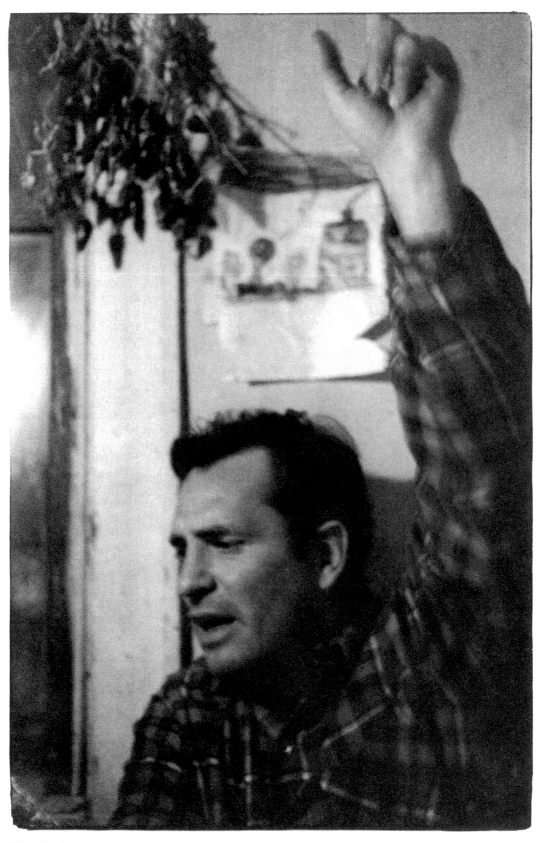

Robert Frank
Jack Kerouac, c. 1962

into the glooming distance where another truck heads obstinately toward some kind of human goal, of zest, or rest. And GULF, the big sign, in the gulf of time . . . a not unusual yet somehow always startling sight in all the pure hotdog roadstand and motel whiteness in a nameless district of U.S.A. where red traffic lights always seem to give a sense of rain and green traffic lights a sense of distance, snow, sand . . .

Then the colored girl laughing as she collects the dollar toll at the Potomac River Bridge at dusk, the toll being registered in lights on the board. Then over the bridge, the flash and mystery of oncoming car lights (something a writer using words can never quite get), the sense of old wooden jetties however unphotographable far below rotting in the mud and bushes, the old Potomac into Virginia, the scene of old Civil War battles, the crossing into the country known as The Wilderness, all a sadness of steel a mile long now as the waters roll on anyway, mindless of America's mad invention, photographs, words. The glister of rain on the bridge paving, the reds of brakelights, the gray reflections from open holes in the sky with the sun long gone behind rain to the westward hills of Maryland. You're in the South now.

A dreary thing to drive through Richmond Virginia in a drenching midnight downpour.

But in the morning, after a little sleep, America wakes up for you again in the bright morning sun, fresh grass and the hitchhiker flat on his back sleeping in the sun, with his carton suitcase and coat before him, as a car goes by on the road—he knows he'll get there anyway, if at all, why not sleep. His America. And beyond his sleep, the old trees and the long A.C.L. freight balling on by on the main line, and patches of sand in the grass. I sit in the car amazed to see the photographic artist prowling like a cat, or an angry bear, in the grass and roads, shooting whatever he wants to see. How I wished I'd have had a camera of my own, a mad mental camera that could register pictorial shots, of the photographic artist himself prowling about for his ultimate shot—an epic in itself.

We drove down into Rocky Mount North Carolina where, at a livestock auction right outside town, hundreds of out-of-work Southerners of the present recession milled about in the Russia-looking mud staring at things

like the merchant's clutter of wares in the back trunk of his fintail new-car . . . there he sits, before his tools, drills, toothpaste, pipe tobacco, rings, screwdrivers, fountain pens, gloomy and jut jawed and sad, in the gray Southern day, as livestock moo and moan within and everywhere the cold sense of drizzle and hopelessness. "I should imagine," said Robert Frank to me that morning over coffee, "though I've never been to Russia, that America is really more like Russia, in feeling and look, than any other country in the world . . . the big distances, the faces, the look of families traveling . . ." We drove on, down near South Carolina got out of the car to catch a crazy picture of a torn-down roadside eatery that still announced "Dinner is ready, this is It, welcome" and you could see through the building to the fields the other side and around it bulldozers wrecking and working.

In a little town in South Carolina, as we floated by in the car, as I steered for him slowly down Main Street, he leaned from the driver's window and caught three young girls coming home from school. In the sun. Their complaint: "O Jeez."

Further down, the little girl in the front seat with pin curls, her mother doubleparked in front of some Five and Ten.

A car parked near a diner near a junkyard further down, and in the back seat, strung to a necessary leash, a frightened little cat . . . the pathos of the road and of Modern America: "What am I doing in all this junk?"

We went off our route a little to visit Myrtle Beach, South Carolina, and got a girl being very pensive leaning on the pinball machine watching her boy's score.

A little down the road to McClellanville South Carolina, scene of beautiful old houses and incredible peace, and the old "Coastal Barber Shop" run by 80 year old Mr. Bryan who proudly declared "I was the first white barber in McClellanville." We asked him where in town we could get a cup of coffee. "Aint no place, but you go down to the sto and get you a jar of powder coffee and bring it back, I got a nice pot on the stove here and got three cups . . ." Mr. Bryan lived on the highway a few miles away, where, "All's I like to do is sit on my porch and watch the cars run." Wanted to make a trade for Robert Frank's 1952 Stationwagon. "Got a nice Thirty Six Ford and another car." "How old is the other car?" "It aint quite as young . . .

but you boys need two cars, dont ya? You goin to get married, aint ya?" Insists on giving us haircuts. With comb in the hair in the old barber tradition, he gives the photographer a weird haircut and chuckles and reminisces. Barber shop hasnt changed since Photographer Frank was by here about five years ago to photograph the shop from the street door, even the bottles on the shelf are all the same and apparently havent been moved.

A little ways down a country road, to the colored houses of McClellanville, a Negro funeral, Strawhat Charlie with razor scar looking out the window of his black shiny car, "Yay" . . . And the graves, simple mounds covered with clam shells, sometimes one symbolic Coca Cola bottle. Things you cant capture in words, the moody poem of death . . .

A little more sleep, and Savannah in the morning. Prowling around we see a brand new garbage truck of the City of Savannah with fantastic propped-up dolls' heads that blink their eyes as the truck lumbers through back alleys and women in their bathrobes come out and supervise . . . the dolls, the American flag, the horseshoe in the windshield, the emblems, mirrors, endless pennons and admirable spears, and the boss driver himself, colored, all decked out in boots and cap and a "garbage" knife in his belt. He says "Wait here till we come around the corner and you catch a pitcher of the truck in the SUN" and Robert Frank obliges . . . prowling around the back alleys of Savannah in the morning with his all-seeing camera . . . the Dos Passos of American photographers.

We investigate bus stations, catch an old boy from the South with floppy Snopes hat waiting at Gate One of the station fingering a roadmap and saying "I dont know where this line go." (*The new Southern Aristocracy!* yell my friends seeing this picture.)

Night, and Florida, the lonely road night of snow white roadsigns at a wilderness crossing showing four endless unreadable nowhere directions, and the oncoming ghost cars. And the roadside gift shoppes of Florida by night, clay pelicans stuck in grass being a simple enough deal but not when photographed at night against the oncoming atom-ball headlights of a northbound car.

A trailer camp . . . a swimming pool . . . Spanish moss waving from old trees . . . and while prowling around to photograph a white pony

tethered by the pool we spot four frogs on a stick floating in the cerulean pool . . . look closely and judge for yourself whether the frogs are meditating. A Melody Home trailer, the canaries in the window cage, and a little way down the road, the inevitable roadside Florida zoo and the old alligator slumbering like a thousand years and too lazy to shake his horny snout and shake off the peanut shells on his nose and eyes . . . mooning in his gravy. Other, grimmer trailer camps, like the one in Yukon Florida, the outboard motorboat on wheels, ready to go, the butane tank, the new lounge chair in the sun, the baby's canvas seat swing, the languorous pretty wife stepping out, cigarette in mouth . . . beyond her all wavy grass and swamps . . .

Now we're in Florida, we see the lady in the flowery print dress in a downtown Orlando Fla. drugstore looking over the flowery postcards on the rack, for now she's finally made it to Florida it's time to send postcards back to Newark.

Sunday, the road to Daytona Beach, the fraternity boys in the Ford with bare feet up on the dashboard, they love that car so much they even lie on top of it at the beach.

Americans, you cant separate them from their cars even at the most beautiful natural beach in the world, there they are taking lovely sunbaths practically under the oil pans of their perpetually new cars . . . The Wild Ones on their motorcycles, with T-shirt, boots, dark glasses, and ivy league slacks, the mad painting job on the motorcycle, and beyond, the confusion of cars by the waves. Another "wild one," not so wild, conversing politely from his motorcycle to a young family sprawled in the sand beside their car . . . in the background others leaning on car fenders. Critics of Mr. Frank's photography have asked "Why do you take so many pictures of cars?"

He answers, shrugging, "It's all I see everywhere . . . look for yourself."

Look for yourself, the soft day Atlantic waves washing in to the pearly flat hard sand, but everywhere you look, cars, fishtail Cadillacs, one young woman and a baby in the breeze to ten cars, or whole families under swung-across blankets from car to car camping in front of dreary motels.

The great ultimate shot of Mrs. Jones from Dubuque Iowa, come fifteen hundred miles just to turn her back to the very ocean and sit behind the open trunk of her husband's car (a car dealer), bored among blankets and spare tires.

A lesson for any writer . . . to follow a photographer and look at what he shoots . . . I mean a great photographer, an artist . . . and how he does it. The result: Whatever it is, it's America. It's the American Road and it awakens the eye every time.

movie journal

by Jonas Mekas

Alfred Leslie's and Robert Frank's "PULL MY DAISY" has finally been premiered at Cinema 16, and those who saw it will now (I hope) understand why I was so enthusiastic about it. We don't see a film every day of such purity, innocence, humor, truth, simplicity. I don't see how I can review any film after "Pull My Daisy" without using it as a signpost. As much of a signpost in cinema as "The Connection" is in modern theatre. Both "The Connection" and "Pull My Daisy" clearly point toward new directions, new ways out of the frozen officialdom and mid-century senility of our arts, toward a new thematic, a new sensitivity.

Nobody Learns

The photography itself, its sharp direct black-white, has a visual beauty and truth that is completely lacking in recent American and European films. The hygienic slickness of our contemporary films, be they from Hollywood, Paris, or Sweden, is a contagious sickness that seems to be inherent and catching through space and time. Nobody seems to be learning anything, either from Lumiere or from the neorealists. Nobody seems to realize that the quality of photography in cinema is as important as its content, its ideas, its actors. It is photography that is the midwife, that carries life from the street to the screen, and it depends on photography whether this life will arrive on the screen alive or dead. Robert Frank has succeeded in transplanting life—and in his very first film. And that is the highest praise I could think of. Also, directorially, "Pull My Daisy" is returning to where the true cinema first began, to where Lumiere left off. When we watch Lumiere's first films—the train coming into the station, the baby being fed, or a street scene—we believe him, we believe he is not faking, not pretending. "Pull My Daisy" reminds us again of that sense of reality and immediacy that is cinema's first property.

One should not misunderstand me. There are many approaches to cinema, and it depends on one's consciousness, sensitivity, and temperament which style one choses, and it also depends on which style is more characteristic to the times. The style of neo-realism was not a sheer accident. It grew out of the post-war realities, out of the subject matter. It is the same with the new spontaneous cinema of "Pull My Daisy." In a sense, Alfred Leslie, Robert Frank, and Jack Kerouac, the film's author-narrator, are only enacting their times, in the manner the prophets do: it is always the case that the time expresses its truths, its styles, its messages, and its desperations through the most sensitive of its members—often against their own consciousness. It is therefore that I consider "Pull My Daisy" in all its inconsequentialness, the most alive and the most truthful of films.

The same evening there was a screening of John Cassavetes' second and commercialized version of "SHADOWS," which in no way should be confused with the original print, screened a year ago at the Paris Theatre, and about which I will have more to say at some later date, when my unrealistic anger for what has been done to that original simmers down. This should be around the time the original "Shadows" is shown again (together with "Pull My Daisy") on January 19 at the 92nd Street YMHA.

The Village Voice, Nov. 18, 1959, vol. 5, no. 4, pp. 8, 12

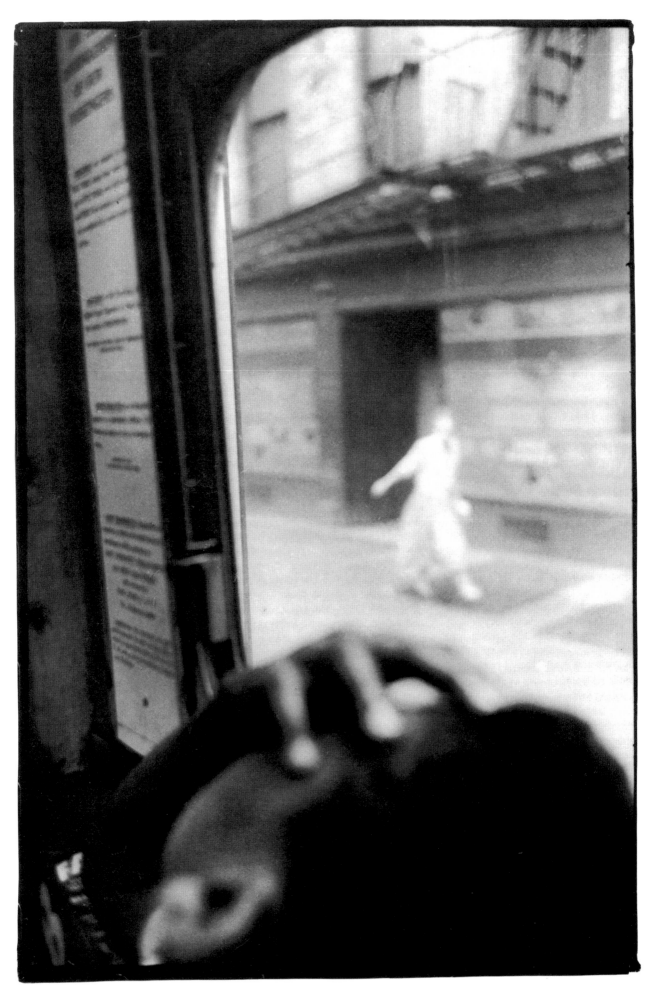

Robert Frank
Untitled from the *Bus* series, 1959
Stanford University Museum of Art
Gift of Raymond B. Gary

movie journal

by Jonas Mekas

I think I was too hard on "THRONE OF BLOOD." What I forgot to say was that even when Kurosawa is bad, he is still an exceptional film-maker. Even a failure by Kurosawa has extraordinary imagination and craftsmanship. We are often unjust to the secondary works of our artists. That also goes for Louis Malle's "ZAZIE" (at the Paris). The fact that the film is a failure means nothing. Didn't God create a failure, too? Just to see how Malle is trying to break out of his usual form, how he is expanding his film vocabulary, is an experience. It is to the credit of the new French directors that they dare to swing to the sides to try the unexpected.

Robert Frank's second film "THE SIN OF JESUS," is being shown on the current program of Cinema 16 (together with Peter Kass "Time of the Heathen"). This was my fifth viewing of the film. I have to admit that when I saw it the first time, I thought I didn't like it. Then I went to see it again, and liked it. Later, with each viewing, the film grew and grew. Now I consider it already a classic.

SOUL OF MAN

In "The Sin of Jesus" (the fact that it is based on a short story by Isaac Babel I consider to be of little importance) Robert Frank continues his documentation of the soul of modern man. Unlike "Pull My Daisy," his first film which relied on free improvisation, the new one is completely controlled.

No, I do not exaggerate much if I say, or rather repeat, that "The Sin of Jesus" will go into film history as one of the most pessimistic films ever made. Its pessimism is its main virtue. "If your aim is high, it should be you that comes through the most," says Robert Frank. The pessimism of the film is his own: it is his own soul that he is revealing, his own unconscious. But we know that when it comes to true creation, it is the most personal art that is also the most universal. Self-expression of an artist is a universal act, it expresses a universal content. The lonely woman's (Julie Bovaso) accusing and desperate cry in the dark, doomed New Jersey fields is an expression of the desperation of our own existence.

Without any digression, in an almost documentary manner, Frank concentrates on the truthfullness of his content; on the landscape in which even spring looks like autumn on the tragic mask of Miss Bovasso; on his blacks and whites. There is not a single note of hope in "The Sin of Jesus." Neither snow nor spring branches nor the wind betrays any hope. The white crown of the flower is a smile of death. The spring wind is a threat. And it is this pessimism, this desolation, or doom, or desperation, that is the true content of the film. It is the inner landscape of twentieth-century man, a place that is cold, cruel, heartless, turpid, lonely, desolate—this obtrudes from Frank's film in crying, terrifying nakedness. There is not a single lie, here, only the facts of our souls. Robert Frank is as much a documentarist as Robert Flaherty in "Nanook." There are movies which are tested by the audience. "The Sin of Jesus" is one of those few movies which test the audience. As for the pessimism of Robert Frank, we should ask, with Nietzsche: "Gibt es einen Pessimismus der staerke?" Isn't there a pessimism that opens the eyes of your self-knowledge?

The Village Voice, Dec. 7, 1961, pp. 13-14

Excerpt from letter, translated from German, to Frank's father, January 27, 1965.

. . .maybe it is the effect of living for so long in the U.S—but I do not expect a Thank you from any-one for the hard work I do. On the contrary—it matters that I'll be the one who's satisfied with the work and enjoyed working, that's the "THANKS" I want. Only by chance a commercial success can arrive. Unfortunately I cannot afford to live without finances. Our living standard is far from grandiose and we are prepared to continue living like that.

I suspect that such a point of view got me started on the project (Film) "Kaddish."* Lot's of obstacles but I believe I can succeed. To take on such a risk is only possible when you have total belief in your-self. It's not a matter of ambition—no AX to grind, not to win approval from a crowd. You and I have gone different ways—nevertheless I'm sure that you and Mother will respect what is in me and continue to believe in me. . .

* This project eventually became the film *Me and My Brother.*

movie journal

by Jonas Mekas

At least for the historical record, if nothing else, I should note here that on February 6 John Chamberlain held the first screening of his first two movies (at the Hunter College auditorium). One was called "Wide Point" and was projected on seven screens placed side by side, with seven projectors. Images: random foolings and sittings around. Taylor Mead appears in most of the footage. But the star of the "projection" was a teenage girl, dressed in blue, playing violin—a very sweet, camera-innocent, curly girl, from a colored postcard, rosy, romantic, and pop. Nothing else struck my eye. Oh, yes: when the "film" was over, the projectors were still running, and the screens were still lit up, in different projector lamp tones. It was very beautiful. But, I guess, to use word "beautiful," when one goes to a pop or camp event, is out of place.

The second movie was called "The Secret Life of Hernando Cortez." Taylor Mead and Ultraviolet were the stars. With the exception of one or two instances, Taylor Mead walks through the movie with no inspiration. The two instances are: a dancing sequence, and a hysterics sequence. But I am no judge of camp, there may be other scenes. I hope there are people who need this type of cinema. I really

hope so. I myself, I am no measure of *all* cinema. During certain kinds of cinema I simply go blank.

Also, for the record: Robert Frank's new film, "Me and My Brother," opened last week (at the New Yorker). I sat through it. I didn't go blank: I hated it. But later I decided that I should see it again some day. I thought it was so unbelievably phony. But I know Robert Frank, and he is the opposite of phony. I can not believe that he would make a phony film. So I must have missed something completely. I seemed to like all of the footage. But I seemed to hate what was done with the footage. I kept cursing the editor. The whole thing seemed so unnecessarily contrived. This is what I propose: Since it seems that I had a bad week, and went blank: why don't you, dear readers, enlighten me about these two films, that is, Robert Frank's and Chamberlain's? Please write me if you found anything good about them. I hate to walk in darkness.

After seeing Jack Smith's "No President," one viewer made a very poignant remark, I thought. "This was a remarkable screening," he said, "a remarkable first public screening of a film made 50 years ago." "What do you mean?" I asked. "Didn't you see in

what shape the film was? All the scratches and things? How could it possibly be that this film was just completed? It looks like it went through half a century of sewer screenings."

I have one nice thing to say in this column. I really liked Mike Jacobson's little film called "Esprit de Corps" which was shown last weekend at the Gotham Art Theatre. There was a positive, life-inspiring energy locked in this little unpretentious film. Probably, it was the only life-generating film playing in New York that evening—or that week. Ah, the reader will jump: You mean, there is good art and bad art? Oh, yes, sirree, take it from an old farmer: there are good horses and bad horses, good chairs and bad chairs, and there are things called weeds.

But please do not misunderstand me, from what I said about camp. I think that campiness is needed today. It will take many more camp movies to bring some fresh life into the acting styles, into the stiffness of Hollywood and independent narrative movies (or Broadway theatre). (Talking about theatre: my trustworthy spies reported to me that last weekend I missed probably the best theatre evening New York has seen in long time, that is, Byrd Hoffman's "The King of Spain.")

The Village Voice, Feb. 13, 1969, vol. 14, no. 18, pp. 57

Peter:

"On January 17, 1965 Orlovsky was released from the hospital in care of his brother Peter. Patient has totally regressed, is an almost mute, catatonic man, who works and functions like an automation who never shows any kind of emotional sign. He is completely self-absorbed and harmless.

"He needs the constant close supervision and direction which is provided by his brother Peter.

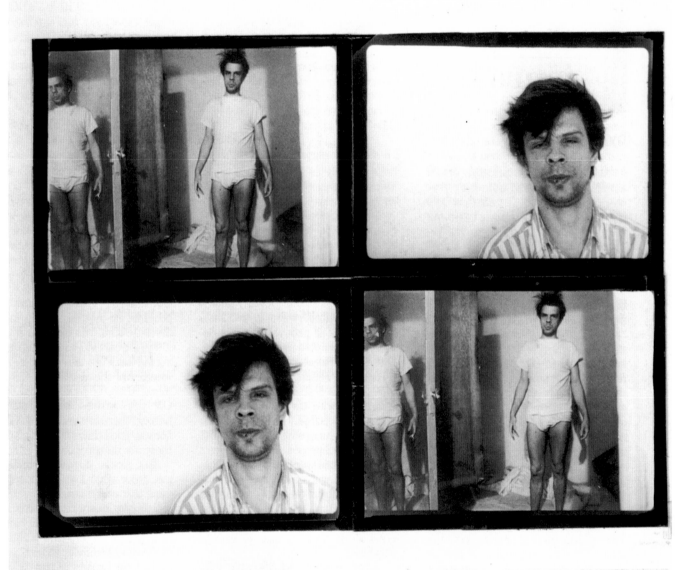

"The patient has been placed on Thorozine, 200 mgs once a day. This different medication was not given to the patient by his brother. Last year he was taken on a tour to the West Coast by his brother, and we lost contact with the patient."

Script pages, *Me and My Brother*, c. 1969

So morning comes and noon comes and I've gotten out of bed...and I see Julius is still sleeping, so I wake him up... and tell him to get up. And, uh, he gets up but he doesn't wash his face...or brush his teeth or go to the bathroom... or start to make breakfast...he just gets up and stares at his mattress and wrinkled sheets...

...and, uh, so I've got to tell him to put his clothes on, so he does that, he doesn't do anything else after that. So I tell him to wash his face. You know, "...come on, Julius, let's get going, let's do the things we have to do..." throughout the day...

And, uh, so he does them one by one, but he has to be told or else he just stands there by his mattress.

Sometimes I figure...well, let's see what he does. Maybe he will get up on his own...maybe he'll wash his face on his own...

But, uh, if I don't say anything, he just sleeps in bed all day...

movie journal

by Jonas Mekas

This is a continuation of last week's column, more rambling on Robert Frank's movie "Me and My Brother" and John Chamberlain's movie "The Secret Life of Hernando Cortez."

1. The tragedies and dramas of the regular movies are ridiculous, outdated, pre-Yippie, pre-hippie, pre-beat, even pre-Freud and pre-Marx. That's what's good about Chamberlain's movie: it doesn't take seriously any of the emotions, ideas, beliefs, or even facts of the Existing Society. 2. "The Secret Life of Hernando Cortez" will be enjoyed by people who have freed themselves (or are attempting to free themselves) from the concerns and passions of the middle-class capitalistic culture. 3. H. G. Weinberg, in his book on Lubitsch, points out how Lubitsch humanized the heroes of the history books. Chamberlain's movie, like a number of other camp movies before it, goes one step further: he makes the heroes of the history books ridiculous. 4. Robert Frank's "Me and My Brother" is about the most beautifully photographed movie you can see around. 5. P. Adams Sitney: "Robert Frank's film reminded me of something I had completely forgotten: that cinematography in a movie can be enjoyed as an independent thing."

6. Why all the tricky editing in Frank's movie? Why this "film within a film within a film" business? I guess my question is not very fair. The filmmaker does what he does because he's following his nose. 7. I was really impressed with Chaikin's imitation of Julius—particularly his body movements. 8. I should never see films in progress, the "rushes." I saw parts of "Me and My Brother" in an unedited form, or at the beginning of editing— and I found the footage so strong, it had such an impact—I thought I was watching a great movie. But when I saw the completed film, the footage was cut to pieces, all kinds of outside ideas imposed or superimposed upon it, it didn't have any of that impact any longer—at least not on me. 9. I found "Me and My Brother" too clever, like trying to tell something, and play five different records at the same time, and maybe stand on your head, and wiggle your toes, and do a few other tricky things at the same time— instead of doing it plainly and to the point. 10. Recently, I saw a few old Kino-Pravda newsreels (1919-22) by Dziga Vertov, and his "A Man With the Camera"—and it amazed me again, its directness, its simplicity. 11. A movie doesn't have to be very good to be liked. 12. I think I like Robert Frank's movie more in retrospect, than when I was watching it. The idea of interchanging, superimposing characters is not a new one, but always challenging. Robert Frank did a few interesting things in that area.

13. A movie in which nothing much happens, like Chamberlain's movie, is a pleasant change from all the movies in which film-makers are desperately trying to keep things happening, as if that would be of such great importance. 14. I disliked Frank's movie because he kept trying (he or the editor) to make it more meaningful, more important, more significant, deeper than the reality itself which was caught by Frank in the footage. By editing, the editor deflated the content of the shots and created a different content, different levels of content which were too vague, and even, I felt, corny, at times. 15. When Julius says, toward the end of Frank's film, that the camera was "disapproving"—did he mean the camera as an instrument, or the cameraman behind it? 16. Where does Robert Frank's morbidness come from? From this world, you fool. . . 17. With his camera Frank captures so much immediate truth about whatever he is shooting that later, whatever plot is imposed upon the footage by the editor, it looks silly, pretentious, incongruous, unnecessary. 18. I am wondering what George Kuchar would have done with exactly the same people, same situations, as Robert Frank? Probably we would have come up with a life-celebrating movie. Now it's so bleak, so hopeless, so down! 19. No film-maker really shows us life as it is: all filmmakers show their own inner states. 20. I thought Chamberlain's four-part poster for the film (I think you can buy it at Castelli) was superior, artistically, to the film itself. 21. I have to admit that I have seen "The Secret Life of Hernando Cortez" already twice, and I wouldn't mind seeing it again. I think it's beginning to grow on me. 22. Taylor Mead is the greatest actor in America today.

The Village Voice, Feb. 20, 1969, vol. 14, no. 19, p. 99

Publishes five monthly columns in *Creative Camera* (London) advertised as "containing comments, criticisms, facts and opinions about any aspect of photography and film-making."

Robert Frank: Letter from New York

Ten or twelve years ago I lived across a courtyard from Bill de Kooning. I could see him from my window; I'd see him with his hands behind his back, his head bent, pacing up and down the length of his studio. I could see the easel standing there and I'd wonder if he ever would get to paint and stop walking up and down. Quite often I think of that image now. That was the time when I was a photographer, doing jobs or going out on my own to photograph in the streets. Then it seemed to me I was making a big effort. Now thinking of de Kooning, I understand better what it is, to face a white sheet or canvas; to face something which does not respond to my movements, all will have to come from inside me. No help looking through the viewfinder and choosing the Decisive Moment. That's where it starts, the difference between doing stills and doing a film. I find it very difficult to organise, to control and to discipline my thinking before I step into the doing of it. I feel a filmmaker must express first what he feels—what's happening to *him*.

It took me years to understand that and some courage to really try to do it. And that's where I am with my last film: *Me and My Brother*.

About this film: The world of which I am a part includes Julius Orlovsky.

Julius is a catatonic, a silent man; he is released from a state institution in the care of his brother Peter. Sounds and images pass him and no reaction comes from him. In the course of the film he becomes like all the other people in front of my camera—an actor. At times most of us are silently acting because it would be too painful not to act and too cruel to talk of the truth which exists . . . I don't want to talk more about my film now, I hope it will soon be shown in London.

In Paris I saw a film by Jaques Rivette: *L'Amour Fou*. I think the film is a masterpiece. Sitting in the cinema, watching the film I felt simply that it was all true: the Terror and the Beauty and the need for Love. It was as true for me as it is for Rivette and a young girl sitting next to me—and me knowing nothing about her—I'm looking at her face when the lights go on and I know that she is moved by what Rivette has told about himself and his world. That's Art! The film was shown in two versions. A four hour version which corresponds to Rivette's idea— a two hour version which represents what the distributor wants. I found that the additional two hours did not add a great deal to the story.

In London I also looked at Anderson's *If*. It's good entertainment and it's well done. It's English and it's not original and it's in the trend of today's slogan: "revolution". And I didn't believe it. He used too many of Goddard's ideas and I realised the hang up of the English on those boarding schools must be for real. The scene where the boy meets girl behind the counter and they both become tigers and make love, that was very good, but after all it was all said with poetry and with feeling in Vigo's *Zero de Conduite*.

I don't really know why I'm going to put down Helen Frankenthaler, a New York painter who is going to have a big show at the Whitney Museum in NY. This is how it happens: I am at the printers where *The Americans* is being reprinted. There, on another press, the catalogue for Frankenthaler's show is run off. The paintings look at me and I look at them: a cold fury comes over me, what white emptiness, what meaningless elegance, what indulgence into TASTE and intellectual snobbery. What makes a show like Frankenthaler's possible is Power and Money; and that, especially the latter, is the mark of success upon which the system insists—Art or business or anything. That's the way it is in America . . . true but sad . . .

Robert Frank: Letter from New York

Dear Bill [Jay],

I'm in a good mood, just got your note about a deadline; this makes me feel like a journalist. I immediately went out after I got your letter, so as not to be a journalist. I went to the garage where they towed my car last night because someone ripped out the battery and cables and all, while I was having an applejack in a bar with friends. It is a wonderful town; I really like it.

I saw Nathan Lyons (Curator of The George Eastman House in Rochester). Terribly boring guy to listen to, but he showed me the latest book he has produced. It's called *Vision and Expression*, published by Horizon Press, in collaboration with The George Eastman House, Rochester, New York. I am moved by many photographs. The best contain and express fantasy and dreams—not corny but clear—like a moment of reality in a dream. The influence of Rauschenberg is evident and in many instances more imaginative than the masters. The selection of about 200 photographs by 200 photographers is very well explained by N. Lyons in the introduction. Lyons' awareness of what goes on in photography today, is shown at high level. I really feel good about feeling good about a photography book. It would disgust me to write about all the bad ones I see. (Have to mention Ken Heyman's book about Leonard Bernstein, absolutely worthless, pretentious shit.) Steichen had his 90th birthday and was fêted at the Plaza Hotel. I did not go; I do not like the adoration of grand old men. Besides, I think that Steichen's influence on photography is a rather mediocre one. Ken Heyman and Steichen have similar tastes in photography—sentimentality and moral—statements I mean.

I've done two interesting trips. With Danny Lyons went to film the first Alloy Conference in New Mexico conducted at an abandoned tile factory near La Luz. The event was initiated and organised by Steve Baer with Berry Hickman. Baer invited people who live in communes, city planners, architects, teachers, students, scientists etc. In a pamphlet sent to me after the event they describe themselves: 'Who are we? Persons in their late twenties or early thirties mostly. Havers of families, many of them. Outlaws, dope fiends, and fanatics naturally. Doers primarily, with a functional grimy grasp of the world. World thinkers, drop outs from specialisation. Hope freaks.'

It was a very good four days with terrific young people who move away from big cities and try to build something better, more true, less frantic, more real; they want to do things themselves, they want to try out other ways. And they seem to find them. Some of them get money from the U.S. Government for land or survival; some of them have money; and some of them have no money and no possessions, but they all believe in what they are doing, their way of living. It seems to me that more of that kind of energy will develop and more young people will want to try to be part of it.

The other trip to Nashville, Tennessee, to film for Danny Seymour. A film about a girl singer named Tracy Nelson who is with Mother Earth Group. It seems Mercury Records is financing part of this film. Danny Seymour is a 25-year-old former photographer who has made a short film in England and another in the States. He is bright and nice and clever and in love with the media. Electronics and tape-stereos and film—anything which runs by a machine into another, Danny loves; especially if it comes out somewhere else and is seen instantly by millions. 'I love that sound, mix it again.' I was very surprised that amongst all the studio musicians recording there was not one black musician. It was good for me to film again, as if I would be a photographer. Just watching what's going on, follow the action, make long takes and hold a steady hand (the Arriflex BL 16 mm is heavy). No problems with actors and script interpretation etc.

And today I also saw the issue of *DU* with Bruce Davidson's photographs of 100th Street, N.Y.C. I find that's the best work Bruce Davidson has produced. He strikes me as being somehow a latter-day Wayne Miller. He wants to do good, he also wants to be a good photographer, he also wants to be good commercially and so he combines all that with his talents—considerable—but not original. He is always influenced by the latest IN photographer. Here his best pictures remind me of Diane Arbus. Bruce Davidson faced by the Blacks is appalled by his own colourlessness. Many of the photos are portraits, they stay in my mind, they are sensual—that, he has gotten into these pictures.

Salut Robert

Creative Camera, no. 61 (July 1969), pp. 234-35

Robert Frank: Letter from New York

Dear Bill

Today Mike Hoffman called to tell me he has the June issue; so I looked up that first article again (I do not make copies of what I write) and I was disappointed, too heavy! I hope the second you have there is better. But now to the third . . . I've just come back from the Philadelphia Museum of Art. To write about that, or some other shows I see, screenings I go to, books that get sent to me etc., that's already academic and right now I want to feel alive. It's all too easy to be established and respected—besides for me there's no money in it. What do I do? Well I keep my eyes open in New York. I have friends that I listen to, girls I'd like to make love with, drunks in the subway which amaze me, blind beggars which are not blind if you watch really carefully, taxi-drivers who drive around stoned, and the familiar sight of a car being towed away by the police who say: 'fuck 'em twice, once for being from New Jersey and once for bringing their car into the city.' There is so much noise, and so much heat in the summer, so much snow in the winter, so many people want to be Mayor . . . (If I had voted it would have been for Mailer of course, he must be ambition-unlimited. I wish him luck—an imaginative politician in New York would be a miracle. Anyhow, he can always use the experience for a film, a book, poetry or tax deduction.) So many people who try not to lose their minds. Encounter groups are very big now; it's better to be miserable in a group on a weekly basis than to have to drag yourself through time and city alone. New York is full of Life. Sick? Yes sir, it's sick all right; why do I stay here? Just to be in IT, to see it coming and going, to let it drive me crazy if it hasn't driven me half-crazy already.

For the weekend, Ralph Gibson, his girl friend Sheila (beautiful and poetic), Danny Lyons (lonely and Jewish), my wife Mary and I went to East Hampton to sleep on the beach, to watch the sun come up and see the Canadian Geese fly north early in the morning, to jump in the cold waves, lie in the sand and I try not to think.

But I do think while writing this letter, only the thoughts come and go. I'd like to catch a good one and pass it on to you. In front of me is the *San Francisco Camera*, a photography magazine with no words except for the photographers' names. I like it; it seems a little bit silly to write about that wordless magazine. I get their point. I've always been trying to get to that with my own photographs. Pictures are probably closer to feelings than to thoughts. The 12 photographers represented in that issue make their point about feeling; it's as if they (the good ones) would say: 'If I had to choose between intellect and intuition, I'd let the latter lead me.' In general the artists I know, and especially the younger ones, have a clear mistrust of words. They seem to look for an experience; they want to be put into a 'state'. After that STATE, come the words. I'm thinking of Revolt and Drugs, the Living Theater, the Bands, the Soul Musicians and also of all the New York Anti-Art Painters and Sculptors who think so hard about what is Not Art—they are DEAD serious about that. For many this Anti-Art is definitely a Dead End Street so some of them turn around and begin to make films. Michael Snow (Canadian) is one of them. I went to the Whitney Museum to see the premier of his new film called ⟶. I have seen his earlier film *Wavelength* and I liked it. This new one is an exercise in movements from right to left and from left to right; after about 40 minutes of that a ten minute climax is provided: a movement of up and down of varied speeds. I recommend you to see this film when stoned; maybe some hippier people than I can get spaced out on a film like that . . . good luck to them.

Conrad Rooks (Chappaqua) came to visit me—immaculate, suntanned, in transit from one vacation to another (he's rich). 'No more Ego-Trip for me,' he says, 'you do it once and that's it. Now I don't care that way about success any longer, it's not that important for me.' Rooks thought that his life would be meaningful if he could only create something—somehow I think Rooks forgot the real life—it passed him by. What indulgence to believe that by creating something you become someone.

Salut Robert

Creative Camera, no. 62 (August 1969), p. 272

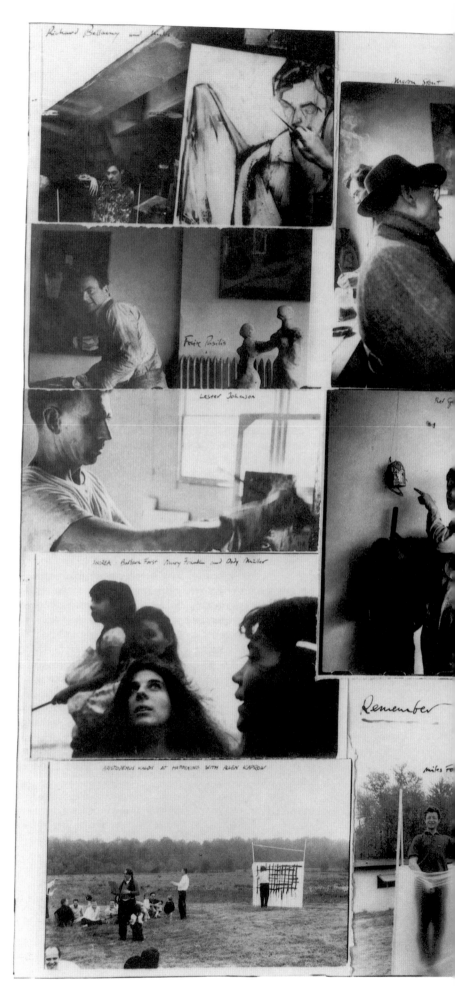

Robert Frank
10th St. Painters, 1950 - 1960/1985

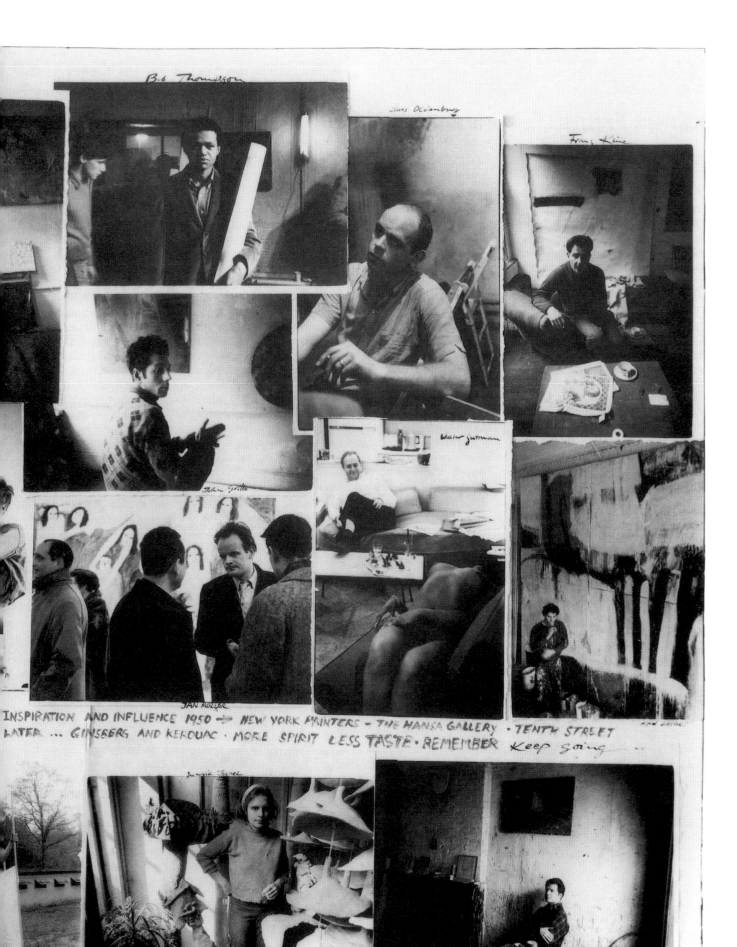

B.b Thompson

Claes Oldenburg

Franz Kline

Walter Gutman

John Grillo

Jan Muller

Alfred Leslie

INSPIRATION AND INFLUENCE 1950 ⇒ NEW YORK PAINTERS · THE HANSA GALLERY · TENTH STREET
LATER ... GINSBERG AND KEROUAC · MORE SPIRIT LESS TASTE · REMEMBER Keep going ...

Marjorie Israel

Jane Brodie

Robert Frank: Letter from New York

Dear Bill

As you know it's hot in New York. Not at all inspiring to go see any photo or painting exhibition. However, I went to the Museum of Modern Art, only to meet there in the cafeteria, having apple pie and coffee, my wife and her lover. It certainly did not help me to sing a song about the Arts. But in my quiet desperation I looked at the Magritte book (a sale at the Museum) and I thought that if I was still doing photography I could not escape Magritte's influence.

Duane Michals is strongly influenced by Magritte; *Man with a Newspaper* painted in 1927 (it's at the Tate Gallery) is the model for Duane's photographic sequences. I think Duane is a good photographer who has never given in to fashionable currents. He has pursued his ideas and gotten them published without concessions. His photographs look to me as if he will not give up. He tells me how silent it is when you photograph the heart.

Now this morning I'm taking a walk on the Upper West Side where I live. A short walk. Suddenly I notice, and look at, what is lying in the gutters, on the sidewalks, in the street, stacked up against the garbage cans—everything that is made and sold and consumed. Here it is, broken—used up—smashed to pieces—thrown away—left to rot. Mattresses, record players, tv sets, bottles, glasses, clothes, toys, furniture, automobiles, photographs, Art. Food and dog shit all over the place. What a fantastic country. Neil Armstrong and Co are going to open shop on the Moon; down here, more is produced than can possibly be consumed. They are yelling about birth control, Teddy Kennedy doesn't want to give up, the Blacks want Retribution. If I was young, I'd want a revolution.

I read somewhere that the question is not *how* to paint, but *what* to paint. I have seen an unfinished film by Walter Gutman. Gutman is a businessman, a Wall Street analyst, in his mid-sixties. A few years ago he started to make films (16 mm.). The entire film is narrated by him. Most of the time, Gutman, a fat old man, is on the screen. In the final sequence Gutman, lying on a rug in his apartment, is undressed by Juicy Lucy, a good-looking girl. She is covering the old man's body with grapes. She throws herself on top of grapes and of Gutman. He can't make love but keeps on talking about his life, his search for happiness, his ideas about country clubs, golfing, water-pollution, American history, why he's not wearing an undershirt, and so on. As the lights went on, and everybody sitting there, embarrassed and silent, I said to Walter: you must be one of the few people who know why he is making films. The man up there on the screen communicated to me who he thought he was, where he came from, how he got to be that fat, his fantasies, the possibility to realise some of his dreams, how he could make money, and that his passions are there for us to see and hear.

It's a good question: why are you doing whatever you are doing. Of course nearly everything here in the good old U.S.A. is made because it has got to sell. So I do not look at many photobooks and almost never go to galleries. My limit for commercial pressures is overflowing—but I just can't go and live in a commune.

I'm working on a film which shows people making music privately and amongst themselves. They are prevented from doing that by a Government Enforcer who demands a licence for everyone that is playing any kind of music. A lot of violence but some really moving music. . .

Salut Robert

Creative Camera, no. 64 (October 1969), p. 340

Robert Frank: Letter from New York

Dear Bill

It made me feel good to see my letters published. The first weren't so hot. Later they got better I think—and now I'm writing the last one. I'm not a writer or a critic and my heart isn't really in it. I do many things and my heart is not in it—these things come and go. The letters are like looking in the mirror, the words stare back at me and I hardly recognise my face. You see a case of vanity.

I've seen the Bill Brandt exhibition at the Museum of Modern Art. I will try to put into words how and what I felt by being surrounded and by looking at Brandt's photography. Well it got to me: right through my eyes into my heart and to my stomach. I heard a sound, and a feeling inside me woke up. Reality became mystery. To see those nudes is wonderful: all together in a room, the photographs become personal. I've felt the whiteness of the skin before, I've looked at a woman's body with desire and it became love making and later habit. Here in that cold museum the same familiar feelings return: I want to see my women like that tonight.

As it was the opening of the show I met Gijon Mili, the *Life* photographer. 'I'm very impressed with all this,' I say to him, and Mili answers, pointing to the room with the nudes 'Yeah, he is great but I don't buy that stuff'. Of course Mili and *Life* and 500 other editors wouldn't buy it either. A lot of photographers wouldn't even think of doing that stuff because the chances that no one would buy it are real and on top of that you have to be an artist to do that kind of stuff. This makes me think of the human spine. Bill Brandt's spine must be really straight. Some of our best photographers had their spines seriously bent under the weight

of *Life* or *Conde Nast* or *Holiday* or some commission without whom they'd be 'poor'. Really? And there is another big difference—that one of the decisive moment. There is all the time in the world in Brandt's photographs. I feel that he has thought, and thought again, stood there with his machine and finally made the machine do exactly what he wanted. This time the viewer makes the decisive moment, maybe he isn't even aware of it, but it's there, you don't have to think about it.

The rocks, the sky, the water and the grass become like we have never seen them before. The intensity in his photography is astonishing. It seems that the more familiar Brandt became with what he saw, the stronger became the image he produced. Brandt is one of the few photographers who maintains a standard in his work as time goes on.

I wrack my brains sitting here, typing, and trying to spell why I know that Brandt is a great artist. He is not afraid to paint the moon into his negative, maybe that's why. There is a picture of a sailor pulling up the sail of his small boat and his shadow falls on to the white sail. Boat and man stand on a rocky beach—it's an old photograph— the rocks in that image already announce Brandt's feeling for what happens when the skin touches the ground.

I've just looked at a statement I wrote about 14 years ago, then I was saying that Walter Evans and Bill Brandt have a great influence on me. I quoted Malraux: 'to transform destiny into awareness.' Now I think and express myself differently but the spell of Brandt's work holds more power than ever for me.

I've just taken a shower and I decided to tear up the continuation of yesterday's letter . . . instead of trying to be an expert or a critic I want to be myself I want to tell you really why I can't go on writing about photography.

In the shower I was thinking how slow it was and how long it took me to give up photography (it will take less time to give up my wife, I speculate). A wife can stop loving you; photography? I loved it, spent my talents and energy on it, I was committed to it; but when respectability and success became part of it, then it was time to look for a new mistress or wife. And this letter will be the final part of it I hope.

In 1958, right after finishing *The Americans* I made my first film. I knew film was first choice. Nothing comes easy, but I love difficulties, and difficulties love me. Since being a film maker I have become more of a person. I am confident that I can synchronise my thoughts to the image, and that the image will talk back— well, it's like being among friends. That eliminated the need to be alone and take pictures. I think of myself, standing in a world that is never standing still, I'm still in there fighting, alive because I believe in what I'm trying to do now.

For me, photography is in the past. I wish I could write about the work of my friend Ralph Gibson or of Danny Lyon's new book or any other photographer whose work I like . . . No, I'm glad I've gone too far: I wish to be free to express my feelings and doubts which live with me. Go and see Goddard's new film *Le Gai Savoir*.

Salut Robert

Creative Camera, no. 66 (December 1969), p. 414

Translation of letter below to Robert Delpire.

September 14, 1970

A Monsieur Delpire

brother . . . maestro . . . czar of good taste . . . Parisian . . . chef . . . see I cannot stop.
Back from Nova Scotia a shock because I am not made of steel.
June and I worked like slaves so the house will stay up. I hope you will see it some day.
The correspondence you sent us was very good for the morale but Mr. Braunberger's* letters made me cry during the night and June's deep and sincere caresses propped me up.
To be back and to see and hear the Bowery is the realization that everything you desire, one day will happen. Only, you must know what you desire. When I was in Mabou it was simple because what [was] important . . . the rain . . . the wind . . . the fire and the cold and every day I could see the two eagles looking for the cat that was looking for little birds and mice. . .
So I am coming back here to finish off a passing thing. I am probably talking about my life.

*French film distributor

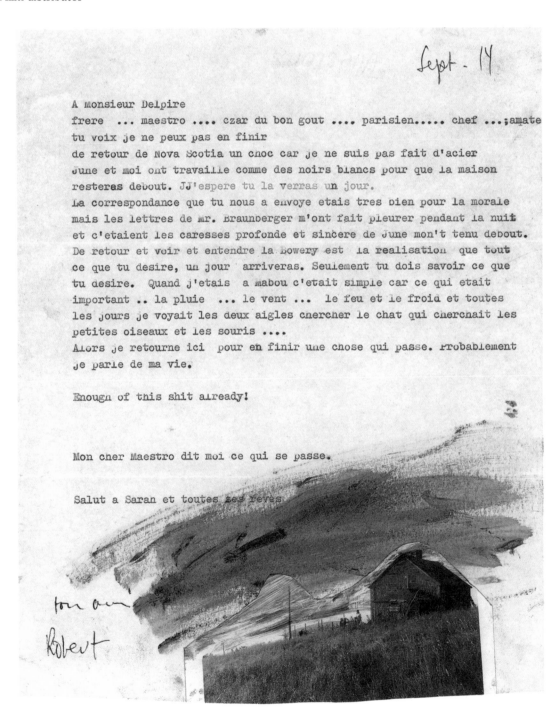

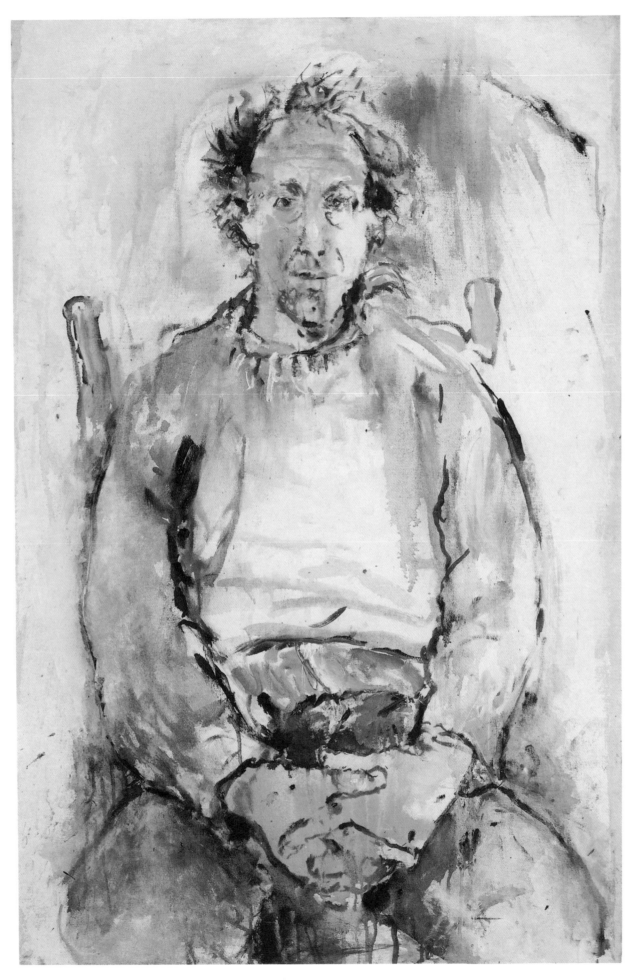

June Leaf (American, b. 1929)
Robert Frank, c. 1972
Oil on canvas
Manuel Bilsky

Robert Frank: Photographs from London and Wales

Robert Frank is one of the great enigmas of modern art. Now widely acclaimed, his work went unremarked for long enough to give him that sort of rare reputation based on the secret knowledge of the few. Somehow that reputation has endured; it claims for him an admiring mention in virtually every piece of contemporary photographic criticism, and his work is constantly imitated and acknowledged by the *avant-garde* of contemporary reportage. Yet he has practically ceased to work as a photographer, and his name is almost entirely associated with work done over a few years in the early 1950s, particularly that which appeared in his great photo-essay of 1958, *The Americans*.

His role can be compared with that once occupied by Marcel Duchamp, the artist whose very withdrawal from the practice of art claimed attention and give rise to puzzlement. Where Duchamp was an urbane practitioner of art as a game, a sophisticated modernist who made and re-made the rules, Frank appears as a deeply serious fundamentalist, a man subject only to the rules of his own conscience.

He figures very prominently in the conventional account of modern photography. He is invariably listed with Diane Arbus and Lee Friedlaender as one of those photographers who exemplifies the new uncompromising modernism. It was principally his sombre vision of the world which disturbed and then ousted the humane and optimistic picture making of the immediate post war years. This mood reached its fullest, even encyclopaedic, expression in Steichen's great Family of Man exhibition in 1955. In the light of this vision humanity was one, despite race and religion; man was on the whole industrious and genial, sharing the same splendours and the same miseries. Both Robert Frank and Diane Arbus were represented in this exhibition, but by 1958 *The Americans* had been published and the mood had changed.

By the late 1960s the world had been made anew by photographers: the old homogeneity may have been retained, but its humanitarian bias had vanished and increasingly man appeared as the victim of his own follies, dead, mad or deformed. The photographers in the public eye during the early 1970s are such specialists in the alienated as Diane Arbus, Les Krims, Charles Gatewood and Bill Owens. American photographers in particular during the 1960s turned from the portrayal of a benign humanity to an insistence on the corrupted face of man which recalls European art of Grosz and Dix at another time of crisis in the early '20s. The Vietnam war may have directed attention away from the optimistic world picture of the early '50s but if the figures in the new landscape were dominated by anyone it was by Robert Frank with his pictures with a sombre and often degraded life lived out precariously on the road's edge.

This is a simplified account of the history of modern photography, but it is true that this evolution is most usually seen with Frank's collection of 1958, *The Americans*, as the point of transition. Its influence was gradual rather than immediate, as though Americans themselves only slowly came to recognise this as the picture of the flawed actuality of the American Dream. In the middle '50s it is still a foreigner's view of the country; this is the period of Nabokov's satiric topiography in *Lolita*, written during the early part of the decade at a time when Frank was also journeying through the United States.

The only exceptional thing about Robert Frank's approach to America was his cultivation of the mundane. Like so many other photographers before him he was a tourist and unavoidably he came to the famous places, to the places of curiosity and notoriety which are the focal points of tourism. He looked at the great cities, at characteristic types and occupations, and

in Britain some years before he had followed just this sort of photographer's progress from the grimed miners of Wales to the bowler hatted City men of London. In America he followed the roads to see famous names and the ethnic minorities of folklore; he saw Blacks in the South, Jews in the big cities, Stars in Hollywood and Westerners at the rodeo. His picture titles are a guidebook tabulation of the places great and small of the United States: underlying the collection is the tourist brochure with its technicolour glimpses of the curving motor road, the Statue of Liberty and Las Vegas by night. To Frank these are some of the co-ordinates against which he works his parodies. In the fictive America the Westerner is a stalwart hero; in Frank's version he is a street idler in cowboy dress, an anonymous pastiche in a neon-lit bar.

Just as Cartier-Bresson had given us *The People of Moscow* in 1955, the classic photo-journalist's view of a community on parade, in leisure and at work, so Frank's people form a complete world in social and private life. Where the rule and the intention had always been to make a picture which summed up a place or a type or an event in its recognisable completeness these pictures do little more than to refer to this aspiration. Frank keeps only the name; it is Detroit or Chicago, but it could be anywhere with apartment blocks and jaded people. It is as though his experience bore no relation to the conventions and fictions proposed as the idea of America. The names may be redolent of glamour, of a heroic past and an optimistic tradition, Santa Fe, Chattanooga, Belle Isle and Butte; he acknowledges this in the roll call of his titles and in his constant allusion to political and religious ideals, to images of leadership and reverence, St. Francis, Washington, Lincoln and the flag itself, but the inescapable actuality is of desolate roadsides, impoverished hotels and the tedium of travel. The ironic inter-

Ian Jeffrey. "Robert Frank: Photographs from London and Wales, 1951." *Creative Camera International Yearbook 1975*. Edited by Colin Osman and Peter Turner. London: Coo Press Ltd., 1974, pp. 11-12.

action of title and mundane image mocks the whole tradition of the significant conclusive picture, and it seems to be from this that the whole snapshot aesthetic of recent photography evolves.

In London Frank had toyed with this play on the fictive image of the country and he looks for City men and the town clothed in Dickensian fogs, but in America the very idea of the country projected by its social symbols seems to have been more transparent and more at odds with the things which he saw on every side and, thus, a far richer hunting ground.

In his work he presents a whole new iconography of the alienated landscape; his is the sensibility, in part, of the Pop artists of the succeeding years. He anticipates the unadorned presentation of the mundane which is a feature of Rauschenberg and Warhol but working as a tourist photo-reporter he is acting in an area of well-defined conventions and within these his pictures can only function as satires and parodies. To have done only this would have secured a reputation but in truth he far transcends the role of critical observer. Like other photographers he sets the real and the ideal in sharp contrast but no matter what the ostensible subject it is caught up and thoroughly shaped by his own fundamental vision of good and evil.

His pictures have a melancholic air remote from the 'good-time' photographic reporting of the era. His subjects are acquainted with grief and near neighbours to death. From the beginning he seems to have been drawn to the skull beneath the flesh, and his early photographs in his anthology *Lines of My Hand* (1972) demonstrate this preoccupation with death and isolation. In London he photographed a hearse in a desolate fog-shrouded street and contrived to place a refuse cart seen through the frame of the open rear window. In America, he returned again and again to funerals and memorials. On "U.S. 91, Idaho", he shows three crosses on the scene of a highway accident with the light flooding in through the dark clouds; it is a picture with no effective precedent outside the work of Rembrandt.

Before his American work there is a macabre element in his pictures; gradually this is assimilated during the early fifties and it survives as a natural part of the sobriety of the images, integral with his insistence on the pervasive opposition of black and white, the lightness and the dark. It may look at times as though he has a moral purpose when he shows, for instance, a black nurse and a gleaming white baby but this polarity in his work passes far beyond matters of justice and equity. He seems to be pointing to the inseparability of blinding light and the most impenetrable shadow. They are constantly in dramatic interplay in his pictures acting out some remote and elemental drama in which men are passive and uncomprehending witnesses.

Of course, the structures of his pictures can be imitated and they have been; in working through systems of contrasts he is following a conventional practice widely developed through the 1930s. The cultivated informality of his picture making has also been suggestive, but without his sombre informing vision these can be mere devices without meaning. His uniqueness is to have made a wholly new elision of the topical and mundane with a personal and awesome metaphysic of darkness and light.

Ian Jeffrey

After you left I went downstairs & bought a pair of pants and then walked around the block thinking about the Interview. It went like this: Both Eva & you (forgot yr name) are chained to the Idea of a purpose. That what one does must have purpose. In that way it is easy to explain etc. to anyone questioning why, how come, how much, etc.

Maybe for me going so far away from NY and its people (vibrations) is to find again a purpose that I will believe in. And then I will work hard to forget & loose that purpose. And then maybe I'll do something really good.

I also want to say that I think a great Deal about Seymour's Book & I find it courageous and moving. It is unusual to say so much about one-self in such a straight way.

Salut Robert

[Shorter version of this letter published in *U.S. Camera/Camera 35 Annual: America: Photographic Statements*. New York: The American Express Publishing Corp., 1972, p. 145.]

Apeiron*
Box 551
Millerton, NY 12546

Dear Peter [Schlessinger],

Often Students ask me why I gave up photography. There is not one answer. Isn't it normal to be curious about other things, if you want to be or become or continue to be an artist; you got to have curiosity

Kerouac said about me : you got eyes, I think that's a pretty good statement

My life is on one track and the work on another track, at times the one overtakes the other and at other times they cross each other; if I can seize these moments—then the work might turn out good . . . that's all I can come up with

I hope you found the carpenters & you haven't used up all the fresh air

*A nonprofit photography workshop where Frank lectured.

Nov.21.74

Dear Kazuhiko Motomura

When I first met you I had just started on a new turn (on the Road) of my life. I seperated from Mary and began to live with June and had bought the place in Canada and now - 5 years later - I'm 50 years old sitting here - at The end of the World waiting for an inspiration to make me do something "creative". Last summer, June & I built a Studio Barn . . . that was a very good experience. It was wonderful to be able to BUILD something so REAL.

Your letters arrive and they are encouraging in their belief in me and I thank you for it. Maybe I will do something soon which can be put on paper or on film.

Besides establishing myself in Canada, this is what happened in those "Waiting Years": I did the Rolling Stones Film : COCKSUCKER BLUES, which is not yet released but I think it is a very strong film about beeing a Rock-Super Star in America in the seventies.

I taught a film course at the Nova Scotia College of Art in Halifax and made a film with 8 Students. The film is called: *This Film is about*. Both these films got made for economic reasons , it means I got paid for making them. So now I wish very much to believe in an idea on my own and to be able to realize and finish such an Idea.

. . . I hope you and your family are well and happy.

NEW YORK, N. Y. 10021, 879-6325

LURECAM LTD.
129 YORKVILLE AVE., TORONTO, ONTARIO M5R 1C4 TEL (416) 922 2012

1 April '76

January 27th, 1977

You won't believe this beca
late stage I"m putting toge
I love and would like to bu
captioned.

Do you do this? What would
this is a business transact

I enclose my choices and de
on the number

My best wishes to both of y
worse, she's on the cover o
hers is my favorite photog

camera Ltd. in California has
reply. We are the Canadian

the camera is processed in
with a mailing label and remittance
to send a camera to our Toronto
only have one central processing
Toronto. Subject to any delay
rvice should be much quicker than
ending to the States. I note
your comment regarding black and white film. Unfortunately, the
rom the plant in the U.S.A. and is
film. We hope this answers all of

Marlborough

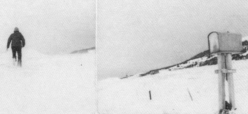

Ontario, London, Canada

MAILBOX MABOU *Robert Frank* WINTER 76-77

February 24, 1976

Mr. Robert Frank
Mabou, Nova Scotia

Dear Robert;

You will be glad to see the en
covers the 50 prints of yours
first step in what I hope wil
relationship.

With the exception of your fri
selling prints to any other co
represent ourselves as "your

The last discussion we had in
I look forward to pursuing the
three months time.

My regards to June and I hope the weather is not too interesting.

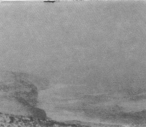

October 25, 1976

April during a retro-
since that time, been
e on Cocksucker Blues,
rly has now told me to
lication. So, I am
ossible to see the film
end of the year. I
d through normal channels.
to meet any conditions

I hope your work is going well and look forward to the

delpire

& Parcher, P.C.
of the Americas
N. Y. 10019

TELEX
224400
CALIFORNIA OFFICE
9200 SUNSET BLVD.
LOS ANGELES, CAL. 90069
(213) 274-6184
CABLE ADDRESSES
SUMMALEX NEW YORK
SUMMACAL LOS ANGELES

Mr. Robert Frank
P.O. Box 18
Mabou
Inverness County
Nova Scotia
CANADA

December 3, 1976

Salut Maestro,

Désolé d'être resté si
c'est le temps, c'est le moment. To
et nécessaires, qui mangent les jou
l'impression d'avoir vécu un matin.

Les ennuis ne sont pas
encore mon agenda mais je suis vrai
à travailler avec une toute petite
Bonaparte avec ses colonnes, son ve
ses clients jamais contents. La mai
seule chose que je regretterai si n
un endroit à Paris, calme et assez
Nous verrons.

Je travaille de plus e
en particulier sur un supplément "
terminée et qui me passionne.

Les livres aussi ça av
parce que le marché américain est ce qu'il est : 5 fois le marché français.
L'Histoire de la Photographie sort ici en Mars,- toi, Cartier-Bresson, Lartigue
et Stieglitz (je ne suis pas responsable du choix de celui-là et puis, à lire
ce qu'il a écrit, je l'ai pris en grippe, jamais vu quelqu'un d'aussi prétentieux.
It's not Camera Work, it's Peacock Work). C'est vrai, les textes d'Aperture sont
plutôt stupides. Mais c'est difficile d'écrire 6 lignes sur un photographe et que
ça ait du sens. Je t'envoie un photostat de ta couverture pour que tu voies ce
que j'ai écrit sur toi.

Il n'est pas impossible que nous allions à New York vers le 26, 27
Décembre pour une semaine. Je te préviendrai bien sûr et peut-être on trouvera
le moyen pour se rencontrer. (Je t'ai téléphoné d'ailleurs plusieurs fois mais
je n'ai jamais eu la communication).

Marlborough pour toi, finalement c'est une bonne solution. Je
regrette de n'avoir rien pu proposer de compétitif. Mes anglais ne faisaient pas
le poids et je ne voulais surtout pas te compliquer la vie. Mais seulement bien
attention pour le contrat et essaie de préserver les livres.

motour, B.V. which owns and
to the United States and
known as the Rolling Stones,
rough July 26, 1972.

ur representatives have caused
Berkley, California.

ted September 25, 1972, between
that our client owns the film
ts exhibition without our

Our client demands that all copies of the film in your
possession, custody or control be surrendered to our offices immediately
upon receipt of this letter.

In addition, you are advised that any future showing of the
film which is caused by you will result in our client's instituting
appropriate legal action.

Very truly yours,

L. Peter Parcher

LPP:ls

Robert Frank
Mailbox + Letters, Winter, 1976
Canadian Museum of Contemporary Photography, Ottawa

Mabou, Sept. 7, 1975

My good old friend,

I received the maquette[1] just as I was leaving for the isolated island where we are shooting a movie.[2] There is nothing on the island except a few shacks and a lighthouse. Very poetic calm – in the middle of the water and hundreds of seagulls – and for a few days we could see a great number of whales pass very close to the island.

Nobody, except us. (The film crew)

As soon as I came back I had a look at the maquette. And – it is difficult for me to have a creative, positive, constructive, etc. . . opinion about these pictures – which have become my "Rubber Stamp." In other words: I am no longer capable to respond like I wished I could. I am glad I did these pictures and I am glad you are publishing them again. The distance betwen me and these photos is the past multiplied by everything that has happened

Silence – Joy – and pain.

The present is stronger

THE LIGHT IN THE LIGHTHOUSE GOES STRONG

than the popularising of established Art.

My good old friend – when do we see each other?

[1] Aperture monograph which was also published in France by Delpire.
[2] *Keep Busy* with Rudy Wurlitzer.

Ottawa Dec. 9 1975

Maestro

The longer it lasts (the trip – the big trip I mean) the more satisfaction I receive from an ordinary day – from a non-artistic existence.

I keep on working – I am making a movie – I try to express a thought (an idea) in the profession I know best.

But this total obsession and this 100% sincerity are no longer available. There are other questions troubling my mind and I can't find any answer to them. And that is why I enjoy the "end of the road" in Mabou. It gives me time to think – lots of space around me and an ever unlimited distance through the sky and the sea.

Your friend

Robert

Thank you.

MÆSTRO

THIS IS

STRANGE

A

Hello

FISH

I like your book
it's like the Testament
of a man
who sees himself
in a mirror
but there is no
mirror

You are going somewhere
you might be lonely
you are also lucky
you can Express
what is inside you
Come and visit us here. There is a good time
SKY
outside WATER

Mabou Dec 3.76

Dear Kazuhiko Motomura —

. . . . Again the winter is coming. The road up to the house is covered with ice.
I have mostly been waiting. Waiting to be able to have the conviction to do some work. This year I finished a 35 Min. film (B/W 16mm) called "Keep Busy" with Rudy Wurlitzer. It was the first time I was able to work on my own (not for a School or lecturing) in Canada. I think in some way the film reflects the influence of "THE CANADIAN LANDSCAPE" on myself. . . .

Mabou Jan. 3, '79

In a week I will return to Vermont where Pablo is Staying and then I will return to New York. Hopefully to continue on my film. Without being able to work I feel discouraged and old. I have photographed with black white Polaroid. These are less pure photographs, they are Moments in my life — in which I try to express something about myself at that particular time and place. I wished that they would be happier. . . .

Dear Philip Brookman

I hope that you have received the 16 x 20 GAF BOX with my photographs. Amongst the pictures is the series of photographs from the Bus NYC. Whenever I look at these pictures I think that I ought to be able to say something about the way it felt when I took them and how I took them (with a Leica) and why I like them.
The Bus carries me thru the City, I look out the window, I look at the people on the street, it amazes me, they are standing up.. looking (like me) at the street, the Sun and the Traffic Lights. It had to do with desperation and endurance—I have always felt that about living in New York. Compassion and probably some understanding for New Yorks Concrete and its people, walking.. waiting.. standing up.. holding hands.. the summer of 1958
The grey around the picture to heighten the feeling of seeing from inside to the outside.
The white border should be eliminated. I like to see them one after another. It's a ride bye and not a flashy backy.
With cold sincerity

Robert Frank

Mabou Dec. 27.77

Envelope/letter to Philip Brookman.

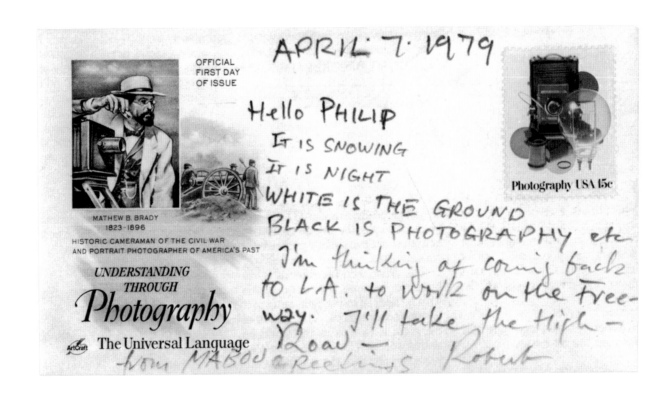

APRIL 7. 1979

Hello PHILIP
IT IS SNOWING
IT IS NIGHT
WHITE IS THE GROUND
BLACK IS PHOTOGRAPHY etc
I'm thinking of coming back
to L.A. to work on the Free-
way. I'll take the High-
Road — from MABOU Greetings Robert

OFFICIAL
FIRST DAY
OF ISSUE

MATHEW B. BRADY
1823-1896
HISTORIC CAMERAMAN OF THE CIVIL WAR
AND PORTRAIT PHOTOGRAPHER OF AMERICA'S PAST

UNDERSTANDING
THROUGH
Photography
ArtCraft The Universal Language

Photography USA 15c

ROBERT FRANK

Tues. Sept 16 - Sun. Sept. 21, 1980	
12:00, 4:00, also Tues. at 6:00	LIFE DANCES ON [1980]. 30 minutes. CONVERSATIONS IN VERMONT [1969]. 26 minutes. ABOUT ME: A MUSICAL FILM ABOUT LIFE IN NEW YORK CITY. [1971]. 35 minutes.
2:00 daily	COCKSUCKER BLUES [1972]. By Robert Frank with Danny Seymour. 85 minutes.
Tues. Sept. 23 - Sun. Sept. 28, 1980	
12:00, 4:00, also Tues. at 6:00	PULL MY DAISY [1959]. By Robert Frank and Alfred Leslie. 29 minutes. KEEP BUSY [1975]. By Robert Frank and Rudy Wurlitzer. 38 minutes.
2:00 daily	ME AND MY BROTHER [1965-68]. 90 minutes.

* * * * * * * * * * * * * *

Robert Frank, Swiss, unobtrusive, nice, with that little camera that he raises and snaps with one hand he sucked a sad poem right out of America onto film, taking rank among the tragic poets of the world.

To Robert Frank I now give this message: You got eyes.

- from Jack Kerouac's "Introduction" to *The Americans*

The frame of the still photograph contains a view, it is the lens' impression from the artist's eye, captured in the developing of the image. The photograph becomes a glossy surface held in the hand, the framed image on the wall, the view printed on the page. We see frozen movement, the stasis of motion, space becomes a contemplative action taken from the camera's point of view. The world is contained, time is held, the contours of action, gesture, become one with the frame and the surface created in the photochemical process. The photograph is a blink of the eye, what your eye barely sees, what is held behind the eyelid,

the wit of the unconscious. The photograph becomes the dream/nightmare in front of our eyes, dimly perceived in our daily lives.

The artist with his camera in his hand reaches into the world, holds what he sees up to the light, returns it to our consciousness. The genius of the artist is to look at the world he shares with us. The illusion of the photograph is one with the realities of our daily world. The photographs become about photography, about the artist, about its images, about us. Like all great art that tells the human condition, it carries the identity of the artist with it. These are not anonymous views, these are not anonymous spaces, places and people. They are the poet's words, richly ambiguous and perfectly poised – read aloud, framed on the wall, held in the hand, printed on the page.

In making films I continue to look around me but I'm no longer the solitary observer, turning away after the click of the shutter. Instead I'm trying to recapture what I saw and what I head and what I feel.

There is no decisive moment, I've got to do everything to make IT happen in front of the lens. . .
 talking. . . erasing. . .
 recording. . . cutting. . .
crying. . . hoping. . . directing
 faking. . . singing. . .
 lying. . .
shouting. . . judging. . . directing
 telling the truth. . .
 distorting. . .
running. . . looking. . .
 pretending. . . explaining
 What a mess until it's done!

- Robert Frank, in
The Lines of My Hand
[Lustrum edition]

Film's genesis is in the photograph. Motion pictures have their origin in the linear sequences of nineteenth century photographs. The cinema removes the distraction of the world, we look to the stage of the screen. The frame is a window onto the world. The action does not hold still, it is motion within a moving frame. In the film–time, gestures, become motion. How to control time, how to uncover, how

to perceive the moving world, at twenty-four frames per second.

Editing pieces motions, and emotions, together. The stage is acting, our daily lives are acting, where does the acting in the camera's frame end and its persona begin?–these are issues central to film, they are central to the artist's work. Recorded moments, intuitions, questions asked, scenes set up, the camera is running. These are films about film, about the artist, about the making of art.

Life dances on, hope and loss, the process of art making, the art of the diary, the art of life. The impressions of the eye become in this work the impressions of the film–the moving eye of the body. It is a transaction between the artist and the people, the world around him. The shifting perspective of the camera, the different pieces of time and place put together in a mise en scene within the rectangle of the screen.

Film is theatrical. We sit in rows, in a darkened silent space, and look into the action–the movement of a time past, that becomes a time present for us now. We carry the memory of these actions with us when we leave the theater–the images of time. These are timeless moments that open up the exploration of the self and society around us through the movement of the camera and the process of production. A seamless test, life dances on, the images carry the fragments of time as memory images.

The poet's words move us.

- John G. Hanhardt
 Curator, Film and Video

The films I have made are the map of my journey thru all this . . . living. It starts out as "scrap book footage." There is no script, there is plenty of intuition. It gets confusing to piece together these moments of rehearsed banalities, embarrassed documentation, fear of telling the truth and somewhere the fearful truth seems to endure.

I want you to see the shadow of life and death flickering on that screen. June asks me: Why do you take these pictures?

Because I am alive. . .

- Robert Frank
 September, 1980

Dear Philip [Brookman],

Thanks for your letter—
Joe Clark lost.
I got an absess on Tooth
We went back to NYC.
Finishing a Film 30 min
and its called "Life dances on"
It's about: Billy (On the Bowrey)
 Pablo & Sandy in Vermont
 Marty in NYC
 and Robert and June in Mabou
 and the film is dedicated to
 Andrea and to Danny—
I think it's very good—
It almost has to be—because of
What it means to me ------
Have done some good Polaroids
Going to Europe—my MA is 80—for
her birthday.
 June paints
 Life dances on
 Good luck R.

Mabou Nov. 2 1981

Dear Kazuhiko Motomura

I have just returned from a trip to Northern Canada. It is a vast country with a small population. I visited a friend who is a Teacher.* For one year he is teaching at a School on an Indian Reservation. There are no roads except a Railroad twice a week. There is snow and frozen lakes and the Indians trap animals (Fur) and Fish. Indians and Whites are seperate—I felt uncomfortable—it was a short visit. I've learned that the bigger the ambitions are, the more difficult it gets to control them. I think that my sympathies will always be with people who are weaker and will almost certainly be loosers. It might be romantic to feel that way—unless I would believe in Justice—and I don't.
 So much for philosophy.
your friend,

*Charlie Murphy from Cape Breton

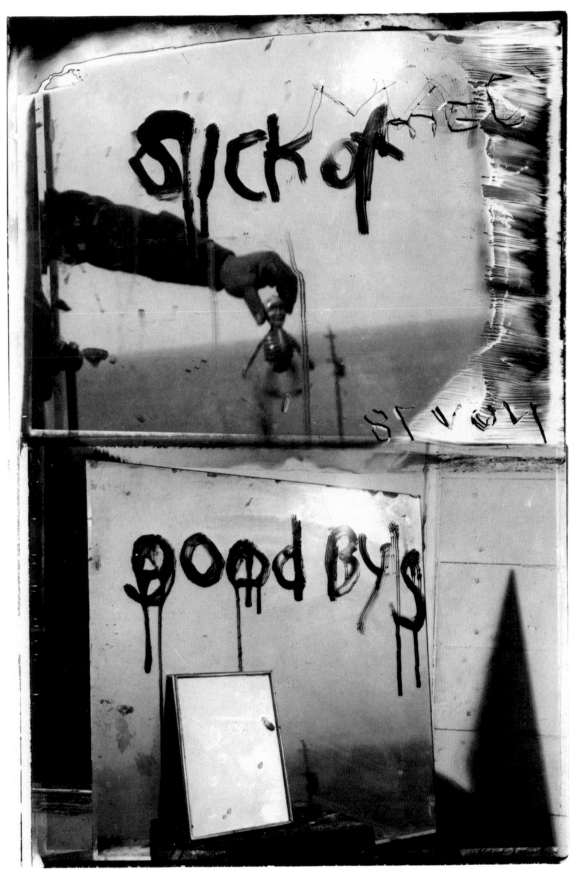

Robert Frank
Sick of Goodbys, November 1978

Mabou Saturday
Oct. 23. 82

Dear Keith [Smith],

Monday I'll go to NYC for two weeks. I'll miss being here. There is peace about this place. But when I'm in at Bleecker St I get exited about HUMAN Suffering and Endurance even Hope. So my life is split. My choice. Don't see many people, no galleries, no social functions, no telephone. Pablo is still in Hospital that is difficult. June is good & works. Nature makes me feel strong & small. Above all that is the Beauty the Sky Water the Rocks. So keep up the good work.
Hello to Nathan.
Good luck
Robert

June 21, 1983
New York City

Dear Maestro,*

You telephoned - Pablo answered. He is better and I hope this will continue. Each weekend he comes to visit me. We leave for Mabou the fifth of July.

For the cover, I am looking at the last proofs—when I went to visit Pablo at the Bronx Psychiatric Center. He had been there 2 months. I think I will be able to defend a choice of cover so seemingly incomprehensible to a Public. First I don't think about any Public.

I am at the End of My work as a photographer (I feel and think that). Naturally I look at my last pictures—it is my life and my connection, my hope, my sadness about Pablo. It is a dedication.

Life dances on—now Life goes on.

*Robert Delpire: Letter translated from French.

70

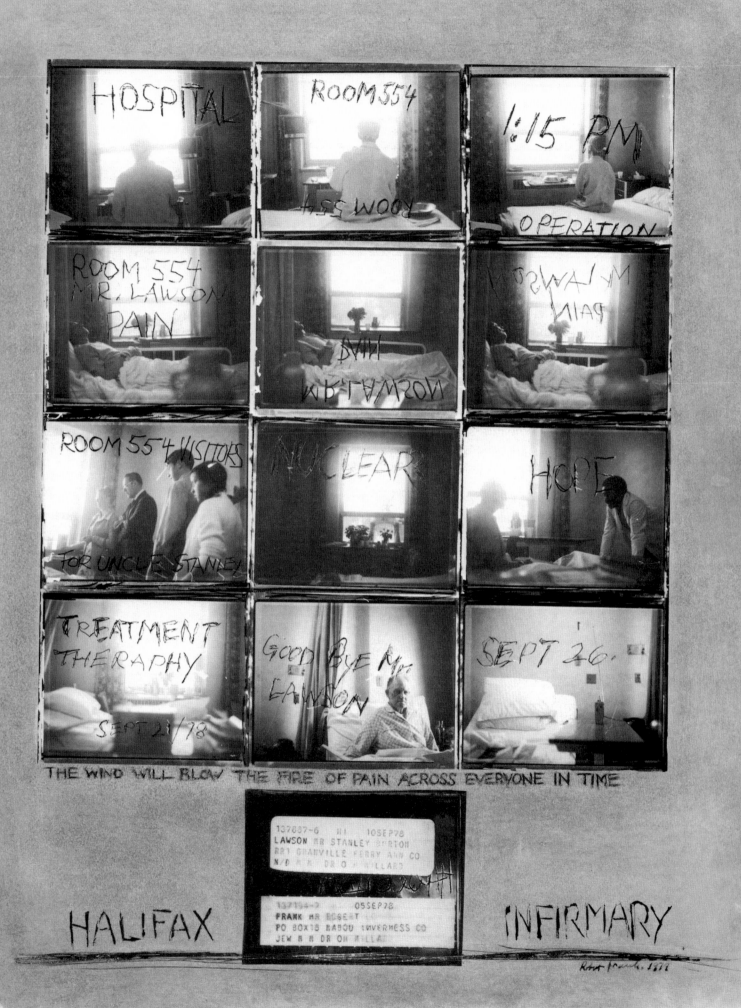

Robert Frank
Halifax Infirmary, 1978
G.H. Dalsheimer Gallery, Baltimore

What I like about the catalogue:

Just like the Photographer, concept after concept.

Two & two is four, etc. How can he make a mistake having been instructed and then go on instructing with total control students himself, writing these clean thoughts on paper.
Dated the build-up to Immortality.
To create Art every time he raises the little thing up to his eye?
I am making souvenirs. I am making memory because that is what I know, that is what I learned to know about, that is hopefully an expression of my true feeling.
To tell my story.
How I know the weakness of these concepts.
The satisfaction, the luxury of faultless presentation of photographs propelled onto plateau of great Art, is that it?
I would like to present my work in the spirit I made it. 1947 Robert Frank was innocent ready to unlearn what the Swiss had taught him. Using freedom in America knowing that it was possible to be your own voice make yr own pictures.
From then on there would be no need to use words, explanations.

. . . . It is Summer in the Heart of Winter

Letter to photographer Ed Grazda.

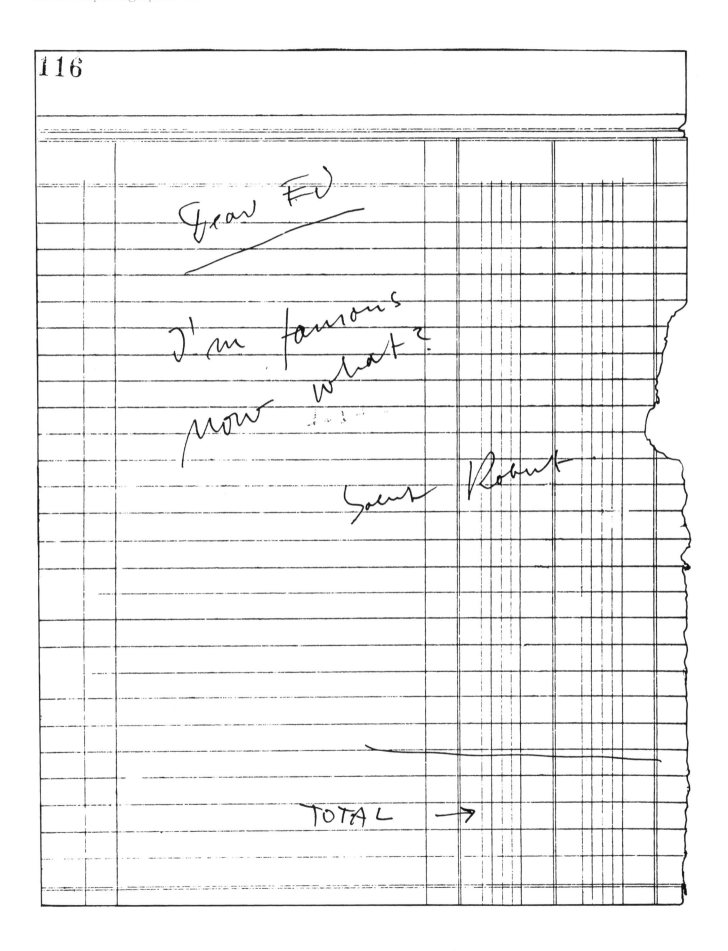

ROBERT FRANK TO 1985—A MAN

Allen Ginsberg

A quality of loneliness in Robert Frank's pictures is visible in Zurich's polished top hat, the little two-legged chair in Paris in 1949, or where Robert later 1950 watching the crowd pass staring at polished shoes on the legs stretched out of fine trouser cuffs lying on the street, someone's heart attack? Nobody at the corner of Rue De Santé's Prison wall monolith—What was Frank doing in outskirts of Paris 1949 in a misty field where a horse stared beside its hay at some kids signaling, running to the path in fields near Porte de Clingnancourt? The lone beggar his cross stick and hat on a paper on a stone balustrade under night's streetlamp? Immediately visible, a man mixed up with his loneliness.

Difficult to maintain continuous awareness, consciousness of frame and space, tonal range, chance casualty half recognized—to look at the world thru an old Leica for years, reduce one's eyes to that attention—focus swiftly, "invisibly," as Kerouac noticed, shoot from the hip—turn the eye aside then click chance in the "windows on another time, on another place." And the camera itself was a mixed machine, with Zeiss lens on Leitz body, "not well adjusted," Frank remarked, so that sprocket holes cut inside the frame.

He had classical training in Zurich under Wolgensinger, an industrial photographer with old world technology & middle European workman's heritage—Apprenticed at 17 to learn to light long steel-ribbed leviathan factory-hangers with magnesium flares—learn the chemistry of film and developer, learn large Universal View Camera work—

Always, a curiosity about cameras—He liked my little cheap Olympus XA. His printmaker Mr. Sid Kaplan, who taught photography at New School, could show me & did the different knacks of the classic Rolleiflex, all its sprigots & sights, upside-down focus eye-level, and mirrored lens & cap for auto portrait focus—delayed click—Robert smiled at his proficiency.

Summer 1984 I had visited with Berenice Abbott in Maine, she said, *All these young photographers with little cameras click click click think they can get something . . . You need to take time and prepare a photograph, and use big frame to get that tiny detail in panoramic scope.*

So I bought a used 1950s Rolleiflex, and said to Robert "I learned something from her." He smiled and said, "Maybe I could show you something too."

Why had he quit still photography? He said he was tired of looking at life thru Leica lens, had used up the variety; and also was disturbed at the exploitation or commercialization of his work, after photography'd become art business investment. And anyway in the early 1970s he'd sold his prints—all made to date—with no further right to make & sell more—in exchange for ten years middle range income: He'd been raising money for movies, for 25 years to the time I speak of, 1984—

I'd known Robert F. as art family friend since I'd worked under his eye at 16 mm. camera *Pull My Daisy* 1958—Walter Gutman, painter financier angel, Zero Mostel big Kafkian comedian, & Robert's patron U.S. spiritual friend protector, Walker Evans, visiting.

Walker Evans, an aristocrat by nature, wondered what R. Frank, his brilliant Protege, was doing with those Bohemians, and had offered to preface Grove Press edition of *The Americans*. But Robert chose Kerouac as writer, an eccentric lonely choice. As Robert had invented a new way of lonely solitary chance conscious seeing, in the little Leica format (formerly not considered true photo art?). Spontaneous glance—accident truth—"First thought, best thought," similar to Tibetan Vajrayana spontaneous primordial mind and Kerouac's improvised *Visions of Cody* Rhapsody.

Berenice Abbott 1985 alive said, "I love that Robert Frank, of all the younger photographers he's so interesting, & honest—I'd like to see him again"—They'd finally met in N.Y. Hotel a year before, she aged 86, but he left her hotel room after brief meeting—a conversation interrupted by arrival of dealers & collectors.

• • • • • • • • •

Returning from India 1963 I was more or less broke, so Robert hired me to his house daily, I wrote a cinematic script for my *Kaddish* one scene a day—Robert paid me $10 an hour or so, or $15 a scene. A subsidy gratefully received, & under his encouraging direction I finished a model script, then at Robert's suggestion, wrote scenes from present time to be interweaved with original narrative, flashes forward. I hadn't thought of that. The poem was an account of my mother's nervous breakdowns and death in a mental hospital. But Robert couldn't raise money to film *Kaddish*, so he started shooting my roommate Peter & his mental hospital brother Julius Orlovsky in New York, in Central Park at night, in Kansas wheat fields and a K.C. night rock club, actual life with improvisations including a scene in our apartment E. 6th Street Lower East Side where I played a waiter's role. Joseph Chaikin played Julius for awhile when in mid-film Julius wandered away, lost—we found him months later in a provincial hospital north of Berkeley. Frank at that time, mid 60s, had a silent Arriflex movie camera.

• • • • • • • • •

His daughter Andrea grown up was killed in a plane crash.

He broke up with sculptor wife Mary Frank, they moved out from their great 8 room European family style solid walled apartment (a famous fortress) on 86th Street Broadway—He kept his film negative files in a closet I saw at the time, he could find things, had some kind of a system, it was difficult always to locate exactly the negative—He still needed to set them in permanent order, that was done decades later.

His son Pablo blackhaired angelic had played David Amram's French horn in 1958 at round table in artist Co-director Al Leslie's loft where Kerouac came to watch *Pull My Daisy* filmed. Gregory Corso poet played Kerouac persona role, Amram played Donovan a simple S.F. hippie cheerful composite invention, Larry Rivers painter supposedly playing the character "Neal Cassady" from Kerouac's earlier autonomous script (still unpublished) "The Beat Generation"—we did first of 3 acts playable, varying improvisation from Kerouac's model—

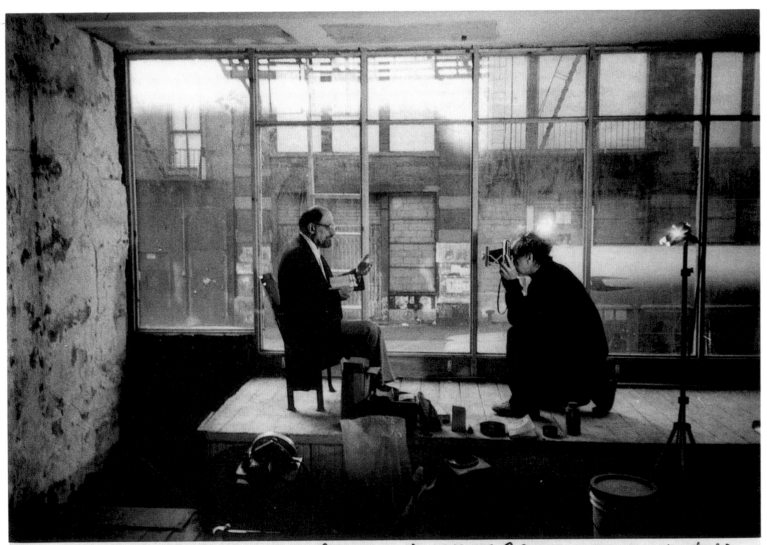

Allen Ginsberg (American, b. 1926)
Robert Frank photographing Allen Ginsberg for Collected Poems 1947-1980,
Frank's studio near Bowery, New York, 1984. Snapped in my camera by Peter Orlovsky.

So Robert Frank's dear son Pablo grown up, working with strange synthetic Chemical irridescent photoprints later had cancer, operation, struck a blow by life, years in help hospitals, later Bronx State across a huge muddy field from an elevated Subway Stop, later recovery. Some kind of reverse *Kaddish* come true, I had always wondered at his interest in my own family story & Peter Orlovsky's.

He thought I seemed to have survived and kept busy, gave me credit for knowing what I was doing as an artist, or middle aged man,—saw I lived somewhat on the edge of slum Lower East Side half prosperity in apartment house penury East 12th Street New York—I was greatly surprised at his glum approval, after nearly 3 decades' friendship, we were both "survivors," at least had no mortal noxious habits, and were still artists, solitary & alone—other friends were rich artists. As Frank was alone till he married June Leaf sculptor and resettled his life, solitary as Mason, Nova Scotia in retirement—1969. He's made many subjective films, some amazingly funny like his collaboration with Rudy Wurlitzer *Energy & How to Get It*, (Burroughs as C.I.A. Army Intelligence Chief deciding not to invest in Robert Golka, who had a scheme for creating electricity for nothing (bypassing nuke bombs), a little Edison's rival Nicola Tessla.)

And *Cocksucker Blues* before that—Invited to preview showing in tiny room at Screen Building Broadway & 48th Street. I sat next to Frank, Mick Jagger sat in back row with lady friend—It opened with Jagger lying in bed, filmed from above, a mirrored ceiling, playing with himself hand inside his long pants—And odd scenes of junkies in hotel airplane cabins sticking hypodevices in arms—A startling accurate documentary disillusioned & brilliant—Afterward, going down on the elevator tall Jagger said "It's a fucking good film, Robert, but if it shows in America we'll never be allowed in the country."—immigration customs border U.S.A. Robert replied that there was no English foreign born person shooting up, only Americans who wouldn't have trouble with a passport or Visa. Thereafter a contest a contest between the two artists—The decision some year or 2 years later, Robert could show *Cocksucker Blues* at college or festival if he were present, as part of show of his life work. So Robert traveled and taught, and continued to make movies.

He came to Naropa Institute 1982 somewhat reluctantly, invited to improvise a film at "Jack Kerouac *On the Road* Celebration 1957-1982—25th Anniversary of Publication."—Many video & movie cameras there interviewed talking heads—Robert took his silent Eclair sound-movie camera to his house porch, residence of the scholars & poets attending invited as friends of Art & Kerouac—himself, Carl Solomon, street poets Ray Bremser & Jack Micheline, Burroughs, Corso again after 25 years, Edie Kerouac Parker, Ken Kesey, Abbie Hoffman, myself, & Peter Orlovsky—sat on the corner-railing coffee morning verandah, & filmed natural conversation. Reality, friendly candid companions exaggerated & conscious of his present cinematic attention. Yet still on their own ground Eternity in Time visible captured in moving image in Chataqua Park Boulder. Later he was glad he'd come & made 28 minute film.

Several years later with lighter weight J.V.C. video that, he said, was easier to carry on his shoulder, the film camera too heavy for his age, hard work for his body at 58—Anyway, video had the improvised quality of still film—the scratch of a chair pulled along the floor as Robert filmed me reading him *White Shroud*, a 1983 epilogue to *Kaddish*, for the first time—shifting the video eye to Peter Orlovsky entering the small room as his name came up in the poetic text & I pronounced it—Easy to visit each other's house & make simple records, I later photographed Robert (using Olympus XA he said was sufficiently good lens & service—) in 2nd Avenue restaurants and at home. Cameras and film, he pointed out, were increasingly made for amateurs, simplified, he recommended I try out Zeiss Lens Yashica 1984 totally automatic, I did, it's curious,—still have to master its tendency to bulge, when you fix focus & change the frame-balance.

Robert Frank writes—brief lonely honest even sentiment-filled prose—letters, even signal slogans on his Polaroid Negatives—

Asked 1982 if he would do cover photo for my *First Blues* music record album, he said, apologetically, with friendly odd glance—"Well it's a continuation of earlier work we did, old long project. So it feels OK." Three years later I asked for back cover portrait *Collected Poems 1947-1980* Harper & Row, he agreed, I came down to his new carpeted studio in an old bowery brick run-down house on Bleecker Street—he used an early 1970's Polaroid model #195 that gives big negatives—3" x 4 1/2"—as well as instant print, so you can check your object image at same time, and vary the frame balance. Same time I snapped his picture as he kneeled to get the right close portrait-angle from slightly below eye-level—and Peter Orlovsky (head cut off in Frank's photo of me) with my Olympus XA snapped ourselves ensemble in a frame which included the near-bowery Yippie side street afternoon window-front passers-by and brick boarded-up factory lofts across the curbs —.

• • • • • • • • • •

Robert Frank as a teacher: as I have prints made, many by Canadian carpenter-photographer-friend Brian Graham whom Robert met in Nova Scotia, Robert looks at what I bring by Bleecker Street, points out one or another he likes—occasionally suggests a cropping, rarely—and says with a rueful smile, "Well you're moving fast" in the world of Aperture, Holly Solomon Gallery, N.Y. Public Library Print Collection. He shuffles thru 30-40 photos fast, says what he likes—sometimes surprising me with his view choices, allows me to appreciate what I wasn't sure of, has his own eye. He said "You seem to know what subject you want to take" as I showed him new big prints of 1953 negatives Kerouac & Burroughs, 1984 Robert Frank close face arm raised (I'd said "Hold still a minute") after midnite in Kiev restaurant we went to on 2nd Ave & 7th Street 1984—or with Pablo by the sink my living room East 12th St. 4 flights upstairs a Sunday family visit.

Kindly teacher, with hesitant humorous trust in himself—and others—still alive together for awhile—for What? Here's a letter 1985—

Mabou July 23.85

Dear Allen,

This letter is being written in God's country aka Cape Breton. No doubt Trumpka[1] already knows this. Soon you ought to come for a visit (a lesson) by the end of July. I'll be in NYC pick up Pablo & return to Mabou for two weeks. Pablo should have a good time fishing, the neighbors and the trees.

Hello to Harry[2] and to Peter. Life dances on sometimes on crutches.

I'm OK here, June works with courageous obsession and occasional doubt. I wished that obsession would still be with me. At sixty events will take their course (curse) Chaos & unpredictability fade away, still fighting, now for dignity? security and naturally immortality.

Occasionally a good letter arrives a call from someone who cares. High winds Lots of rain green green grass crows good fish clouds moving very fast and the Sea always together with sky, there is much Beauty here.

Andrew[3] is working on contracts for Books & I think he is OK, I trust him - now my paranoia fades away Life is fragile. . .

Moral overtones overtake this machine

Bonjour - Bonsoir Saluti

Robert

[1]Chogyum Trungpa Rinpoche, Tibetan meditation teacher, President of Naropa Institute, who has a center in Halifax, N.S.
[2]Harry Smith, avant-garde filmmaker visiting with Allen Ginsberg for half year
[3]Andrew Wylie, literary agent

ROBERT FRANK'S AMERICA

Robert Coles

To some extent we see the world we're looking for—select for ourselves virtually what our minds and hearts crave to notice. Robert Frank came here from Switzerland to look and look—brought with him his own particular sensibility, and soon enough, offered us in *The Americans* an aspect of ourselves. Not all there is to see, obviously, but a selected number of images meant to convey one more lyrical observer's examination of this wonderfully sprawling and changing subcontinent, its people so diverse, its social and cultural history so dramatic and compelling to contemplate, and so thickly textured. Even as the photographs offer, well, in a way, *him* as much as the Americans he chose to connect with, as a photographer, and later, as someone assembling a portfolio, a book, so we readers will have our individual responses to what is offered by Mr. Frank, who, to make matters even more complicated, as I fear is necessary, might well now choose different photographs from among the many he took, and might well choose to take others, were he on some more contemporary self-assignment with respect to a documentary effort at taking the measure of Americans.

All the above is a prelude to a wish, so to speak, my constant personal wish that Robert Frank could have known the William Carlos Williams of the 1930s and 1940s, who gave us in poems and short stories and novels and essays what Robert Frank gave us in photographs—a series of remarkably vivid and searching portraits of ourselves, our manner of speech, our habits and preferences, our ideals, our worries, our aspirations. Perhaps this wish that Robert Frank had known William Carlos Williams is the wish that I had known Frank as I knew Williams, had seen the eye of the photographer as I remember seeing the eye of the writer at work. I well remember trudging with Williams, up and down those New Jersey tenement house stairs, as he made his medical rounds, a plain doc, seeing plain people: the poor, the hardpressed, the newly arrived in America, men and women and children who, often enough, never paid him. Not in cash, at least. They did give him rather a lot, though—that writing doctor knew—gave him themselves, in all their diversity, exuberance, vitality, assertiveness, melancholy, bitterness, apathy; the ambiguities and contradictions and inconsistencies that make us what we are, make us more than a match for the various categorically minded theorists who want to declare their unequivocal findings. "Look, over there," he'd exclaim as we'd walk the streets of Paterson, an industrial city that has harbored so many different immigrants over the generations. I would look, often enough to be interrupted by another, similar injunction: a poet at work, noticing and noticing, preparatory to the crafting of words and phrases, of images and metaphors and symbols, for him the evening's effort that followed all that daily doctoring.

What Williams saw was in certain respects what Frank saw—waiters and waitresses, people riding buses and trains and motorcycles, children in playgrounds carving out their various territories, real and imaginary, barber shops, billiard parlors, gas stations, tables and chairs and juke boxes and statues and cemeteries and cars everywhere—cars, the great ticket to American citizenship. "If I couldn't get me a car when I was grown, I'd ask the Lord to call me back," said a black Alabama sharecropper's young son to me in desperate hope, in fearful expectation, he who barely had enough food to get him by, but who saw the automobile as an incarnation of God's judgment, virtually: saved in America, or destined never to be of any use at all here, hence someone to be "recalled," even as the rest of us know about automobiles that get recalled!

I remember Williams with his own car, forgetting to shift, stalling, squeezing the brakes too hard, cursing the motor, the tire that had disappointed, fallen flat; Williams, roaring with excitement at the other cars passing by, their inhabitants roaring themselves, the horns, the lights flashing, the radios blaring, the voices working their way into the (mostly) modest streets, though lively and invigorating, rather than drab, the doctor felt. "Voices!"/ he once virtually shouted (in *Paterson*) and went on: "Multiple and inarticulate, voices/ clattering loudly to the sun, to/ the clouds. voices/ assaulting the air gaily from all sides." A bit further on (picking up ironically on Alexander Hamilton's characterization) he would refer to "The 'great beast' come to sun himself": his Americans. And how hard he worked as a poet to capture their language, its nuances, its moments of strength, its weaker spells, its victories and defeats. Once I asked him, as others have before, why he didn't stop practicing medicine, work as a poet full time. "Hell, I can't do that," he shot back and explained sternly: "These people feed me! Their tough, plenty tough struggle to stay afloat, to keep breathing, gives me life, keeps my head alive and humming." He, who would write *In The American Grain*, could never stop finding his fellow citizens enlivening, a challenge to the imagination.

So with Frank's *The Americans*: a statement of the life and death of a particular bourgeois Swiss man, poised with a camera, happened to find as he crossed a particular continent at a particular time in his and its life. He is no muckracker, no Dorothea Lange nor Lewis Hine, surely—no matter those who want to appropriate him politically, even including (maybe) himself. There is a great and solemn dignity in his glimpses, his gazing, his inspections and arrangements of a few of the billions of fragments of what the abstract mind tries to summarize with a sound, a word: reality. This is a mid-century watch of sorts, scenes obtained by a lens both misty and keen-eyed. The moving spirit is more the lyricist (albeit grim or downcast or sardonic or appalled or enraged) than the social analyst, the political activist, or the moralist. I may be wrong (Is the issue with respect to photographic impressions really one of right or wrong?) but I sense affection and surprise and perplexity more than outrage and horror in a Robert Frank whose own sensuality, one comes to believe, is fired by that of lots of other people.

True, there is death, too—literally and symbolically, in these presentations (in the form of representations) of our life. Yet, a certain gauzy restraint obtains, the camera's holder excited as well as saddened, even as in the *Bible* the Angel of Death is never denied his dramatic, powerfully stirring possibilities as a continual presence in our lives. I think it would be a mistake for us to appropriate the black, cheerless, heavy-hearted side of Frank's footage in the

78

service of a wholesale, embittered denunciation. Lord knows, America is not perfect; and there is a long tradition of the outsider arriving to criticize this country, with even one as usually shrewd and open-eyed as Dickens, alas, succumbing to bitterness in his nineteenth-century travel notes, letters, essays, written while he worked his way across the nation. I believe it is the enviable power and the great mysteries of our giant nation that sometimes induce such an angry response: the sprawling energy and promise of the mighty geography, the apparently endless procession of "others" who have yearned out of their desperation and hope, both, for these shores, and who, by God, have gotten here, have become part of what is here.

It was a story-teller's dream, Kerouac's words wedded to Frank's pictures, yet another stab into the American dark. The two of them gave all us readers and viewers a bit of light. And we were grateful. To this day my students look at Frank's look at their country, its people, and re-member places and things, and read Williams' *Paterson*, and read Whitman, and get sentimental, a danger; but also become truly, cannily observant in a contemplative way, as they catch a sharper than usual glance at the crowded, hassled urban landscape. "There be plenty of sick ones, and death will come and take me soon," a dying child's mother once told my wife and me, "but I'm not ready to quit this place, yet, and who knows what a smiling God may have in store for us here." Us here, in America.

IN THE MARGINS OF FICTION: FROM PHOTOGRAPHS TO FILMS

by Philip Brookman

> They were like the man with the dungeon stone and the gloom, rising from the underground, the sordid hipsters of America, a new beat generation that I was slowly joining.
>
> Jack Kerouac, *On the Road*

I. *For the Glory of the Wind and the Water*

I first met Robert Frank on East Twenty-Third Street in New York City in the middle of winter. There was ice on the sidewalk and he wasn't wearing any shoes. "He must be used to the cold," I thought.

Elmore Silk, a character in Rudy Wurlitzer's new screenplay *There Ain't No Candy Mountain*, reminds me a lot of Frank. Silk is something of a legend, a guitar maker whose creations are sought after by the greatest rock-and-roll musicians. When Elmore disappears and his guitars become scarce, a slick entrepreneur decides to find Elmore, pay him off to fill the demand, and satisfy the rumbling axe-men of the business. He hires Julius, a disgruntled musician, to track down Elmore. Julius follows his leads across the wasteland of post-industrial New Jersey into the ice and snow of rural, northeastern Canada, where the people are culturally independent and happy to leave well enough alone.

When they finally meet, Julius says to Elmore, "I don't understand, you've got guitars stashed all over the place and you don't want to sell. I'll do it for you."

"It's over," Elmore replies. "That's all. What's done is done. I don't look back. I don't look ahead. That's all I have to say about it. There's always the open road out there, son. It's better than a dead-end street."

Robert Frank and writer Rudy Wurlitzer are collaborating on the film *There Ain't No Candy Mountain*. Wurlitzer describes his script as ". . . a journey from the center of one culture into the margins of another."[1] They are neighbors in Mabou, a few hundred miles north of Halifax on the west coast of Cape Breton Island. *Candy Mountain* is their third film together. "We're doing it because it's very personal to both of us," says Wurlitzer. "The script is very personal to Robert. It's about going from one country to the next and leaving. It's about separation. I think it's not his temperament or his intention to be any kind of celebrity. As an artist, he exists in a kind of anonymous space. You could even say that his work was a strategy towards inhabiting the present. So whenever the past gets too extreme with Robert, one of the solutions is to go somewhere else."[2]

Robert Frank has steered his work into uncharted waters, an intuitive gesture that has characterized his methods since leaving Switzerland in 1947 at the age of twenty-three. In 1958, *The Americans* was first published. That same year Frank turned his attention to making films. It was the challenge of making something new that propelled his decision to hang his camera in the closet. In the words of Elmore Silk, "It's better than a dead-end street."

He had lived and worked in New York for over twenty years. When he left the city in 1969 for the wind and the water and a piece of land by the sea on Cape Breton Island, Frank was retreating from a cultural milieu that he now tenderly describes as "human mayonnaise."[3]

For the next ten years, his films grew increasingly personal and introspective. "I became more occupied with my own life, with my own situation, instead of traveling and looking at the cities and the landscape," Frank recalls. "And I think that brought me to move away from the single image and begin to film, where I had to tell a story. And I guess I most often chose to tell my own story, or part of it, or make up some story that is related to my life."[4]

The one thread that runs through all Frank's films is the expression of his personal vision. The shifting boundary between personal experience and fiction is a kind of sieve between Frank and the illusionary possibilities of the medium. Some films, like *Conversations in Vermont* and *Life Dances On*, are brazenly autobiographical. Others, like *Me and My Brother*, are more allegorical while still focusing on people and events that were a direct part of his everyday life. Even when Frank turns his camera in a more documentary manner on images outside of his own world he imbues small personal events and objects with a heady significance. In *Cocksucker Blues*, his controversial record of the 1972 Rolling Stones tour across a star-struck America, he turns his camera away from the music on stage and points it at his friend Danny Seymour.

"Everything he does is personal, and comes from the inside out," says Wurlitzer. "It's a great risk to be that personal, and that's what makes his work alive because the personal has to point to the opposite, has to point to the universal, and his work at its best really does."[5]

In Frank's films, the viewer has a sense of being a witness to what Frank saw. This impact is partially derived from the unusual importance that he places on the icons of everyday life. He often also uses deadpan humor to lend an added atmospheric charge. Frank has developed a personal style that allows the audience to participate like an archaeologist, digging down through layers and shards of information to create a whole picture.

Recently he has subjected his own life to personal scrutiny. *Home Improvements* is his first work done with portable video, allowing him an uncanny, diaristic freedom. Frank confronted himself about his work as an artist. In one scene, he photographed his reflection by pointing his camera into a mirror set up to show both the landscape behind his house in Nova Scotia and his own image. He said, "I'm always doing the same images. I'm always looking outside, trying to look inside, trying to tell something that's true. But maybe nothing is really true except what's out there. And what's out there is always different." He moves the camera away from his image reflected in the mirror, panning across the hills, wires, and road. He focuses on infinity: the sea, sky, and horizon come into view.

Frank's move to the complex and dynamic world of filmmaking from still photography was part of his search for the right way of life, also symbolized by his moves from Switzerland to New York to Nova Scotia. His films are signposts on this road, and the process of making them has guided his journey during the past twenty-five years. They have been attempts at understanding the past and the meaning of what he has done.

In his 1972 autobiographical book of photographs, *The Lines of My Hand*, Frank wrote, "I am looking back into a world now gone forever. Thinking of a time that will

Philip Brookman (American, b. 1953)
Robert Frank, New York, 1985

never return. A book of photographs is looking at me. Twenty-five years of looking for the right road. Post cards from everywhere. If there are any answers, I have lost them. The best would be no writing at all."[6] Like the best of his photographs, his words can make you think with very little direction. What is not seen or heard is equally important to what is given. What is outside the frame is implied by the borders of what is shown. This concept is apparent in the structure of Frank's films. His combinations of written language and visual images are often unapparent in viewing the finished films, yet they form an invisible framework of ideas holding the pieces together.

Frank has often included his photographs within his films in an illusionary look backward, symbolizing the past. Within the body of his new work, these pictures become symbols for the past, accentuating his creative distance from them.

In a pun on this process Frank once hung a flag labeled "WORDS" on a clothesline outside of his house. The flag had been made for a film in progress. Next to the banner he hung two photographs made in the fifties. Like dirty laundry, *Political Rally, Chicago* and *London to New York* are flying in the breeze against a gray Mabou sky. The horizon is visible behind the snowy landscape, mimicking the clothesline in the way it bisects the picture. In this picture, titled *Words*, an illusionistic symbolic meaning is suggested in the manner these photographs are displayed. Frank is expanding the limitations of the camera's memory by rephotographing his old work. This extends the significance of the image in time, an idea also seen in his films. The clothesline holding symbols of the past reads as the horizon, negating the spatial qualities implied by the actual horizon beyond. His photographs, which signify the past, are superimposed against the landscape that symbolizes a new kind of life and freedom.

In a unique black-and-white Polaroid photograph titled *Mabou*, Frank gives a similar significance to Canada's wilderness landscape. As in *Words*, a small picture frame is hung on the clothesline with the churning sea behind it. The

horizon line bisects the center of the empty frame in the foreground, becoming a picture both within the frame and within the borders of the actual photograph. In a kind of homage to the landscape and the unexplainable visual quality of that space where the sky meets the water, he inscribed on the picture: "For the glory of the wind and the water." According to Frank, "It saved my life."[7]

II. *A Terrific Flash Went Off*

Robert Frank remembers the moment when he first recognized the "magic" of photography, the moment when his interest was stirred. He was eleven years old when he accompanied his father, a Swiss radio importer from Zurich, on a trip to Italy. They went to a carnival. Frank was particularly drawn to a shooting gallery. "You had to aim a rifle at a target, and if you hit the bull's-eye, a terrific flash went off. There was a camera that took your picture when your aim was right. I still remember the smell of the flash powder at the fair. If you won, then you had to wait, and you would get the photograph as a prize. I saved a picture of my father at the booth. I am barely visible peeking over the counter, watching the whole thing."[8]

His father photographed the family constantly with a stereo camera. The glass plates he made could be viewed on a special viewer at their home. There were pictures of the immediate family as well as of aunts, uncles, and relatives from afar who posed stiffly for the camera.

Born in 1924 in Zurich, Robert Frank grew up in a middle-class Jewish family. Frank said, "I think what I learned as I grew up was all negative. I didn't want to be a businessman, to make more money, to buy a better house, a fur coat. Our relatives were all concerned with the same thing. There was a silent struggle, who will come out on top, make the most money."[9] He slept under a portrait of Franklin Delano Roosevelt, which he had cut from a newspaper and hung above his bed. An article about Roosevelt's New Deal policies and their relationship to the concept of democracy was taped to the picture.

Robert Frank and his father at a carnival, Italy, 1936

At the age of eighteen, Frank quit college after two weeks and went to work for H. Segesser, a man who lived upstairs in their building. Segesser had a technical photography studio in Zurich. He taught Frank many of the complex processes of studio photography. Frank remembers learning to retouch negatives and manipulate chemical formulas to vary the contrast and sensitivity of film during its processing. He was put to work lifting the emulsion from cracked photographic plates, restoring otherwise unusable negatives.

It was far from serene for a Jewish family in Switzerland after Hitler's rise to power in 1933. "I saw fear in my parents," remembers Frank. "If Hitler invaded Switzerland, and there was very little to stop him, that would have been the end for them. It was an unforgettable situation. I watched the grown-ups decide what to do, when to change your name. It was on the radio every day. You could hear Hitler cursing the Jews, it's forever in your mind. Because I lived with that fear it made me less afraid and better able to cope with difficult situations later. Being Jewish and living with the threat of Hitler must have been a big part of my understanding of people that were put down or were held back. And I think it never left me. I do have a tremendous sympathy for people who are poor."[10] In 1944, Frank entered the military service, feeling "the Nazi influence was a real threat. They could have crossed the border at any time."[11]

After leaving the military service, Frank was apprenticed to several photographic firms in Switzerland. He also did still photography for Gloriafilm, a motion-picture company in Zurich, which was his first opportunity to observe how films were made. After trying to work on his own as a photographer in Paris, he left Europe behind and sailed for New York in March 1947 on the *S.S. James B. Moore*. Years later, he wrote, "That was the new world. I thought I was lucky."[12]

It is hard to imagine today what it was like to arrive in America as a Jewish immigrant from Europe after World War II. It is also not easy to judge how this might color the perceptions of an artist. According to filmmaker and critic Jonas Mekas, who also immigrated to the United States from Europe, "I have never been able to really analyze that aspect, either in my own work or in Robert's. One thing that I can say is that his choice in coming—leaving his country and coming here—was his own choice. And he wanted to come here to do something. I always wanted to stay where I was. I was thrown out, and when you are thrown out, you always want to go back. I think in his case it affected his work much less than it did mine."[13]

The importance to Frank of being an immigrant was also observed by Rudy Wurlitzer. "Robert comes out of this totally formal situation: middle-class, Jewish, Swiss. Where he saved himself was to embrace the opposite," he said. "So he went to the chaos and the newness of New York in the late 1940s. It was completely a new country, a new land where the space wasn't contaminated with culture and history. What drove him there was this excessive form and culture and language and all the rest of that baggage that he felt crushed by."[14]

The best work Robert Frank accomplished when he arrived in New York was done on the streets. He most admired the photographs of Walker Evans and Bill Brandt, yet he was interested in experimenting with the extremes of the photographic process. He worked primarily with a small, hand-held Leica and wide-angle lens popular with other photographers who were haunting New York's streets. Working outside the studio, the spontaneity of the Leica helped him form a new sensibility.

In order to distance his work from the language of the "beautiful photograph," Frank worked in extreme conditions that were not conducive to such an image. "I went away from my early lyrical images because it wasn't as good as all that," remembers Frank. "It was a myth that the sky was blue and all photographs were beautiful."[15] In 1955 and 1956 he traveled throughout the United States with the intention of observing "the kind of civilization born here and spreading elsewhere...."[16] After completing his odyssey, Frank printed the best of his photographs and put them together into the book *The Americans*. Its overriding theme was the alienation and dissociation he found throughout the country. The book did point to a certain resurrection of culture among the American blacks he visited in the South and the "beat" lifestyles he photographed when he met hitchhikers and motorcyclists on the road.[17]

In the 1950s, the American image was glorified in the media, bolstering the political stance of the nation during the Cold War years. Frank's photographs were conscious of such posturing, as if he were looking in from the outside without being seen. "I felt it was a powerful country but a very hypocritical country," he recalls. "I felt it was brutal, the people mostly. And there was a lot of violence that I had not known in Europe."[18] The pictures present a journey through a world with which many younger Americans could identify. The greatest shock for photographers who first saw these pictures was not the subject matter but the recognition of their world in the pictures.

Throughout *The Americans*, Frank's presence and his experience of being alone within the dispassionate vastness of his chosen land is evident in the photographs. He was at home in the landscape of black rooftops and strip-mined hillsides. Looking out a hotel window through an unfocused curtain, he was the solitary observer holding his breath and understanding something of the view. The manner in which he was able to impart this understanding through an unglorified and somewhat raw vision hit hard when the pictures were published.

By the end of the project, Frank recognized that the style he had developed would be difficult to continue without repeating what was already accomplished in endless variations. If he continued, the style would control his vision. He edged toward the decision to make films.

In the summer of 1958, Frank completed the pictures he has since described as "my last project in photography."[19] This was the *Bus* series, photographed from the windows of buses traveling through the streets of New York. His camera was actually in motion, and his viewpoint was limited to the route of the bus. These pictures are ultimately impersonal. They are innocent and uncomposed, blending art and the observation of life on the street into a duality of experience. The fact that Frank and his camera were in motion while observing people on the street extracts a metaphor for time passing, pushing the limits of still photography to an extreme.

"They were absolutely candid," says art director Lou Silverstein of the *Bus* series. "It was an artist trying to catch the quality of a Brownie picture in your hand.... It was like a skier going down a hill, and if you drop one more degree, they'll never find you again. These pictures were a

deliberate attempt to see how far you can go before you've destroyed the canvas. He had broken every rule in the business."[20]

Frank began to work for Silverstein at *The New York Times* in 1958. Silverstein had conceived an advertising campaign for the trade journals intended to convey the vitality of New York to potential advertisers. Frank was hired because his photographs had the simple and dynamic quality that Silverstein was looking for, and his pictures were published over a period of five years. During the first year, Silverstein would often set up specific situations for Frank to photograph. A cast would be assembled to direct the campaign at a specific market.

Sometimes "he had the three or four guys involved in the picture come into the door, sit at the table, and would be click, click, clicking as they were moving," according to Silverstein. "I realized we were producing a little film, you know, and it was just a question of picking one of about eighteen dozen marvelous pictures to run.... The pictures suggest something having happened, something about to happen. What we were describing came across as a single thing, except it had movement in it. This fit in very naturally with what we were doing, particularly Robert. He was more and more interested in film. It's reasonable to say around then he probably was losing interest in still photography. He said as much and I think it was true."[21]

In several of the later campaigns, Frank produced double images printed one on top of the other. These were combined with copy that described the thoughts of the subjects to convey the message through time. Later, Silverstein decided to use actual strips of 16mm motion-picture film that Frank shot around the city. Different strips of film, each showing maybe one second of time, were placed side by side. These moments or flashes of life created a sense of literal motion in the advertisements. His assignments at the *Times* paid the bills during his transition from still photography to film.

III. *Pull My Daisy, Tip My Cup, All My Doors Are Open*

The camera, it has been said, records the instant when the present reality becomes that of the past. This residue of an experience can allude to other ideas, and therefore photography can lend meaning to occurrence on many different levels. Thoughts generated by looking at a photographic representation of experience become far removed from the experience, and the flat abstract qualities of photographs bear little resemblance to the collective memories that make up historical thought.

Film, on the other hand, holds a different kind of illusion. Movement is created by the sequencing of pictures and literal passage of time. Movement and the illusion of space are actualized. When images are edited, the ordering of ideas and the addition of sound create a new kind of history, in which the connective tissue is linguistic, kinaesthetic, and spatial. The possibilities are more complex.

The Italian neo-realist cinema was born in the ashes of Europe after the second World War and sought an up-to-the-minute impression of what it was like to live cast out by violence. The psychological, political, and sociological repercussions of those days were set forth in Roberto Rossellini's two films about the war years, *Open City* and *Paisan*. Presented in a straightforward manner, Rossellini's images had a dramatic effect on Robert Frank and

other younger filmmakers. More than almost any other film made in the five years following the war, *Open City* proved that filmmakers, independent of major film studios, could make their own statements. Neo-realist directors dramatized the monumentality and symbolic nature of experience through seemingly insignificant events in the daily lives of common people with little power to make decisions. A realistic viewpoint evolved, engaging the audience through their own experiences and reflecting the lives of the filmmakers.

Younger filmmakers, including François Truffaut, Jean-Luc Godard, Alain Resnais, Louis Malle, and Jean Rouch in France, perceived the rapid changes that were occurring both in their lives and in the arts. Their work was championed as the *politique des auteurs*, meaning their films were conceived by those who made them rather than by an indifferent machinery geared for the commercialization of art. Jonas Mekas, paraphrasing Truffaut, described this movement known as the French "New Wave" as "an eruption of new filmmakers whose first and fundamental characteristic, and the only one on which they all agreed, was to have complete control over their own productions.... If nothing else, the *Nouvelle Vague* has done one thing in America: it has prompted America to search for its own new generation of movie-makers."[22]

Robert Frank saw several important American independent productions during the fifties. Helen Levitt, James Agee, and Janice Loeb's *In the Street*, released in 1951, was a documentary that dealt with life on the street. Shot on locations throughout New York without the pretense of actors or set-up scenes, it allowed the action to unfold spontaneously. Sometimes the camera was concealed so the subjects were unaware of being documented. The effect was one of immediacy and unrehearsed improvisation. Agee said that "the films I most eagerly look forward to will not be documentaries but works of fiction, played against and in collaboration with unrehearsed and uninvented reality."[23]

The Little Fugitive, Morris Engel and Ruth Orkin's low-budget feature film, presented a fictional story about a child who escaped the pressures of the city at Coney Island. They relied on portable production equipment, turning their backs on the technicalities of shooting on a set and the strict episodic structure of most narrative films dominating the commercial market. Frank remembers being impressed by the spontaneity and ingenuity of these films, which broke the conventions of both documentary and Hollywood form.

Two other works that were helpful in establishing spontaneity and improvisation in the arts were Jack Kerouac's novel *On the Road* and Allen Ginsberg's prose poem *Howl*. Both were published in the mid 1950s and sent up smoke signals across the country, establishing the beat generation as a new aesthetic voice. Speaking about the emergence of the beat sensibility, Jonas Mekas states, "Democratization was bringing in life that usually was insignificant and unimportant. The details of life. I think from literature, from beat poets, this went into other arts, at least reaching the filmmakers."[24]

Frank's interest in filmmaking was noted as early as 1954 in an article about his photography which stated, "He is at present investigating a field that seems to him to be the next logical step — movies."[25] But he didn't pick up a movie camera until he completed the Guggenheim project, when he traveled to Florida with art director Ben Schultz.

"I began filmmaking right after *The Americans*," says Frank. "This guy said, 'Let's go down to Florida with a camera and you make a little film there, like your photographs.' So I went down there, and I shot about fifteen rolls... I thought 'I've done the same thing as I've done in photographs. I photographed the same scenes and the same people.' I never have developed the stuff. I just thought a lot about it. It was a terrific lesson. It taught me that I didn't want at all to make a film that would look like my photographs—that would have any connection with them...."[26]

Robert Frank and Jack Kerouac became friends in early 1958. When Frank was looking for someone to introduce the first U.S. edition of *The Americans*, Kerouac was suggested. "I think he liked Kerouac because they both had this spontaneity, an allowance of accidents," remembers Allen Ginsberg. "I think Kerouac really liked Robert. And Kerouac's mother did. Robert was one of the very few people that Kerouac's mother would accept. He had a thing of his own that he was doing, but he also had a car."[27]

In April, Kerouac and Frank got some money from *Life* magazine to drive to Florida. Someone there thought their combination of words and pictures would make an interesting feature. "I suddenly realized I was taking a trip with a genuine artist and that he was expressing himself in an art form that was not unlike my own," said Kerouac.[28]

In the summer of 1958, Frank went to Provincetown, Massachusetts. He began another small film project. In this 16mm black-and-white home movie, his wife Mary Frank acted out a brief scenario in which she is pampered by several suitors who are frightened away by a likeness of Neptune emerging from the ocean carrying a trident. The god of the sea is played by Allan Kaprow, and this event is like the spontaneous "happenings" Kaprow was then organizing among artists.

Frank had also been working with his neighbor, painter Alfred Leslie, on the production of another film, titled *Pull My Daisy*. They planned to produce a film based on the third act of Jack Kerouac's unproduced play, *The Beat Generation*. For the script Kerouac made a tape recording of the story, improvising all the different parts. The process was not unlike his writing, which was based heavily on his experiences. "Jack's was a more romantic, national ambition," according to Allen Ginsberg. "Robert was more world weary and unillusioned. But on the other hand, they both had an eye for wild detail, eccentric detail, crazy people, crazy Americana."[29]

They invited some of their friends to hear the story. Composer David Amram recalls, "We were listening to it and Robert Frank said, 'What do you think of that?' It was just Jack, bombed out, making up this crazy story of his adventures.... Robert Frank said, 'We're going to make a movie out of it.' I said, 'No kidding.' He said 'Yeah, and you're going to play Mez McGillicuddy.' Then he handed me a script which had been typed from Jack's spontaneous ramblings."[30]

Kerouac's script was based on an actual occurrence in 1956 at Neal Cassady's house in Los Gatos, California. Cassady had met a young Swiss bishop and invited him to meet Kerouac. The bishop arrived with his mother and aunt, only to be greeted by Allen Ginsberg, Peter Orlovsky, Pat Donovan, Kerouac, Cassady, and Cassady's wife Carolyn. According to Ginsberg, "I was present when a priest from some kind of psychosis sect, somebody from the coastal nut belt who believes in karma, arrived with his mother. What Kerouac wrote was a very simple down-home story of family life."[31] Carolyn Cassady remembers that "Jack sat on the floor by the bishop's feet, turning to look up at him and say, 'I love you.' The two little old ladies sat on the couch. Allen made room for himself between them and put his head on the ladies' knees, insisting 'Let's talk about sex.'"[32]

The script transformed Cassady into a young railway worker, Milo, who is visited by some of his poet friends. Since Milo is an ex-junkie, his wife invites a self-ordained bishop and his family over to the house at the same time, hoping to reform her husband. "It was the wife pissed-off because all these bohemian guys were coming to visit her hard working railroad husband, who was also kind of a wild party goer, party giver," according to Ginsberg. "All of them a little spiritual, talking about holiness, but acting a little silly."[33] The interaction between the poets, who are playing music, getting high and carrying on, and the bishop, who is nonchalantly drinking tea with his mother and Milo's wife, forms the core of the story.

The funding for the film was obtained primarily from Walter Gutman, then a securities analyst, who met Frank in Provincetown through Mary Frank. "After Mary asked me if I would raise the money for the film...I had lunch with Jack Dreyfus," says Gutman. "Jack wanted me to come over and join their company....So I said 'I don't know of any good way for you to make money, but I know a way you can lose money.' I told him to invest in *Pull My Daisy*."[34] The two Wall Street investors put up close to $25,000 for the project.

Filming on *Pull My Daisy* began in Alfred Leslie's Third Avenue loft in January 1959. Larry Rivers, the painter, was Milo. Delphine Seyrig, the only professional actress in the cast, played his wife. Allen Ginsberg and Peter Orlovsky played themselves as poets. Gregory Corso played Jack Kerouac. Richard Bellamy was the bishop, and painter Alice Neel played his mother. The script was relatively useless. Most of the action was improvised, shot silent in somber 35mm black and white that echoed the coarseness and graphic simplicity of Frank's photographic style.

"What we had to do was invent, following the script in a very general way, not keeping to actual dialogue and not keeping to the actual scenes," says Ginsberg. "That's where Robert was good. He didn't make us memorize the script, and we didn't have to act. All we had to do was be ourselves and improvise in that situation...the same as we might have improvised in real life in Neal Cassady's living room or kitchen in Los Gatos.... And the film had the quality which Robert allowed, of planning for eternity and at the same time being right there in time."[35]

To follow the action, Frank utilized the acrobatic style with which he covered events on the street. According to Amram, "It was a madhouse. If things were getting dull, Allen and Gregory would start cutting up, take off all their clothes and threaten to jump out the window or pour water on anybody that looked like they weren't interested.... Most of us were drinking wine and trying to think up outrageous jokes that we could pull on Robert Frank so that he would laugh so hard he wouldn't be able to film us in action.... Poor Delphine would pace up and down on the side, having practiced something that she was going to do and when she would begin acting, Gregory would say 'Come on, come on, stop that shit. This is supposed to be real and poetic, beautiful and soulful. Not that show busi-

ness bull-shit. This is life and truth and God touching us all with his divine finger of reality. Later with all that acting. This is rea-al-ity, captured forever by the sacred box of the angel, Robert Frank.'"[36]

After filming thirty hours of material, the story was edited to about thirty minutes by Leon Prochnik, Frank, and Leslie. Then Kerouac was invited into the sound studio to narrate the film. He improvised all the parts again to reconstruct the story, ad-libbing the narration several times while watching the film. This sound-score was edited together with a music track by Amram and lyrics from an old poem called *Pull My Daisy* Kerouac and Ginsberg had written together in 1948.

> Pull my daisy, tip my cup, all my doors are open
> All my thoughts for coconuts, all my prayers
> awaken
> Start my garden, gait my shades, now my life is
> spoken.[37]

The song provided an elegant, haunting introduction to Kerouac's story, which expressed a way of life by juxtaposing the divergent values of the poets and the bishop. They discussed their sympathy for the sacred nature of life, which lay somewhere between their respective beliefs.

Pull My Daisy brought a beat sensibility to the screen. It proposed that everyday life was important and, given the awareness of its intricacies and beauty, could be art and poetry. When he first saw the film upon its completion, Ginsberg remembers, "I was overjoyed with that one panoramic awareness scene, when after asking if the cockroaches are holy, there's a moment of silence and Kerouac says, 'The angel of silence has descended,' in response to what Robert did. He panned the camera 360 degrees, surveying the entire universe of that room from every side. I thought that was the acme of visionary art, of ordinary mind, allowing the viewer to see everything in a 360-degree circle, all the space compressed. It is akin, I think very much, to Kerouac's panoramic awareness."[38]

The film achieved the goals of the independent film movement in New York and maybe even defined them. In 1960 Robert Frank joined a group of twenty-three independent filmmakers to form the New American Cinema group, organized to encourage greater freedom in the directions that filmmakers could follow. "We believe that cinema is indivisibly a personal expression," reads the first statement issued by the group.[39] *Pull My Daisy* became one of the models for young filmmakers like Ron Rice, who worked on *The Flower Thief* and *Queen of Sheba Meets Atom Man*. While productions such as Godard's *Au Bout de Souffle* from France had achieved a certain amount of notoriety in international distribution, American filmmakers could point to few films independently produced at home. John Cassavetes' *Shadows*, released just before filming began on *Pull My Daisy*, and *Daisy* itself provided some meaningful proof that freedom of expression was possible in a medium dominated by commercial interests.

"Everything seems to be perfect there," says Jonas Mekas of *Pull My Daisy*. "It's a very rich experience and I think it sums up the period, the feeling of the period. You can look at it as a little short story, a little narrative or a documentary on the period."[40]

Pull My Daisy, Robert Frank's first film, brought real life within the boundaries of fiction, and mixed the two into an inexorable stew where the flavors of reality spiced the broth of fiction.

IV. *The Storehouse of Snow*

In the twenty-five years since the successful release of *Pull My Daisy*, Robert Frank has continued to make films at a steady pace. He has usually worked alone or with a few friends, eschewing actors and sets in favor of documenting life around him.

He confronts his surroundings with an intensity that is sometimes hard to follow. Frank's style escapes classification. It can't be called documentation, cinema vérité, or narrative, yet it falls within the boundaries of all three. Nor has he accepted the simple mastery of technique as an end in itself. "I've never been successful at making films," he says. "I've never been able to do it right. And there's something terrific about that. There's something good about being a failure. It keeps you going.... You look for it, to do it right."[41]

Many of Frank's films are an accumulation of experience, sandwiched into an idea or theme which he allows to unfold through time. In an effort to make sense and order out of the chaos around him, fragments of observation are combined like scraps of time and space. This process began with *Pull My Daisy*. Before he began to make films, Frank realized that the illusionary nature of the photographic medium usually presented more questions about the truth of images than it answered. When he began to work wholeheartedly as a filmmaker, he found that the absolutes necessary to create a narrative structure—the progression from A to B—eluded him.

The first two films he made after *Pull My Daisy* were *The Sin of Jesus*, 1961, and *O.K. End Here*, 1963. He deemed them both failures, though they received some positive critical attention. They were shot with actors working from prepared scripts, and Frank self-consciously borrowed both tone and style from Ingmar Bergman and Michelangelo Antonioni, two European directors he unabashedly admired.

In 1963, Frank encouraged Allen Ginsberg to create a film script based on *Kaddish*, the poem he had written about the inner and outer worlds of his mother's illness. When necessary funding for this large film project could not be found, Frank began to focus his camera on Ginsberg, Peter Orlovsky, and Peter's brother, Julius. He continued filming them in spurts between 1964 and 1968.

Me and My Brother, Frank's first feature-length film, places this documentary footage of Julius Orlovsky within a fictional framework. Actor-playwright Sam Shepard helped him with a segment of the script. Constantly delineating real and imaginary situations and moving back and forth between black and white and color, the film describes the inner and outer worlds of Julius, a catatonic man who silently observes his brother Peter's life as a poet.

Me and My Brother begins with the following words superimposed across a Bible on the screen: "In this film all events and people are real. Whatever is unreal is purely my imagination." A double life emerged in the film, one that was real and one that Frank invented and directed. Julius disappeared during a poetry tour by Peter Orlovsky and Allen Ginsberg. The actor Joe Chaiken was then hired to play Julius in his absence.

In making *Me and My Brother*, Frank returned to the spontaneous process that typified the production of *Pull My Daisy*. He let people talk and act out their own beliefs. The film ends with a documentary sequence in which Frank

visited Julius who was incarcerated in a hospital in Napa, California. Julius had undergone shock treatments and was no longer catatonic. He was again confronted by Frank's camera. Julius responded to Robert's questions:

Robert: How do you feel about acting?

Julius: Acting is something beyond my collaboration.

Robert: Tell it to the camera.

Julius: Acting is beyond my thought process sometimes. At times. It may be a waste of time.

Robert: That's good. Say something to the camera.

Julius: Well, the camera seems like a reflection of disapproval or disgust or disappointment or unhelpfulness, unexplainability to disclose any real truth that might possibly exist.

Robert: Where does the truth exist?

Julius: Inside and outside the real world. Outside the world is…maybe it's just a theory, a theory or an explanation to the matter…whatever you concern yourself with.

Robert Frank's turn from fictional to autobiographical films was solidified in *Conversations in Vermont*, 1969, and *About Me - a Musical*, 1971. In *Conversations in Vermont*, Frank stated in the narration, "Maybe this film is about growing older, past and present. Some kind of family album, I don't know." He traveled to confront his children, Pablo and Andrea, at their school in Vermont. He showed them old photographs he had taken when they were chil-

dren growing up in New York and talked with them about their upbringing. In the film, he combined discussions with his children with photographs from their past, creating a dissociation of past and present.

In *About Me - a Musical*, he asked an actress to play him and filmed her reciting pages from a diaristic script. He confronted questions about the value of his photographs to himself and about his decision to withdraw from New York to Mabou, Canada. These scenes were juxtaposed with documentary sequences of improvisational music, a metaphor for spiritual need, and of a visit to his parents' home in Zurich. His father was shown looking over old stereographic photographs of the family. Frank's use of photographs in his films, as reference points and symbols of the past, validates his own presence in the layered time frame he establishes.

The documentaries *Life-raft Earth*, 1969, and *Cocksucker Blues*, 1972, recorded events that typify the media consciousness of the counter-culture during this period. *Life-raft Earth* depicted a hunger strike in California held to call attention to the world food shortage. *Cocksucker Blues* focused on the 1972 American tour of the Rolling Stones. In both these films, Frank deemphasized the overt issues and tried to question the structure and ultimate motivations behind these events. He refused to glorify them or use his work to popularize even those issues with which he sympathized. *Cocksucker Blues* was never released, because

Jay Manis (American, b. 1946)
Robert Frank filming Toronto Rolling Stones concert, August 1972

Photographer unknown
Filming Keep Busy, *Canada*, 1975

Frank had focused on the overriding alienation, media consciousness, money, and drug abuse on the tour rather than on the music on stage.

Keep Busy, written by Rudy Wurlitzer and completed in 1975, is an improvised story about a group of islanders who are played by friends and neighbors of Frank and Wurlitzer in Mabou. It is one of the most abstract films Frank has made. "A bunch of people are living in shacks on an island, surviving barely," says Frank, "and the winter is coming. The lighthouse keeper, alone on top of the island, is talking about the weather and how it used to be."[42]

The islanders are shown to be obsessed with the dailiness of their lives and the cycles of nature. Therefore they are subjugated by the lighthouse keeper and his messenger, who have access to the only radio, giving them control of all the news. "One of the interesting things about the film is that we used actors and real people," says Wurlitzer. "What interested me was questioning where the boundaries of fiction lie and where the margins are, how to use reality on one level and fictional approach on the other. They mutated where you use them together."[43]

Frank's and Wurlitzer's other collaborative film, *Energy and How to Get It*, 1981, is a similar combination of documentary and fictional ideas. What began as a documentary about Robert Golka, an engineer who was experimenting with ball lightning and the development of fusion as an energy source, was turned into a spoof on the documentary form. Frank and Wurlitzer inserted several fictional characters into the theme, including the Energy Czar, played by

William Burroughs. Again they were testing the power structure by formulating a characterization of its inner mind.

In Robert Frank's other recent films — *Life Dances On*, 1979, *This Song for Jack*, 1983, and *Home Improvements*, 1985 — he returned to an internal, autobiographical format. *Life Dances On* and *Home Improvements* are his most personal and emotional works because they deal directly with his family and close friends. They are composed of delicately balanced, intuitive moments that almost deify everyday life. The streets of New York, ice crystals on the window in Mabou, his own photography, and the simple acts of putting out garbage or watching it blow down Bleecker Street are all viewed with the same simple significance and sense of wonder. Some of his inner thoughts and harshest worries are also revealed, making his own life the subject of his inquisition.

In *Life Dances On*, June Leaf asks Robert Frank, "Why do you want to make these pictures?" Throughout the film he tries to answer, and only later wrote, "Because I'm alive."[44] The film is ostensibly about his daughter Andrea and his friend Danny Seymour. Both had died. He has merged his own sense of loss of two people close to him with several filmed portraits of those who share his life, including both family and people on the street. With no apparent beginning or end, the film appears as a slice of life, cut from his intimate observations. Frank combines details with few references to their continuity, simply showing the passage of time and its minute effects, colored by the

movement of the film itself. "I've done Nova Scotia with a movie camera," he said. "I've gone from left to right, when it snowed, when it hailed and then when the wind was blowing, and I plan to use that in some way. It's not the beautiful photograph. It just means the passage of time to me."[45]

Life Dances On ends in a conversation between Robert Frank and his son Pablo, who holds up a little crucifix with a fish attached to a chain. Frank asks, "What is it?" Pablo refers his father to the Bible, answering, "Job 38:22." Frank asks Pablo, "What is your happiest moment with Sandy?" Pablo looks at Sandy, who is sitting beside him and answers, "When she told me that if I wanted to live to be eight hundred, I should do it somewhere else." The verse from Job emerges as the film fades to black: "Have you been to the storehouse of snow, or have you seen the arsenal where the hail is stored?"

The questions Frank is asking about the significance and value of his own actions remain bonded to those asked of the bishop in Kerouac's *Pull My Daisy*. This is an important thread that runs through all his films. When the bishop was asked, "Is it true we're all in heaven now, but don't know it?," the street outside the window was instilled with a universal significance that went far beyond the look of the place.

V. *Do You Like What You See?*

Robert Frank once held a mirror in front of my face. Reflected in the glass was an image that I knew well enough already, but it seemed different this time. I was sort of embarrassed by the attention since no one had confronted me this way before. Holding up the mirror before me, Robert asked me, "Do you like what you see?"

I understood then that this was similar to the way that Frank confronts the rest of the world. He was asking me to examine my image, reflected as it was back at me. By posing the question he was showing me something more than just what I saw and asking me to examine the image more deeply. I wanted to say something more, like why I was there, instead of answering in a word or two. Yes or no. I have since come to realize that telling a story with minimal means is one of the things he is very good at.

He holds this mirror up to the world, sometimes reflecting it back at himself. His camera is like a mirror, creating a new image that is a reflection of what he sees. He holds the cards close to his chest, giving of himself while standing aside, watching, waiting, and recording what is passing before his eyes.

[1] Rudolph Wurlitzer, *There Ain't No Candy Mountain* (unpublished treatment for feature film), p. II.

[2] Interview, October 16, 1985, New York, videotape no. 37.

[3] Dennis Wheeler, "Robert Frank Interviewed," *Criteria*, vol. 3, no. 2, (June 1977), p. 7.

[4] *Robert Frank: the Poetic Image*, film documentary directed by Giampiero Tartagini, for Radio Television della Svizzera Italiano.

[5] Wurlitzer interview, October 16, 1985, videotape no. 36.

[6] Robert Frank, *The Lines of My Hand*, Lustrum Press, New York, 1972, p. 5.

[7] Robert Frank letter to Philip Brookman.

[8] Robert Frank to Philip Brookman, New York, October 21, 1985.

[9] Ronit Shani, "Bli Flash," *Monitin*, no. 57 (May 1983).

[10] William Johnson, "Robert Frank," *The Knute Rockne Oasis Newsletter and Journal of Critical Opinion*, vol. 1, no. 7 (July 1984), pp. 5-6.

[11] Robert Frank to Philip Brookman, New York, October 21, 1985.

[12] Robert Frank, *The Lines of My Hand*, Yugensha, Tokyo, 1972, p. 8.

[13] Interview with Jonas Mekas, New York, October 15, 1985, videotape no. 27.

[14] Interview with Rudy Wurlitzer, New York, October 16, 1985, videotape no. 36.

[15] William Johnson, "Public Statements / Private Views: Shifting the Ground in the 1950s," *Observations: Essays on Documentary Photography*, ed. David Featherstone, Friends of Photography, Carmel, 1984, p. 89.

[16] Application to Guggenheim Foundation, October 1954.

[17] For additional discussion see George Cotkin, "The Photographer in the Beat-Hipster Idiom: Robert Frank's The Americans," *American Studies*, no. 26 (Spring 1985) pp. 19-33.

[18] Videotape of Robert Frank lecture at Dazibao, a non-profit gallery in Montreal.

[19] *The Lines of My Hand*, p. 100.

[20] Interview with Lou Silverstein, October 14, 1985, New York, videotape no. 21.

[21] Silverstein interview, videotape no. 21.

[22] Jonas Mekas, "Cinema of the New Generation," *Film Culture*, no. 21 (Summer 1960), pp. 3-4.

[23] Jonas Mekas, "Notes on the New American Cinema," *Film Culture*, no. 24 (Spring 1962).

[24] Interview, videotape no. 25.

[25] Byron Dobell, ed., "Feature Pictures," *U.S. Camera* (September 1954), p. 84.

[26] "Robert Frank," *Photography Within the Humanities*, Eugenia Janis and Wendy MacNeil, eds., Addison House, Danbury, 1977, p. 58.

[27] Interview with Allen Ginsberg, October 13, 1985, New York, videotape no. 13.

[28] "On the Road to Florida," *Evergreen Review*, no. 74 (January 1970), p. 43.

[29] Interview, videotape no. 13.

[30] Barry Gifford and Lawrence Lee, *Jack's Book, an Oral Biography of Jack Kerouac*, St. Martin's Press, New York, 1978, p. 260.

[31] Inteview, videotape no. 13.

[32] Ann Charters, *Kerouac, A Biography*, Straight Arrow Books, San Francisco, 1973, pp. 404-405.

[33] Interview, videotape no. 13.

[34] Interview with Walter Gutman, October 17, 1985, New York, videotape no. 42.

[35] Interview, videotape no. 13.

[36] David Amram, *Vibrations*, MacMillan Co., New York, 1968, pp. 313-14.

[37] Ginsberg interview, videotape no. 15.

[38] Ginsberg interview, videotape no. 17.

[39] "The First Statement of the New American Cinema Group," *Film Culture*, no. 22-23 (Summer 1961).

[40] Mekas interview, videotape no. 27.

[41] Janis and MacNeil, p. 53.

[42] *Robert Frank*, Aperture, Millerton, 1976, p. 96.

[43] Interview, June 22, 1985, New York.

[44] Statement, film retrospective, Whitney Museum of American Art, New York, 1980.

[45] Janis and MacNeil, p. 61.

IT'S THE MISINFORMATION THAT'S IMPORTANT

by Anne W. Tucker

Basically, Robert Frank is famous for a book made thirty years ago and a film issued one year later. These works are included in every major survey of twentieth-century photography and film. John Szarkowski, director of the photography department at the Museum of Modern Art, made *The Americans* one of the cornerstones of the exhibition and book *Mirrors and Windows: American Photography since 1960*. But few have seen Frank's other films or photographs.

There are diverse views about Frank's work and contradictory speculations about the course of Frank's career which he has fueled. He makes intensely personal photographs but protects his privacy. He is famous but doesn't promote his work or himself. Rather, fame has grown up around him. He prefers not to teach, lecture, or give interviews and makes little effort to distribute his work. He says all his photographs are autobiographical, yet he is identified as a major influence on the Modernist tradition that claims art is not personal but is intrinsically about other art. He is included in most discussions of documentary photography, but he is inattentive to facts. He commonly misdates photographs and gathers the events of his life around a central year. The photograph of *St. Francis, Gas Station, and City Hall, Los Angeles* is not of a statue of St. Francis or City Hall. Knowing that makes it no less convincing a photograph. The sentiment was right if the facts were wrong.

When Frank said "it's the misinformation that is important," he was speaking to a group of filmmakers, photographers, and curators dining with him in New York. They were organizing an exhibition of his art and had proposed making a video documentary about Frank and his work. It was clear he wouldn't welcome the project, but he wouldn't stop it. "Great wisdom about art is embarrassing to me," he said. "If you make a film about me, there is so much material. Why, then, does it have to have me on top of it or under it?"[1] So the video was planned without him, but he encouraged his friends to participate. To the directors of the video he was both encouraging and distant, uninvolved and controlling, generous and silent. In the age of information, he has gained power by withholding or selectively releasing information.

He is not anti-intellectual but anti-academic. He seeks to convey truth as he sees it. Frank states in one of his films, "The truth is somewhere between the documentary and the fictional, and that is what I try to show. What is real one moment has become imaginary the next. You believe what you see now, and the next second you don't anymore."[2] These are the issues which have engaged Robert Frank for the last twenty years. They evolved from a life and career with many changes in location, aim, and companions.

Robert Frank was twenty-three when he landed in New York seeking employment as a commercial photographer. Six years earlier he had apprenticed himself to a photographer in Zurich to avoid going into his father's importing business. After working for three other photographers and a film company, he decided to seek his fortune, first in Paris and then in New York, where he was hired by Alexey Brodovitch to photograph for *Harper's Bazaar*. Art director of *Harper's* since 1934, Brodovitch was legendary for his ability to discover and nurture talent. What

prompted him to hire this unknown young Swiss photographer?

Frank had favorable letters of reference, and in lieu of a portfolio, he showed Brodovitch a book, titled *40 Fotos*, he had made the year before. The book demonstrated Frank's command of the skills required of a commercial photographer. It included portraits, landscapes, reportage, and studio still lifes. All were technically superb, manifesting the precision characteristic of Swiss photographers.[3]

The pictorial solutions in *40 Fotos* are fairly traditional, with little that anticipates Frank's famous style of the fifties. But there are seeds of his future work. This first book is characteristic of subsequent publications in its minimal use of text. More important is Frank's impulse to organize his photographs in a sequence and to think about how they will look on a page. This is the first of four books with Frank's original photographs. All four precede *The Americans*. In *40 Fotos*, he began to explore how juxtaposed photographs affect one another. Unlike later works, there is no overall sequence which gathers the images into a coherent whole. The primary associations are one-to-one comparisons of similar subjects or contrasting formal qualities: the placing of a white snowscape next to a dark mountain scene, the pairing of portraits or of views of mountain farmers at their tasks.

A few of the page spreads are cynically humorous. A photograph of the Swiss flag between columned buildings faces a photograph of chimney pots and laundry. Recurrence of the Swiss flag throughout *40 Fotos* presages the importance of the American flag in *The Americans*. However, in Switzerland the national flag is always displayed on a pole, and its display doesn't convey the range of cultural messages Frank discovered for the American flag in *The Americans*. Other photographs in *40 Fotos* also prefigure later works. In the picture of a small pig hanging upside down between a farmer's hands, one can foresee the 1949 image of a horse hanging in the Parisian slaughterhouse; an air-borne skier rising off a slope anticipates the giant balloon of a man in *Macy's Parade, New York* (1948). However, the later pictures are more evocative. The photograph of the skier conveys only the drama of his leap into space. The balloon manages to appear both precarious and ominous.

For those familiar with Frank's later work, the greatest surprises in *40 Fotos* are the photographs of floating gear wheels and light bulbs, raking sunlight on rough-cut logs, and eggs studied as form. Frank has not published this early studio work elsewhere, indicating his rejection of it. But it is probable this competent rendering of objects got Frank the job at *Harper's Bazaar*, because Brodovitch hired Frank initially to photograph shoes, handbags, and other fashion accessories for the magazine's "Shopping Bazaar" section. He worked on salary in The Studio, an elaborate studio and darkroom operated just for *Harper's* photographers. Here everything was shot in black and white, within the rigid limits of camera on a tripod, lights on stands, and accessories arranged on seamless background paper. Brodovitch, or the editors, conceived the basic idea for each shot and generally left the details to the photographers.

Louis Faurer was the only photographer working at The Studio with whom Frank identified. "The others," he

said, "were different. Photographers like Mark Shaw and George Hoyningen-Huene were consumed with the commercial work. Lou was only one like me. I went to Peru to get away from that make-money crowd."[4] After *Harper's* decided to economize by closing The Studio, Frank continued working on contract for the "Shopping Bazaar" section. He rented a studio on Lexington Avenue. Later he and Faurer shared a darkroom/studio that was owned by Fernand Fonsagrives. Frank's by-line first appears in the July 1947 issue and continues regularly though 1951.[5]

For the last six months of 1948, Frank traveled by himself at his own expense in Bolivia and Peru. In Peru, he worked extensively for the first time with a Leica 35mm camera. He photographed Peru as a vast, open terrain inhabited by Indians whose existence seemed only marginally affected by the twentieth century. He had selected a culture completely alien to the world of high-fashion accessories. After the density of New York, he responded again to the calm of roads vanishing into distant and unbroken horizons. The land dwarfed the Indians. He perceived them as a community, traveling and working in groups. They were gentle and smiling. There were no figures of authority except soldiers, who were not perceived as oppressive. Frank admired, rather than pitied, the Indians' hardships, whether the high risk of injury in the labor of adults or the shy anxieties of youths.

The informality of America had begun to affect him, for he worked much closer to his subjects in Peru than he had in Switzerland. However, he still worked in full daylight, not in the subdued light that would characterize his later work. The negatives Frank chose to print on his return to New York in 1949 are fine examples of magazine journalism, much freer than his commercial work. Two decades later he printed negatives from this trip that are more enigmatic and visually sophisticated; for example, a dark interior with shiny parts of dolls' bodies hanging on a line and a boy who has left the darkness through an open doorway. Are the doll limbs native industry or native medicine? Through what kind of darkness has the boy passed?

Another photograph printed later was taken through a train window. It is of a concrete billboard with architectural embellishments. The billboard advertises a 1949 Ford. (Oddly, the 1949 Ford coupe was virtually identical to the 1950 model Frank would buy five years later to travel in throughout America.) A little girl in a dress and white socks stands in the shadow of its base. Since she is not dressed in the native costume, this is one of the few pictures that intimates the intrusion of Western styles on Peruvian culture. The Ford, as a means of transportation, contrasts sharply with Frank's images of Indians crowded into an open truck, riding burros, waiting for trains, or covering vast areas on foot, often with substantial loads on their backs.

On his return to New York, he made another book of original photographs. As in *40 Fotos*, photographs were mounted on stiff board and held together with a ring binder. One copy he presented to Brodovitch with an acknowledgment of his support: "Before leaving New York /I want to thank you /and wish you/ good luck/ bonne chance/ Robert Frank." He gave another copy to his mother for her birthday. Frank's book on Peru contained thirty-seven photographs and a diptych that wraps around the cover. He grouped picture sequences by activity (cutting cane, market day), but there is nothing anecdotal in the images or the

sequencing, no attempt to force the material into a narrative line.

The editions of *Peru* were finished before Frank returned to Europe in 1949 to see his parents and to photograph. In Paris, he made a charming series on the chairs in the Tuileries and Luxembourg gardens. The chairs are animated by their groupings and what these arrangements imply about their last occupants.[6] He also began a series on flowers. One of most widely published images from the series is of photographer Louis Stettner holding a single tulip behind his back as a young woman approaches. It is possible the moment was staged. The picture conveys, nevertheless, a sense of intimacy and expectation.

On the boat to Europe, Frank met the photographer Elliott Erwitt, with whom he traveled to Italy. In Paris he also met the publisher Robert Delpire and showed him the photographs from Peru. Delpire published a selection of twenty-eight Peruvian photographs in his magazine *Neuf* and later included fourteen in a book that also included the work of Pierre Verger and Werner Bischof. Thus began a forty-year collaboration and friendship between Delpire and Frank.

Frank was joined in Paris by sixteen-year-old Mary Lockspeiser until her English father separated them. For Mary he made a book of photographs mounted on folded white cardboard. There are seventy-four photographs on twenty-two pages. Most of the photographs are small, two or three inches wide. There are six to ten photographs per page. The text was written in both French and English and was about Paris and Frank. With the series on the chairs in the Tuileries garden, Robert wrote about "l'air triste of the chairs." With photographs of gas street lamps, roofs with chimney pots, bridges over the Seine and flowers, he wrote,"Peu de choses . . . tous cela ça fait beaucoup."[7] It is a very personal book, intimate in scale and diaristic in tone. Its use of multiple images on each page and autobiographical text are unlike anything Frank would produce for thirty years.

The following year, Robert and Mary were married in New York. Robert was twenty-six; Mary was seventeen. He was gaining recognition; she was just beginning to draw. "I idolized him," she recalled. "He was committed, passionate, and judgmental about his and other people's work. He had a strong, personal, nonintellectual eye, very fast. With him, I learned to see, work, draw fast."[8] Their first child, Pablo, was born in 1951 and Andrea in 1954. Mary remembers that early period of marriage and motherhood as one of helpless disorganization. "We lived such a Bohemian life. I'm always amazed at people with kids making schedules for work and so on. It seems to me I've had no plans at all."[9]

For the next ten years, Mary and Robert's apartments in New York would always be open to a rich assortment of artists, writers, photographers, and patrons. They lived in lofts in low-rent neighborhoods. Mary was beautiful, and men remember her with wonder. Emile de Antonio remembers Robert watching with amusement other men's reactions to Mary's beauty. Robert was a good listener and easy to be with. "He is exceptional, but not conspicuously so," said Hugh Edwards, retired curator at the Art Institute of Chicago. "We had an ordinary friendship—no motives of any kind between us. The great bond between us was French literature."[10] Both Lou Faurer and photographer Ralph Gibson spoke of Frank's sense of humor. "He

has perhaps the best, wriest, most sardonic sense of humor that I've ever encountered," said Gibson. "I found that we spent a lot of time laughing and getting off lines to one another that were very obtuse and utterly hilarious and unexpected."[11]

How and where the Franks lived and how they dressed was a social message. "My lifestyle is my politics," he said. He abandoned a "clean Swiss" look for unpressed pants and worn jackets. Mary bought long skirts at the thrift store. Both wore their hair long. This was in a era when men wore military-short haircuts and most restaurants required a suit and tie. Doormen and security guards frequently stopped Frank to check his appointments. A waitress once refused to serve him coffee and apple pie.[12]

He continued to support his family as a commercial photographer and to work independently photographing New York City. Frank's feelings about New York have always been ambivalent. His first pictures are typical of someone discovering the city. Working with a Rolleiflex camera, he photographed skyscrapers and heavily trafficked streets. After he began to use a Leica, he shifted his focus to the city's rituals, both daily and annual. He began to isolate symbols—ticker tape, bunting, decorative lights, and vendors—that register the occasion without describing the central event.

What Frank loved about New York was its complexity, its opportunities, and its pace. Lou Faurer remembers Frank uttering, "What a town, what a town, what a town. It could only happen here; it couldn't happen in any other town."[13] What Frank hated about New York was its brutality. He became tough working in New York. He watched in pain as others were crushed. He had only been in New York a week when he noticed life was difficult for older people with no resources and "it was everyone for himself. I would not want to live here forever," he concluded.[14] The loneliness of the city also began to weight his photographs.

In 1951, Robert and Mary decided to move to Europe. Mary and Pablo left for Switzerland in the summer. Robert stayed to finish his entries for *Life* magazine's Young Photographers Contest. He submitted work in both divisions: individual photographs and picture story. His entries in the individual division included the pictures of Stettner with a tulip, of Mary nursing Pablo, and of the white line down 34th Street. His picture essay was titled "People You Don't See." It portrayed six people from Frank's block on 11th Street.[15] He selected the six "not because they are unusual, but because they are typical of people I had seen before, almost anywhere in the city."[16] Anticipating the judges' standards, he wrote, "I have not tried to show moments of excitement or emotion, but to emphasize the scenes that I have noticed over and over again, day after day."

The contest pictures are not among Frank's most original. In the tradition of *Life*'s series, *A Day in the Life of . . .*, the series had extensive captions to explain the pictures, the only time Frank ever relied on captions. However, the series is significant because he began to isolate the kinds of people and places he would photograph for *The Americans*. The essay didn't win any prizes, but Frank won $1250 for second place in the individual picture division.

The Franks lived in Paris for a year and a half except for two months in Valencia and trips to London and Wales.[17] Once again, Frank began to photograph the variety and ubiquity of flowers in Paris. He isolated flowers in Paris as he later focused on flags and bunting in America. In Paris, flowers are sold day and night, rain, snow, or shine. They are scrutinized by shoppers, waved by young girls, presented by children, and abused by dogs. Displayed in markets, on monuments, at rituals, or in homes and cafes, cut flowers are the traditional response to any occasion.

As in Peru, Frank continued to photograph parades and festivals as grace moments in workers' lives. He also began to identify cultural forces like religion and politics. These pictures prefigure famous images in his later work. For instance, *Champs Elysées, Paris* (1952), a photograph of marchers in the Armistice Day parade, anticipates the fatuous politicians in *City Fathers, Hoboken, New Jersey* (1955). Also, Frank's intense, productive response to Welsh miners predicts his series on factory workers in Detroit two years later. But the contrasts between the European photographs and the American are much greater than the similarities. Certainly European children and adolescents are portrayed as being more innocent. There is no parallel in Europe for the rich boys in *Motorama, Los Angeles* (1955) or the surly adolescents in *Port Gibson, Mississippi* (1955). It is curious, too, that there are no animals in Frank's America. Formally, the European photographs marked the beginning of Frank's preference for photographing in low light rather than full sunlight. He begins to work in overcast, late-day, or rainy light. The grayness suited his vision; the somber range of shadings created a darker mood.

In the fall of 1952, Frank met Edward Steichen in Zurich and introduced Steichen to Swiss photographers. Steichen, director of the photography department at the Museum of Modern Art, was making an exploratory survey of material for two future exhibitions: *Post-War European Photography* and the epic *Family of Man*, both of which were to include Frank's photographs. Frank saw Steichen again in Paris where Frank presented him with a new book of original photographs. Designed by Werner Zryd, *Black, White and Things* is the first of Frank's books with a brief text and printed captions. On the title page in lower-case type is the following introduction:

> it is only with the heart that one can see rightly.
> what is essential is invisible to the eye.
> Antoine de Saint-Exupéry
>
> somber people and black events
> quiet people and peaceful places
> and things people have come in contact with.
>
> this, i try to show in my photography.

Three sections, titled "Black," "White," and "Things," contain twelve, eight, and fourteen photographs, respectively. Between the first and second sections, the book is inscribed to Steichen "with much respect and gratitude." The images Frank included were made between 1949 and 1952 in America, Peru, France, England, and Spain. Within each section, the photographs are paired across double-page spreads.

The basis for Frank's assignment of photographs to a particular section is not necessarily apparent. If "black" is "sombre people and black events," why did he include the young couple in a bumper car? Their eyes are closed, but both are smiling. Are they blind? If an empty road in Peru is "black," why is a white line down an empty city street "white"? However, most of the associations are clear.

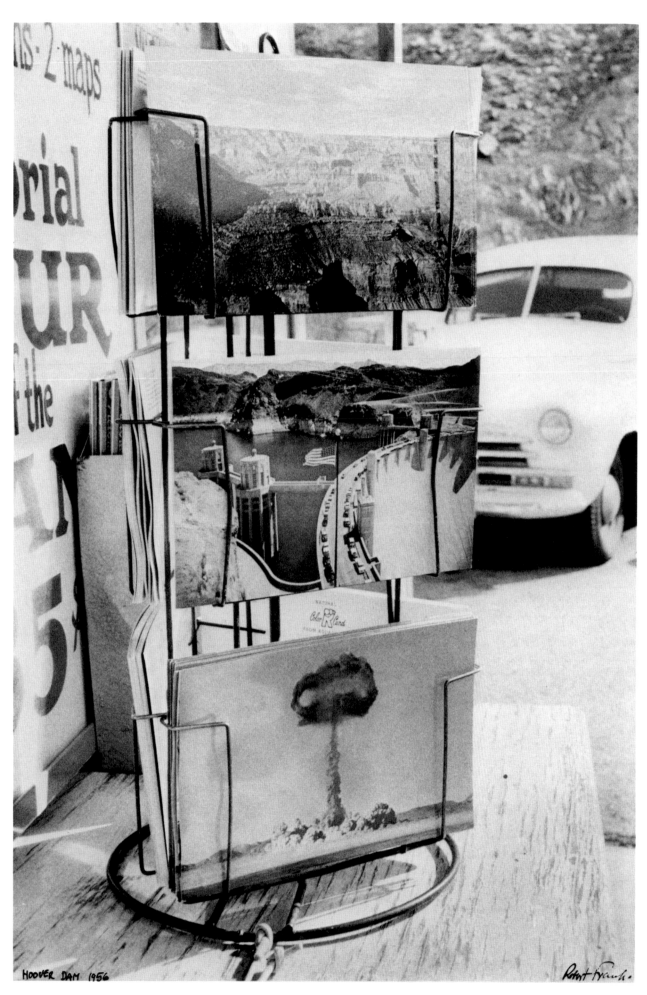

Robert Frank
Hoover Dam, Between Nevada and Arizona, 1955

Funerals and beggars are "black." Given Frank's lexicon, it is not surprising that bankers are also considered "black." Families, children, and parks are "white."

Most of the captions identify the subject, place, and date of the photograph: *Parade, Valencia, 1952*; *Bankers, London, 1951*; and *Ticker Tape, New York, 1951*. But in the last section, the titles make generic references. *Women of Stone* is of a man carrying a sculpted bust of a woman. *Men of Wood* is of a statue of Christ in a religious procession. *Men of Air* is of a balloon in the Macy's parade. *Iron* is of altar boys carrying a cross. None of these are paired with each other but appear in successive double-page spreads. *Women of Stone* is paired with Louis Stettner holding the tulip. The Christ statue is facing a hand holding religious medals. Sometimes the pairing is based on similarity, and sometimes on dichotomy. One dichotomy is economic. An old woman selling Chesterfields on a sidewalk in Barcelona is juxtaposed with a Parisian woman in a skin-tight white dress and fur.

Because it was organized according to abstract concepts rather than by subject matter, *Black, White and Things* was Frank's most ambitious book to date. It had more to do with personal metaphors than photo-journalism. Ultimately, the sequences and individual pairs seem forced, and the captions are self-consciously literary, but *Black, White and Things* signifies an important turn in Frank's career. He had begun to search for personal meanings in his work, to present the photograph as a metaphor, and to explore sequencing as a way to direct the viewer's responses. Frank would return to the idea of black and white as metaphors in a 1959 statement. "Black and white is the vision of Hope and Despair. That is what I want in my photographs."[18]

In 1952, the Franks spent the Christmas holidays in London with Mary's father. They had a small apartment, and Frank continued to photograph bankers in the old City section of London. At the beginning of March 1953, they traveled by train to Caerau, Wales, where Frank had arranged with the miners' union to photograph.[19] After an intense and productive week, they sailed from Southampton for New York. The trip to Europe had been fruitful. In addition to the book *Black, White and Things*, he produced series on flowers in Paris, a bullfighter in Valencia, bankers in London, and miners in Wales. The European photographs are romantic but incisive vignettes of daily life. In that way, they are like the Peruvian work and early photographs of New York. But Frank's style and his ambitions had shifted. He gave up fashion work, and soon he began to make pictures that were too stylistically radical and personal for most magazines. The schism increased between what he did as artist and as breadwinner.

When the Franks first returned, they lived on West 23rd Street. In 1956 they moved to Third Avenue near Tenth Street. Painter Alfred Leslie lived next door, and Willem de Kooning's loft was across the backyard. In Europe, Mary Frank had begun to sculpt. In New York, she enrolled at the Hans Hofmann School, where she met other artists and sculptors. This community had a tremendous effect on both Robert and Mary. "What influenced me strongly," said Robert, "was the way these painters lived in the '40s and early '50s—their struggle. It wasn't so much what they did, but they were people who really believed in something they did and got very little support for it. It impressed me tremendously that they could be so believing in what they did."[20]

Frank immersed himself in a world of people seeking to change jazz, literature, and art as he was trying to change photography. Spontaneity was a vital tool; they revered risk-taking. Risk was the antithesis of repetition. He had no set method for accomplishing anything, no lasting "right way" because perhaps a better way could be found. Frank's impatience with duplication and his pleasure in spontaneity has kept his work open to continued evolution. "Robert has always left things," said friend and colleague Rudy Wurlitzer. "He has always moved on, at great cost and suffering and great renewal."[21]

For Frank, process became more important than result. He added experimentation to technical mastery. Constantly risking his control and incorporating chance into technical decisions meant commercial jobs sometimes were not successfully completed. Another consequence of searching for "a better way" has been that a great variety of prints now exist from certain of Frank's negatives. Over the years he has cropped his pictures differently, printed variant negatives of famous images, added or eliminated black borders, and changed the size and grade of paper on which he prints. He works intuitively. He doesn't explain his reasons for change and rarely comments on the explanations of others. Ralph Gibson voiced one explanation shared by others: "He is the kind of artist who is reaching so far beyond his grasp that he has grown accustomed to the feeling of being in over his head and would be uncomfortable if he were in total control, which is one of the things I admire most about him."[22]

Soon after returning from Europe in 1953, Frank met Walker Evans, then a contributing editor to *Fortune* magazine. Evans encouraged Frank to apply to the John Simon Guggenheim Memorial Foundation for a fellowship and was one of Frank's references. Frank's proposal was "to photograph freely throughout the United States, using the miniature camera exclusively This project is essentially the visual study of a civilization and will include caption notes, but it is only partly documentary in nature: one of its aims is more artistic than the word documentary implies." Not surprisingly, Frank projected the final outcome of the project would be a book. Given his work in Europe and the community into which he settled upon his return, it also is not surprising that his aims were more artistic (i.e., personal) than documentary.

Typically, Frank's trip through America was a combination of planning and chance. Mary Frank remembers they "just took off in a car. I thought we were going off on some sort of picnic. Two kids, one of them sick, no place to wash the diapers. I couldn't drive. We didn't know where we were going to, where we'd stay."[23] Actually, Frank planned the trip with assistance from American Automobile Association and advice from Evans. He also obtained advance permission to photograph certain factories and oil refineries and carried letters of introduction to people in major cities who might be helpful.

He purchased a 1950 Ford Business Coupe from art director Ben Schultz and began to photograph during a short trip to Savannah, Georgia, and along the coasts of South and North Carolina. These pictures may have been made as early as the spring of 1955. In July, he made his first of two trips to photograph Ford's River Rouge plant in Dearborn, Michigan.[24] Then between October 1955 and May 1956, he was on the road. He traveled from New York down the East Coast to Florida and across the South to Texas. Mary and the children joined him in Houston in

November, traveled with him across the Southwest, and stayed with him in Los Angeles. In the spring, Mary returned to New York with the children; Frank drove to San Francisco, across Nevada and the Midwest to Indianapolis, where he stopped photographing and drove straight through to New York. He had exposed almost 800 rolls of film.[25]

Frank processed the film and made contact sheets throughout the project. As he looked at his contact sheets, he recognized certain recurring images: cars, flags, jukeboxes, politicians, religious figures, and roadside entertainment. He saw these objects and people as American icons and invested them with symbolic power. When he returned to New York, he printed enlargements, then selected and sequenced the photographs for his book. He structured the sequence around the recurrence of these icons, especially of the flag. Initially the book was broken into four sections, each of which began with an American flag. Part 1 began with *Parade, Hoboken*, part 2 with *Fourth of July, Jay, New York*, part 3 with the photograph of the flag between portraits of Lincoln and Washington in Detroit, and part 4 with *Political Rally, Chicago*. The divisions eventually were collapsed into one whole, but the flag remains as a "leitmotif, a mysterious shroud to cover reality with."[26]

In the 1950s, the automobile dominated the American scene. It was every family's first major possession. It offered transportation, status, recreation, shelter, and escape. Stickers and dangling objects advertised political and religious beliefs. Frank described and commented on American uses of the car, its care and feeding, and how the culture had conformed to its presence with new highways, parking lots, service stations, and drive-in parks, restaurants, and movies. He also noted that cars kill.

Another theme in *The Americans* is the role of music in American culture. Country music was one of Frank's first connections with America. To the horror of his colleagues at *Harper's Bazaar*, the first record that he purchased was by Johnny Cash on the Sun Records label. Hank Williams is still one of Frank's favorite performers. Frank is also knowledgeable about jazz, rock, and blues. In the late fifties, he listened to jazz at the Five Spot on 5th Street and Bowery following innovations of John Coltrane, Thelonious Monk, and Lester Young. His interest in music eventually led him to be commissioned to make record covers for the Rolling Stones and the J. Geils band and to work as a cameraman on several films about rock music.

In the fifties, the jukebox was the obvious way to symbolize popular music. One could be found in every

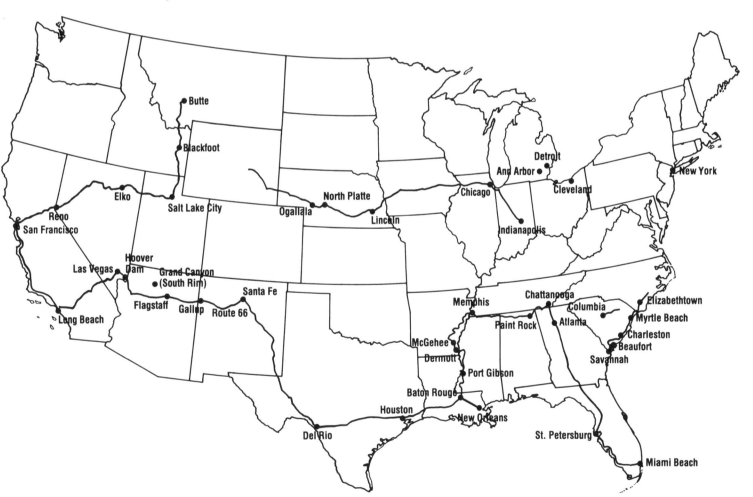

Map tracing Frank's tour in 1955 - 1956. Tour-line is broken when the exact route is unknown.

sweet shop and bar. Most of those Frank photographed were not new. A jukebox ordinarily passed though a three-tiered lifespan. Fancy hotels and restaurants bought new jukeboxes. When a newer model was bought, the older jukebox was sold to some respectable neighborhood meeting place. Finally, bumped again, the jukebox went to an out-of-the-way lower-class bar or grill.[27] Jukeboxes in *The Americans* had been new in the mid-forties and by 1955 were third-tier. In looking at Frank's starkly black-and-white images, one forgets what brilliant colors these boxes displayed. The one in *Candy store, New York City* was known as the Mother of Plastic because it was the first jukebox to use colored fluorescent lights. The Rock-ola model in *Cafe, Beaufort, South Carolina* was red, blue, orange, and green.

In the third-tier homes of these jukeboxes, Frank found the people he had an inclination to photograph—people without power and "no names." It was a matter of both sympathy and respect. He sympathized with the weakness of their position, and he responded to their lack of pretense. Some of Frank's most powerful images are of blacks and women, two groups that would soon contest their powerless status.[28] Against images of the powerless, he juxtaposed fatuous bureaucrats, haughty socialites, and scheming politicans. His photographs gave new vitality to social stereotypes.

Midway through his Guggenheim fellowship, Frank wrote to his parents that his attitude about what he was doing had changed. "I am working very hard not just to photograph, but to give an opinion in my photos of America America is an interesting country, but there is a lot here that I do not like and that I would never accept. I am also trying to show this in my photos."[29] Critics objected to such personal observations being published in a book titled *The Americans*. Margot Weiss found the pictures "filled with almost neurotic anger and slashing judgments."[30] William Hogan accused Frank of portraying only The Ugly American and concluded Frank was wrong to publish pictures, however memorable, that had no hope.[31]

Frank was not surprised by the reactions to his harsh view of America. He had realized after his first week in New York that Americans didn't like to be criticized. His response to critics was "that life for a photographer cannot be a matter of indifference. Opinion often consists of a kind of criticism. But criticism can come out of love."[32] In speaking about Frank's films as well as his photographs, Emile de Antonio concurred Frank had a dour outlook on American society, but one with affection and connection. "He is not as alienated as most people say. Maybe in his life, but not with the camera. He was able to discover on camera for us a slice of life in America that nobody else had ever put on a screen."[33]

Frank was disappointed in the lack of understanding. He had hoped magazines would publish excerpts and galleries or a museum would exhibit prints. Once again he was fortunate to have Robert Delpire as a champion. But even Delpire could not find the backing to publish the series without text, as Frank wanted. Published in France in 1958, *Les Américains* contained passages of text selected by Alain Bosquet on every page facing a photograph. In 1959, Frank convinced Grove Press to publish the book in America with a brief introduction by Jack Kerouac and only concise descriptive titles. Eventually *The Americans* found its audience among young photographers, and since 1958 it has been reprinted six times in three languages.

Beyond Frank's iconography, *The Americans* is important as one of the most sophisticated sequences of photographs ever published. All Frank's prior book projects, with their experiments in juxtaposition and linear flow, culminate here. The structure of images builds its effect like a musical score or a poem, symbol on symbol. There is, of course, also a debt to the structure of Walker Evans' book *American Photographs*. But the debt is not as exclusive as has been proposed.[34] The radical difference between Evans' and Frank's work is style. Evans worked with a view camera. His photographs are classic, understated, and immaculate. Frank's handling of the Leica is athletic, spontaneous, and daring. He shot from low angles and used lenses of different focal lengths in unusual ways. As curator Anita Mozley observed, "He disregarded the dictum that a photographer should keep the light behind him, the foreground in focus, and the subject still."[35]

Frank's compelling demonstration of the small camera's potential changed contemporary understanding of how a photograph might look and what it could mean. Comparing Frank's use of the 35mm camera to that of the French photographer Henri Cartier-Bresson, photographer Joel Meyerowitz said, "Robert's form is looser, more conversational, harder, dirtier, ruder. Robert had his own tempo. He had balletic grace in his approach to making photographs."[36] To the general camera world, many of whom were preoccupied with previsualization of the negative in order to control nuance of tone and detail, the force of the pictures in light of their spontaneity and innovation was, in the least, disturbing and, for many, unforgivably offensive.

By 1959, when *The Americans* was published in New York, Frank had completed two modest series of photographs[37] and had announced them to be his last personal project in photography. For the next decade, he devoted all his creative energies to film. Frank is frequently asked why he stopped making still photographs. He generally responds that he had come to an end and could no longer express what he wanted to say in still photography. He had exhausted the single image as a tool to express his vision and had completed what he wanted to say about America. There were no other "locations" he wanted to photograph. He had to feel connected to his subjects. "Realism," he said, "is not enough—there has to be vision and the two together can make a good photograph."[38]

Perhaps what he abandoned was not photography but the printed page. Frank matured in the heyday of the picture magazine. He admired W. Eugene Smith's work at *Life* and for a time wanted to work there. The strong graphic quality of his photography, with its black-and-white contrast of subject and field, seizes the eye and stops anyone thumbing through pages of his work. It is clear from his books that he photographed for the printed page. Frank's abandonment of still photography seems in retrospect an omen for the picture magazines. *Collier's* died in 1957, *Coronet* in 1961, *American Weekly* in 1963, *The Saturday Evening Post* and *This Week* in 1969, *Look* in 1971, and *Life* in 1972.[39]

Between 1959 and 1969, Frank produced five films. He did some commercial work in both still photography and film. He and Mary were divorced; he began to live with artist June Leaf. *The Americans* was republished. By the time Frank met curator John Szarkowski in 1962, Szarkowski said, "Frank was kind of an underaged legend looking for money for his films."[40] Being a legend was a

burden. He has neither the temperament nor the inclination to be a celebrity. He will gracefully accept tributes to the work, if he regards them as substantive and not too much interest is directed at him personally. He doesn't gladly suffer fools or the merely curious. He doesn't accept that the public has a right to know. Before agreeing to a retrospective of his work, he stipulated that he would give no press interviews.

Frank doesn't promote or actively distribute his films or his photographs. He is admired by many photographers and filmmakers who understand that he would rather have the work not seen at all than have it misinterpreted or shown in the wrong way. A primary example of his stubborn integrity was his clash with Steichen over the title of Frank's 1962 retrospective. Steichen was about to retire from the Museum of Modern Art and planned a dual retrospective of work by Harry Callahan and Robert Frank as the sixth and final exhibition in his series *Diogenes with a Camera*. Frank was flattered and felt it would be a "great event" to have a show with Callahan, but he asked Steichen to drop the series title. "There is one thought [which] may seem small," he wrote to Steichen, "but for me it represents the completion of what I have been working for. May I ask you to call the exhibition *Photographs by Callahan and Frank*. I think it won't be difficult to justify the absence of a theme."[41] Steichen agreed, but when a press release from the museum reiterated this was part of the *Diogenes* series, Frank wrote again. "I do not wish to be part or used as being part of any specific theme such as DIOGENES," he said. "Should this prove to be impossible, I will prefer not to have a show."[42]

Steichen had been one of Frank's earliest and strongest supporters, and Frank always had been grateful for that support. A retrospective exhibition at the Museum of Modern Art is the dream of most American artists. Frank's willingness to drop out of the show rather than support Steichen's theme indicates the strength of his feelings.

In 1969, Frank left New York and moved with June Leaf to Mabou, Nova Scotia, Canada. In 1970, Japanese publisher Kazuhiko Motomura approached Frank about publishing a book of his photographs. *The Lines of My Hand* (1972) is Frank's first retrospective book. He dedicated it to "Friends now gone forever" and to his children. Each dedication page includes names and photographs without indicating when or why these people were important to Frank. The list of names and the photographs are not organized in the same order, so the names cannot be matched with the photographs. The dedication acknowledges Frank's debt to his friends, but primarily it is there to emphasize the retrospective and very personal nature of the book.

However, *Lines* also is dedicated "above all for Pablo and Andrea who are trying to find a better way to live." This dedication and the words with which Frank ends the book indicate he also was looking forward. On the last photograph in the American edition Frank wrote, "Yes it's later now Will we go back to New York? Just stay here and watch the weather and television. June is looking through the microscope. I will do something. Isn't it wonderful just to be alive."

Producing *Lines* brought Frank back to still photography. In an interview earlier that year, he indicated he had at least considered picking up a still camera again. "If I were to photograph now," he said, "I certainly would double

print or do all kinds of things so that I wouldn't be stuck with that one image."[43] His new interest in multiple imagery is manifested in *Lines* in many examples. He included several collages made from his photographs. He also included photographs of anonymous photographs in arrangements found on walls or in card stands. There are a diptych and a triptych from 1955 negatives and contact sheets he had assembled from his negatives of *The Americans* and of his films. Finally, on the last page of the American edition of *Lines* are two new photographs, panoramas created in 1972 by sequencing photographs of his land and the Gulf of St. Lawrence. Multiple images dominate the last half of the book.

In 1974, Frank began to produce still photographs again while continuing to make films. Using black and white, positive/negative Polaroid film, he made a series of collages using multiple negatives and words.[44] Texts for the new Polaroids were written onto objects in the picture, scratched into the negatives, or written below the photograph on the mat. The words were not captions. Their purpose was not to describe but to direct. They were an integral component of the image. Text passages included cryptic communiqués—Lookout for Hope, Be Happy, Bonjour Maestro—and evocative word associations—"Fate, Death, Hope, Soup, Shoes, Shelter, Strenght" and "Blind, Hope, Faith." The use of sequential imagery and words in his still photographs reflected the influence of filmmaking, but interest in both—words and sequences—were presaged in the books Frank began to make as an apprentice in Switzerland.

Frank turned his camera 180 degrees from urban scenes and strangers to his own life and environment. The intense scrutiny he once focused on others he shifted onto his family, friends, and himself. Like his earlier works, these are characterized by honesty. Writing about a photograph of Frank at age four, June Leaf described Robert as being "so well made for this world. That scowl, that indignation. 'What the fuck is going on here?' About to have a tantrum, because the heart is so strong."[45] Frank refuses to mask or shade what might be embarrassing, even deeply painful, to himself or his family.

Three of the most overtly painful collages are dedicated to his daughter Andrea. On *Andrea* (1975), the inscription reads, "for my daughter Andrea who died in an airplane crash at Tical in Guatemala on December 28 last year. She was 21 years and she lived in this house and I think of Andrea every DAY." The dedication is inscribed over photographs of Andrea, the house and land in Mabou. On *for Andrea* (February 1977), the text is simply, "for Andrea, April 21, 1954 - December 28, 1974." There are eight photographs of upended logs and telephone poles, totems against the vacant sky.

Frank's loss of Andrea and other friends is also expressed in *Sick of Goodbys* (1978), a vertical diptych. In the upper image, the sea's calm horizon is broken by an arm holding a small skeleton. This view is reflected in a mirror on which the words "Sick of" have been painted with a broad, runny brush. "Goodbys" appears on the same mirror in the lower image. A smaller framed mirror, reflecting empty space, leans against the larger glass. The piece refers to Frank's personal loss, but the viewer does not have to know its specific reference to Andrea to find the work compelling.

The photographs of June are personal but less chilling. Made with Ektacolor prints from the Lurecamera neg-

Robert Frank
Home Improvements, November 1983 - February 1984 / March 1985

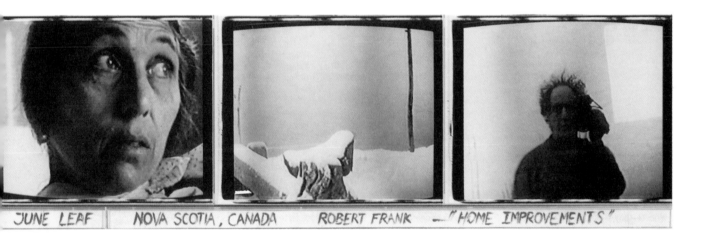

JUNE LEAF | NOVA SCOTIA, CANADA | ROBERT FRANK — "HOME IMPROVEMENTS"

atives, the collage *In Mabou / Wonderful time / with June* (summer 1977) shows June's arms, legs, breasts, and face as she lies naked on the beach. The inscription is on blue-lined paper pasted between the photographs. Frank characterizes his recent work as "trying to show my interior against the landscape I'm in." That landscape has primarily been the bleak, rolling hills of Nova Scotia and the low, open horizon of the sea beyond his door in Mabou, but it also includes his other residence, a loft on Bleecker Street in New York City. In these settings he creates tableaux by directing his subjects and constructing and arranging objects.

Frank frequently reiterates the importance of moving to Canada. For many years, New York kept him on an edge that he needed to walk in order to produce new work. But when he had exhausted his vision of what to photograph in New York and in himself, he moved to Nova Scotia. His production has greatly slowed, but it is steady. The new works are larger and more intricate than his earlier still photographs. They are perceived more clearly in exhibitions than on the printed page. The Polaroid composites range from sixteen by twenty inches to twenty-three by forty inches. Frequently the collages are unique; one with drawing and paint was created with June Leaf. Others are so complicated and difficult to print that he has been willing to make only very small editions. Or if the subject of the work is especially private, he limits the edition to one or two prints. He has sold some of the recent composites; others are not available for sale or publication.

In 1986, four books will be published about Frank and his work. Some misinformation about his life, photographs, and films will be amended. Frank is gracious about the effort but not always convinced it is necessary. One senses that he prefers his truths to others' facts.

[1] New York City, June 1985.

[2] Script book, *Me and My Brother.*

[3] Among those Frank had worked with in Switzerland was Michael Wolgensinger, who had studied with Hans Finsler at the Zurich School of Arts and Crafts. As a teacher and practicing photographer, Finsler influenced several generations of Swiss photographers to value precise description and order over subjective expression. He created highly structural images of objects that were cleanly lit, sharply focused, and conveyed texture, pattern, and form with great fidelity.

[4] Frank to Anne Tucker, New York, June 1985.

[5] While working for The Studio, Frank also photographed college campuses in St. Louis, Kansas City, and Boston for *Junior Bazaar.*

[6] While working at *Harper's Bazaar,* Frank had become familiar with the work of André Kertész. It's possible that Frank saw Kertész's photographs of the same chairs made a decade earlier. (This was the first and only picture story Frank ever sold to *Life* magazine.)

[7] "Very little . . . all this makes for a lot."

[8] Eleanor Munro, *Originals: American Women Artists,* Simon and Schuster, New York, 1979, p. 298.

[9] Munro, p. 298.

[10] Interview with Anne Tucker, July 1985.

[11] Interview October 17, 1985, videotape no. 39.

[12] Frank to Anne Tucker, June 1985.

[13] Interview October 15, 1985, videotape no. 28.

[14] Letter to his parents, March 1947.

[15] The six were Melvin Tucker, superintendent of the Pallizzio shoe factory; a fruit peddler; Connie Daliani, who worked at Plymouth Toy Co.; George, age five; Lena Kansler from Benny's luncheonette; and Mr. and Mrs. Feiertag.

[16] Unpublished introduction to the series.

[17] The European pictures have been dated incorrectly in various publications. Frank was in Spain in the summer of 1952, not 1950; in London in 1951 and the winter of 1952-53; and in Wales in March 1953, not 1952.

[18] Written on the back of an envelope mailed to Edward Steichen at the Museum of Modern Art.

[19] Frank may have been stimulated by W. Eugene Smith's photographs of Welsh miners, one of which was published in *Life,* February 20, 1950.

[20] Walker Evans and Robert Frank, "Walker Evans on Robert Frank / Robert Frank on Walker Evans," *Still/3,* Yale University, New Haven, 1971, p. 3.

[21] Interview, June 1985.

[22] Interview, October 17, 1985, videotape no. 41.

[23] Munro, p. 298.

[24] Frank has always captioned these photographs *Detroit,* not Dearborn.

[25] In various publications, Frank has set the number closer to 500, but there are contact sheets numbered 1-751 and a second series of numbers for the Democratic Convention.

[26] Ricardo Block letter to Anne Tucker, June 30, 1985.

[27] For the discussion on jukeboxes I am indebted to Vincent Lynch and Bill Henkin, *Jukebox: The Golden Age.* New York: Putnam Publishing, 1981.

[28] Mrs. Rosa Parks initiated the Alabama bus boycott only a month after Frank left the South.

[29] Winter 1955.

[30] "Book Review," *Infinity,* vol. 11 (September 1962), p. 13.

[31] "A Bookman's Notebook: Photo Coverage of the Ugly American," *San Francisco Chronicle,* January 27, 1960, p. 25.

[32] *U.S. Camera Annual, 1958,* U.S. Camera Publishing Corp., New York, 1957, p. 115.

[33] Interview, October 18, 1985, videotape no. 46.

[34] Tod Papageorge, *Walker Evans and Robert Frank: An Essay on Influence,* Yale University Art Gallery, New Haven, 1981. A richer comparison is found in Leslie Baier, "Visions of Fascination and Despair: The Relationship Between Walker Evans and Robert Frank," *Art Journal,* vol. 41, no. 1 (Spring 1981), pp. 55-63.

[35] Unpublished exhibition labels, Stanford University.

[36] Meyerowitz to Anne Tucker, December 1985.

[37] *Coney Island* and the *Bus* series.

[38] Edna Bennett, "Black and White Are the Colors of Robert Frank," *Aperture,* vol. 9, no. 1, p. 22.

[39] *Life* renewed publication in 1978.

[40] Interview, October 16, 1985, videotape no. 34.

[41] Letter to Edward Steichen, October 30, 1961.

[42] Letter to Grace Mayer, December 23, 1961.

[43] Evans and Frank, p. 3.

[44] In 1976 and 1977, he also used Ektacolor prints from Lurecamera negatives. The Lurecamera cost $5 and was sent back to the manufacturer for processing and new film. It pleased Frank to create with something most serious photographers regarded as a toy.

[45] Letter to Philip Brookman and Anne Tucker, June 1985.

ACKNOWLEDGMENTS

Anne W. Tucker and Philip Brookman

This catalogue and the exhibition it accompanies have been made possible through the generosity of the trustees of the Museum of Fine Arts, Houston. Support also has been received from Ford Motor Company Fund, Target Stores, Polaroid Corporation, and the National Endowment for the Arts. The photographs by Robert Frank in the museum's collection were purchased with grants from Target Stores, Charter Bank, and Mr. and Mrs. Jerry E. Finger; others were donated by P/K Associates. The video documentary accompanying the exhibition was made possible by generous grants from Gay Block and from Sidney L. Shlenker, because of his love and affection for Gay Block. For their hospitality, we would like to acknowledge Robert Frank and June Leaf, Gay Block, Alison Bond, and Evan Schwartz.

For sharing their extensive research, generous thanks are due Stuart Alexander and William S. Johnson. Additional research was provided by Claudia Beck; Anne Bushman; Ray Dudley Cashman, Jr.; John Gossage; John Simon Guggenheim Foundation; Beth Schlanger; Margaret Anne Boulware; Peter MacGill and Robert Burge, Pace/MacGill Gallery; Paul Schimmel, Newport Harbor Art Museum; Thomas W. Southall, Spencer Museum of Art, University of Kansas; Arthur Ollman, the Museum of Photographic Arts, San Diego; and Cynthia Read-Miller, Edison Institute, Dearborn, Michigan.

Personal insights about Robert Frank and his work were given by Emile de Antonio, Richard Bellamy, Ricardo Block, Sara Driver, Elliott Erwitt, Louis Faurer, Miles Forst, Pablo Frank, Ed Grazda, Ralph Gibson, Allen Ginsberg, Brian Graham, Walter Gutman, Raoul Hague, Jim Jarmusch, Sid Kaplan, June Leaf, Nathan Lyons, Grace Mayer, Cynthia Macadams, Jonas Mekas, Joel Meyerowitz, Peter MacGill, Duane Michals, Gunther Moses, Louis Silverstein, John Szarkowski, and Rudy Wurlitzer. The gift of their time and their patience is appreciated.

We are especially grateful to many individuals who answered our correspondence and allowed us to view their collections. The staffs of public collections which were engaged at length included Marni Sandweiss, Amon Carter Museum; David Travis, Nancy Hamel, and Clarissa Cutler Benson, the Art Institute of Chicago; Martha Langford, Sue Lagasi, and Martha Hanna, Canadian Museum of Contemporary Photography; James Enyeart and Terence Pitts, the Center for Creative Photography; Weston Naef and Gordon Baldwin, the J. Paul Getty Museum; John Szarkowski and Susan Kismaric, the Museum of Modern Art; James Borcoman, National Gallery of Canada; Martha Chahroudi, Philadelphia Museum of Art; Anita Mozley and Betsy Gates, Stanford University Museum of Art; and Van Deren Coke, San Francisco Museum of Modern Art. We would also like to thank staff members at the Akron Art Museum; the Detroit Institute of Arts; International Museum of Photography, the George Eastman House; International Center of Photography; the Metropolitan Museum of Art; the Minneapolis Institute of Arts; Museum of Contemporary Photography (Chicago); Museum of Fine Arts, Boston; National Museum of American Art; National Museum of American History; the Toledo Museum of Art; and Seattle Art Museum.

Private collectors and artists who offered assistance include Timothy Baum; Mary Frank; Robert Freidus; Morgan Garwood; Mr. and Mrs. Arthur Goldberg; Pierre Apraxine, Gilman Paper Company; Jay Manis; Richard Menschel; Toby and Lilyan Miller; Julie Pratt; Tennyson Schad; Joseph E. Seagram & Sons, Inc.; John C. Waddell; and Clark B. Winter, Jr., all of New York. Other collectors who gave generously of their time and resources include Manuel Bilsky; Jane Corkin; Evelyn Coutellier; G.H. Dalsheimer; Jeffrey Fraenkel; Ian Glennie and Fredericka Hunter; Gene Gary Gruver; Keith F. Davis; Hallmark Collections, Hallmark Cards; G. Ray Hawkins; Ernst Herzig; Mr. and Mrs. William A. Hogan; Thom Sempere, Joseph Monsen Collection; David Robinson; David C. Ruttenberg; Brent Sikkema; John Jasinski, the Southland Corporation; Andrew Szegedy-Maszak; Jo C. Tartt, Jr.; Mr and Mrs. Leonard Vernon; Maggie Weston and C. Russel Anderson; and Ed Wills and Melinda Blauvelt.

For making it possible to view Frank's films, we would like to thank Ralph McKay, the Museum of Fine Arts, Houston; and in New York: Sidney Geffen and Michael Silberman, Carnegie Hall Cinema; Ron Magliozi and Charles Silver, Film Study Center, the Museum of Modern Art; Fred Riedel, American Federation of the Arts; and Filmmakers Co-op.

We would like to thank the following persons for permission to reproduce in the catalogue works in their collection or images by them: Manuel Bilsky; Canadian Museum of Contemporary Photography; Louis Faurer; Robert Frank; June Leaf; the J. Paul Getty Museum; Jay Manis; Stanford University Museum of Art; and Weston Gallery. And thanks to the following for permission to reproduce articles or letters: Robert Frank; W. Eugene Smith Archive, the Center for Creative Photography; Robert Delpire; Hugh Edwards; John Hill and the estate of Walker Evans, the estate of Jack Kerouac and the Sterling Lord Agency, Inc.; Mary Frank; Ed Grazda; John Hanhardt and Whitney Museum of American Art; Ian Jeffrey; June Leaf; Jonas Mekas; Kazuhiko Motomura; Annamarie Schuh; Keith Smith; and the publishers of *Creative Camera* and *Popular Photography* magazines. Very special thanks to Robert Coles, Allen Ginsberg, and Peter C. Marzio for the essays written for this catalogue.

Special translations were done by Ralph Kaethner and Margaret Olvey, the Museum of Fine Arts, Houston; Setsuko Collum, Japan America Society of Houston; Jo Ann LeQuang, Goethe Institute, Houston; Bernard Brunon; and Brigitte P. Crull.

This exhibition would have been impossible without the support of Peter C. Marzio and the staff of the museum, in particular: David B. Warren, William G. Bradshaw, Margaret C. Skidmore, David L. Griffith, Edward B. Mayo, Charles Carroll, Robert P. Roman, Celeste M. Adams, Karen Bremer, Anne Lewis, Beth Schneider, and, most especially, Carla Carouthers, Kathryn L. Kelley, Ralph McKay, Elaine Mills, Margaret Olvey, and George T.M. Shackelford.

For catalogue production, special thanks to Arthur White for design; Barbara Michels and Anne Feltus for editing; Kathryn L. Kelley for production; Ed Grazda, Jim Sandall, and Shiftung für die photographie (Zurich) for reproduction prints; and Andrew Wylie and Alison Bond, literary agents. Special thanks to Terry Hackford at New York Graphic Society.

The museum coproduced a television program with KUHT/Channel 8 to accompany the exhibition. Thanks are due James L. Bauer, Steven Gray, Miriam Korshak and Paul Yeager of KUHT; Amy Brookman, Babette Mangolte, and Mark Daniels, production; Sam Edwards, Sidney Bartholomew, and Jonas Mekas of the Anthology Film Archive; and Matt Bullock of the Museum of Modern Art, technical assistance.

We would like to acknowledge colleagues from the museums on the exhibition's tour: Evan Turner and Thomas Hinson, Cleveland Museum of Art; T. Carroll Hartwell, Minneapolis Institute of Arts; Kathleen Gauss, Los Angeles County Museum of Art; and Constance Llewallen and Susan Teicholz, University Art Museum, Berkeley, California.

Personal thanks to Joe D. Wheeler and Amy Brookman.

Hello to Robert.

Checklist of the exhibition

All photographs are gelatin silver prints; exceptions are described below. Asterisks identify photographs which are illustrated in this catalogue. Image descriptions appear in brackets after the title and date.

There are many variant dates for Frank's photographs. The prints have been dated here in accordance with his chronology and early publications. The date of the negative is given following the title. If two dates have been published and neither can be verified, both have been listed separated by a slash [/]. If the print is not approximately contemporary with the negative, the date of the print is also given.

For photographs included in published or unpublished books, reproduction notations including page numbers follow each entry. For those images included in *The Americans*, the number refers to the sequence of the plates rather than the page number. Abbreviated book titles in the checklist refer to the full-length bibliographic entries listed below.

AMERICANS: *The Americans*. Introduction by Jack Kerouac. New York: Grove Press, 1959.

B/W/T: *Black White, and Things*. Book with original photographs, 1947-52. Edition of 3, 1952.

INDIENS: *Indiens pas morts*. Photographs by Werner Bischof, Robert Frank, and Pierre Verger. Text by Georges Arnaud. Paris: Robert Delpire, 1956.

LINES: *The Lines of My Hand*. New York: Lustrum Press, 1972. Distributed by Light Impressions, New York, 1972. Japanese edition: Tokyo: Yugensha, Kazuhiko Motomura, 1972. [page numbers in brackets]

NEUF: *Indiens des Hauts-Plateaux*. Text by Georges Arnaud. *Neuf*, no. 8 (December 1952), pp. 1-36.

PANTHEON: *Robert Frank*. Text by Robert Frank and Rudolph Wurlitzer. Collection Photo Poche, no. 10. Paris: Centre National de la Photographie avec le concours du Ministère de la Culture, 1983. Reprinted, New York: Pantheon, 1985.

PERU: *Peru*. Book with original photographs. Unique, 1948.

TODOLI: *Robert Frank: Fotografias/Films, 1948-1984*. Essays by Vicent Todoli, Jno Cook, and Martin Schaub. Collection Imagen, no. 2. Valencia, Spain: Sala Parpallo/Institucio Alfons el Magnanim, 1985.

*1. *On Boat to USA*. March 1947
[man looking off stern of ship]
Lent by Robert Frank, courtesy of Pace/MacGill Gallery, New York

*2. *New York*. 1947
[line of men along wall]
Printed 1947, inscribed 1977
Collection of Jay Manis, New York

3. *Macy's Parade, New York*. 1948
[figure hanging from balloon]
Lent by Robert Frank
B/W/T 25 (Things: Men of Air);
LINES 23 [20]

4. *34th Street, New York*. 1948/1951
[empty street, pedestrian approaching white stripe]
Collection of the Gilman Paper Company, New York
B/W/T 20 (White); LINES 20 [17];
PANTHEON 20

5. *New York*. 1948/1954
[legless man on dolly]
Collection of John C. Waddell, New York

6. *White Tower, 14th Street, New York*. 1949
[six girls in window]
Collection of the Museum of Modern Art, New York; Purchase

7. *San Genaro, New York*. 1949/1951
[festival lights above hand holding medals]
Printed 1970s
Collection of the Museum of Fine Arts, Houston; Gift of P/K Associates
B/W/T 23 (Things); LINES 24
[16-reversed]

8. *New York City*. 1951
[42nd St. marquees, hand with Bible, religious placard, flag]
Lent by Robert Frank, courtesy of Pace/MacGill Gallery, New York
LINES [15]

9. *George at noon*. August 1951
From photo essay, "People You Can't See"
[small boy on sidewalk]
Collection of Stanford University Museum of Art; Gift of Bowen H. McCoy

*10. *Peru*. 1948
[boy in doorway]
Printed 1970s
Courtesy of the Weston Gallery, Carmel, California
LINES 17 [12]; TODOLI 47

11. *Peru*. 1948
[lilies in back pack]
Cibachrome photograph from slide transparency, printed 1985
Lent by Robert Frank, courtesy of Pace/MacGill Gallery, New York

12. *Peru*. 1948
[billboard: El Ford 1949]
Collection of Andrew Hogan
LINES 19 [14]; TODOLI 45

13. *Peru*. 1948
[hand on shoulder]
Collection of the Center for Creative Photography, Tucson, Arizona
INDIENS 17; LINES 16 [11]; NEUF 34

14. *Peru*. 1948
Diptych
[heads and mountains]
Lent by Robert Frank
NEUF cover; PANTHEON 23; PERU cover; TODOLI 46

15. *Road to La Paz*. 1948
[truckload of people on road, mule and rider approach]
Printed 1969
Collection of Ernst Herzig, Toronto
INDIENS 12; LINES 18 [13]; NEUF 22;
PANTHEON 24; PERU 11; TODOLI 44

16. *Peru*. 1948
[boys waiting, sailors at attention]
Collection of Andrew Szegedy-Maszak, Middletown, Connecticut
PERU 31

17. *Mallorca*. 1952
[black chicken on doorstep]
Collection of John C. Waddell, New York

*18. *Valencia*. 1952
[bull with sword in neck]
Printed 1970s
Collection of the Museum of Fine Arts, Houston; Gift of P/K Associates

19. *Valencia*. 1952
[Pablo on wooden horse]
Printed later
Collection of Pablo Frank, New York
LINES 45 [43]; TODOLI 60

20. *Valencia*. 1952
[marching band]
Courtesy of Charles Isaacs, Philadelphia
B/W/T 1 (Black); LINES 40 [39];
TODOLI 62

21. *Mur de la Mort, Paris*. c. 1949
[trailer in parking lot]
Printed later
Collection of Rudolph Wurlitzer, New York

22. *Paris*. 1949/1952
[boys teasing horse]
Printed 1973
Lent by Robert Frank, courtesy of Pace/MacGill Gallery, New York
B/W/T 33 (Things); LINES 38 [35];
PANTHEON 6

23. *Paris*. 1951
[crowd around body]
Printed 1970s
Collection of Stanford University Museum of Art; Gift of Raymond B. Gary
PANTHEON 4

24. *Paris*. 1951
[child sitting on curb]
Printed 1978
Courtesy of Douglas Kenyon, Inc., Chicago
LINES 30 [28]

25. *Paris*. 1949/1952
[couple in bumper car]
Printed 1970s
Collection of the Museum of Fine Arts, Houston; Gift of P/K Associates
B/W/T 4 (Black); LINES 23;
PANTHEON 8; TODOLI 64

26. *Paris*. 1949
[flower cart seen through doorway]
Courtesy of Jane Corkin Gallery, Toronto

*27. *Paris*. 1949
[white flowers in cans on sidewalk]
Collection of the J. Paul Getty Museum, Santa Monica, California

28. *Paris*. c. 1949
[woman asleep on grass]
Collection of the Museum of Modern Art, New York; Gift of the photographer
LINES 29 [26]

29. *Paris*. 1949
[tulip held behind back]
Courtesy of Ursula Groper Associates, San Francisco
B/W/T 21 (Things); LINES 34 [31];
TODOLI 67

30. *Paris*. 1951
[nun buying flowers]
Printed 1970s
Collection of the Museum of Fine Arts, Houston; Gift of P/K Associates

31. *Champs Elysées, Paris.* November 11, 1952
[Armistice Day parade, men with flowers]
Printed 1970s
Collection of the Museum of Fine Arts, Houston; Gift of P/K Associates
LINES 28 [25]; TODOLI 65

32. *Paris.* 1952
[tulips in open suitcase]
Printed 1970s
Courtesy of Edwynn Houk Gallery, Chicago
LINES 36 [33, copyright page]

33. *Pour la fille.* January 21, 1980
[field of daisies]
Lent by Robert Frank, courtesy of Pace/MacGill Gallery, New York
TODOLI 164

*34. *London.* 1951/1952-53
[bankers passing winged statue]
Printed 1970s
Collection of the Museum of Fine Arts, Houston; Gift of P/K Associates

35. *London.* 1951/1952-53
[banker in crosswalk]
Printed 1960s
Lent by Robert Frank
LINES 48 [49]; TODOLI 69

36. *London.* 1951/1952-53
[bankers passing on sidewalk]
Printed 1960s
Lent by Robert Frank
LINES 48 [49]; TODOLI 70

37. *London.* 1951/1952-53
[banker in top hat on narrow street]
Printed 1960s
Lent by Robert Frank
LINES [48]; TODOLI 71

38. *London.* 1951/1952-53
[banker with newspaper behind him]
Printed 1970s
Lent by Robert Frank
LINES 48 [49]

39. *London.* 1952-53
[girl running past hearse]
Collection of the Museum of Modern Art, New York; Gift of the photographer
LINES 52 [51]; TODOLI 72

40. *London.* 1952-53
[street fiddler at night]
Printed 1970s
Collection of the Museum of Fine Arts, Houston; Gift of P/K Associates
LINES [47]; PANTHEON 7; TODOLI 50

41. *Caerau, Wales.* 1953
[children on coal slag heap]
Lent by Robert Frank, courtesy of Pace/MacGill Gallery, New York
PANTHEON 26

42. *Ben James, Caerau, Wales.* 1953
[drinking from cup]
Lent by Robert Frank, courtesy of Pace/MacGill Gallery, New York
LINES [44]; PANTHEON 25; TODOLI 51

43. *Wales.* 1953
[miners]
Lent by Robert Frank, courtesy of Pace/MacGill Gallery, New York
TODOLI 53

44. *Caerau, Wales.* 1953
[men against wall, in rain]
Printed 1973
Collection of Canadian Museum of Contemporary Photography, Ottawa
LINES 50 [45]

45. *London to New York.* 1953
[also titled: *Evening Before Arriving*; passengers on *Mauretania*]
Printed 1970
Collection of Ernst Herzig, Toronto
LINES 53 [52]; TODOLI 73

46. *Tatoo Parlor on Eighth Ave., New York.* 1951
[pictures of freaks and entertainers, including Arbus image]
Printed 1970s
Collection of Canadian Museum of Contemporary Photography, Ottawa
LINES 89 [86]; TODOLI 127

47. *Parade, Hoboken, New Jersey.* 1955/56
[flag, spectators at window]
Printed 1977
Collection of the Museum of Fine Arts, Houston; The Target Collection of American Photography
AMERICANS #1; LINES 60 [57], contact strip 91 [89]

48. *City Fathers, Hoboken, New Jersey.* 1954/55/56
Collection of the Museum of Fine Arts, Houston; The Target Collection of American Photography
AMERICANS #2; PANTHEON 33

49. *New York City.* 1955/56
[three gay men]
Printed 1977
Collection of the Museum of Fine Arts, Houston; Museum purchase
AMERICANS #12; LINES contact strip 90; PANTHEON 36

50. *Yom Kippur, East River, New York City.* 1955/56
Printed 1977
Collection of the Museum of Fine Arts, Houston; The Target Collection of American Photography
AMERICANS #16; LINES contact strip 90; PANTHEON 32

51. *Fourth of July, Jay, New York.* 1955
Printed c. 1969
Collection of Philadelphia Museum of Art; Purchased with funds given by Dorothy Norman
AMERICANS #17

52. *Westside, Bar, New York City.* 1955/56
Printed 1977
Collection of the Museum of Fine Arts, Houston; Museum purchase
AMERICANS #43

53. *Rodeo, New York City.* 1955/56
Printed 1977
Collection of the Museum of Fine Arts, Houston; Museum purchase with funds provided by Charter Bank and Mr. and Mrs. Jerry E. Finger
AMERICANS #65

54. *Cafe, Beaufort, South Carolina.* 1955
Printed 1977
Collection of the Museum of Fine Arts, Houston; Museum purchase with funds provided by Charter Bank and Mr. and Mrs. Jerry E. Finger
AMERICANS #22

55. *Funeral, St. Helena, South Carolina.* 1955
[man playing harmonica]
Printed 1977
Collection of the Museum of Fine Arts, Houston; Museum purchase with funds provided by Charter Bank and Mr. and Mrs. Jerry E. Finger
AMERICANS #4

56. *Charleston, South Carolina.* 1955
[black woman and white child]
Collection of Evelyn Coutellier, Moncton, New Brunswick, Canada
AMERICANS #13

57. *Restaurant, US 1 leaving Columbia, South Carolina.* 1955
[Oral Roberts on television]
Printed 1977
Collection of the Museum of Fine Arts, Houston; The Target Collection of American Photography
AMERICANS #45; LINES [contact strip 90]; PANTHEON 44

58. *Belle Isle, Detroit.* 1955
[family in convertible]
Printed 1977
Collection of the Museum of Fine Arts, Houston; The Target Collection of American Photography
AMERICANS #77

59. *Drive-in Movie, Detroit.* 1955
Printed 1973
Collection of Canadian Museum of Contemporary Photography, Ottawa
AMERICANS #46; LINES [contact strip 89]

*60. *Dearborn.* July 1955
[tall man waiting in bus line]
Lent by Robert Frank, courtesy of Pace/MacGill Gallery, New York

61. *River Rouge Ford Plant, Dearborn.* 1955
[man in goggles]
Printed 1970s
Lent by Robert Frank, courtesy of Pace/MacGill Gallery, New York

62. *River Rouge Ford Plant, Dearborn.* 1955
[car passing factory]
Printed 1970s
Lent by Robert Frank, courtesy of Pace/MacGill Gallery, New York

63. *River Rouge Ford Plant, Dearborn.* 1955
[two men talking in plant]
Printed 1970s
Lent by Robert Frank, courtesy of Pace/MacGill Gallery, New York

64. *Assembly Line, Detroit [Dearborn].* 1955
[looking down line]
Printed 1977
Collection of the Museum of Fine Arts, Houston; The Target Collection of American Photography
AMERICANS #50; LINES 71

65. *Detroit.* 1955
[Joan Crawford posters]
Collection of Dr. Arthur H. Rubinoff, Toronto
LINES 81 [78]; TODOLI 125

66. *Detroit Bus Depot.* 1955
[man with road map]
Printed 1970s
Collection of Stanford University Museum of Art; Gift of Raymond B. Gary

67. *Elevator, Miami Beach, Florida.* 1955
Printed 1977
Collection of the Museum of Fine Arts, Houston; The Target Collection of American Photography
AMERICANS #44; LINES contact strip 91 [87]

68. *U.S. Post Office, Paint Rock, Alabama.* 1955
Triptych
Collection of Mr. and Mrs. Clark B. Winter, Jr., New York
LINES 84-85 [81-82]

69. *Mississippi River, Baton Rouge, Louisiana.* 1955
Printed 1977
Collection of the Museum of Fine Arts, Houston; The Target Collection of American Photography
AMERICANS #47

70. *Trolley, New Orleans, Louisiana.* 1955
Printed 1960s
Lent by Robert Frank, courtesy of Pace/MacGill Gallery, New York
AMERICANS #18; LINES contact strip 90; PANTHEON 34

71. *Canal Street, New Orleans, Louisiana.* 1955
Printed c. 1969
Collection of Philadelphia Museum of Art; Purchased with funds provided by Dorothy Norman
AMERICANS #19; PANTHEON 35

(a). *Prudential Building, Houston.* 1955
Printed 1985
Lent by Robert Frank, courtesy of Pace/MacGill Gallery, New York
[Houston showing only]
LINES [80]

72. *U.S. 90 en route to Del Rio, Texas.* 1955
Printed 1977
Collection of the Museum of Fine Arts, Houston; Museum purchase with funds provided by Charter Bank and Mr. and Mrs. Jerry E. Finger
AMERICANS #83; TODOLI contact strip 86

73. *Car Accident, U.S. 66, Between Winslow and Flagstaff, Arizona.* 1955
Printed 1977
Collection of the Museum of Fine Arts, Houston; The Target Collection of American Photography
AMERICANS #35; LINES 82 [79, contact strip 88]

74. *U.S. 285, New Mexico.* 1955
Printed c. 1969
Collection of Philadelphia Museum of Art; Purchased with funds provided by Dorothy Norman
AMERICANS #36; LINES 83 [88]

75. *Bar, Gallup, New Mexico.* 1955
Printed 1977
Collection of the Museum of Fine Arts, Houston; The Target Collection of American Photography
AMERICANS #29; PANTHEON 43; TODOLI 118

76. *Pablo in Motel Room, Gallup, New Mexico.* 1955
Diptych
Collection of the J. Paul Getty Museum, Santa Monica, California
PANTHEON 19

*77. *Hoover Dam, Between Nevada and Arizona.* 1955
Printed later
Lent by Robert Frank, courtesy of Pace/MacGill Gallery, New York
LINES 80 [77]; PANTHEON 15; TODOLI 124

78. *Jehovah's Witness, Los Angeles.* 1955/1956
Printed 1977
Collection of the Museum of Fine Arts, Houston; The Target Collection of American Photography
AMERICANS #28; LINES [contact strip 90]

79. *Los Angeles.* 1955/56
Printed c. 1978
Collection of Canadian Museum of Contemporary Photography, Ottawa
AMERICANS #61; LINES [contact strip 88]; TODOLI 119

80. *Ranch Market, Hollywood.* 1955/56
Printed 1977
Collection of the Museum of Fine Arts, Houston; The Target Collection of American Photography
AMERICANS #14

81. *Movie Premiere, Hollywood.* 1955/56
[woman in white fur]
Printed 1977
Collection of the Museum of Fine Arts, Houston; Museum purchase with funds provided by Charter Bank and Mr. and Mrs. Jerry E. Finger
AMERICANS #9; LINES [contact strip 89]

82. *Movie Premiere, Hollywood.* 1955/56
[movie star and fans]
Printed 1977
Collection of the Museum of Fine Arts, Houston; The Target Collection of American Photography
AMERICANS #66

83. *St. Francis, Gas Station, and City Hall, Los Angeles.* 1955/56
Printed 1977
Collection of the Museum of Fine Arts, Houston; The Target Collection of American Photography
AMERICANS #48; TODOLI contact strip 86

84. *Covered Car, Long Beach, California.* 1955/56
Printed 1977
Collection of the Museum of Fine Arts, Houston; Museum purchase with funds provided by Charter Bank and Mr. and Mrs. Jerry E. Finger
AMERICANS #34; LINES contact strip 90 [87]

85. *Chinese Cemetery, San Francisco.* 1956
Printed 1977
Collection of the Museum of Fine Arts, Houston; The Target Collection of American Photography
AMERICANS #57

86. *San Francisco, California.* 1956
[couple on hillside]
Printed 1977
Collection of the Museum of Fine Arts, Houston; The Target Collection of American Photography
AMERICANS #72; LINES 73, contact strip 91; PANTHEON 41; TODOLI #115, contact strip 86

87. *City Hall, Reno, Nevada.* 1956
Printed 1977
Collection of the Museum of Fine Arts, Houston; Museum purchase with funds provided by Charter Bank and Mr. and Mrs. Jerry E. Finger
AMERICANS #81; LINES [contact strip 90]

88. *Idaho.* 1956
[teenagers leaning on car]
Printed 1970s
Lent by Robert Frank

89. *U.S. 91 Leaving Blackfoot, Idaho.* 1956
Printed 1977
Collection of the Museum of Fine Arts, Houston; Museum purchase
AMERICANS #32; LINES [contact strip 89]

90. *Luncheonette, Butte, Montana.* 1956
Printed 1977
Collection of the Museum of Fine Arts, Houston; The Target Collection of American Photography
AMERICANS #41

91. *View from Hotel Window, Butte, Montana.* 1956
Printed 1977
Collection of the Museum of Fine Arts, Houston; Museum purchase with funds provided by Charter Bank and Mr. and Mrs. Jerry E. Finger
AMERICANS #26; LINES 86 [83]

*92. *Political Rally, Chicago.* 1956
[tuba]
Printed 1970s
Lent by Robert Frank, courtesy of Pace/MacGill Gallery, New York
AMERICANS #58

93. *Convention Hall, Chicago.* 1956
Printed 1977
Collection of the Museum of Fine Arts, Houston; Museum purchase with funds provided by Charter Bank and Mr. and Mrs. Jerry E. Finger
AMERICANS #51

94. *Political Rally, Chicago.* 1956
[man with outstretched arms]
Printed 1977
Collection of the Museum of Fine Arts, Houston; The Target Collection of American Photography
AMERICANS #3

95. *Robert Kennedy, Democratic Convention, Chicago.* 1956
Courtesy of Edwynn Houk Gallery, Chicago
TODOLI 77

96. *Chicago.* 1956
Printed 1977
Collection of the Museum of Fine Arts, Houston; The Target Collection of American Photography
AMERICANS #79

97. *Indianapolis.* 1956
Collection of the Gilman Paper Company, New York
AMERICANS #82; PANTHEON 37

98. *Store Window, Washington, D.C., Inauguration Day.* 1957
Printed 1977
Collection of the Museum of Fine Arts, Houston; Museum purchase with funds provided by Charter Bank and Mr. and Mrs. Jerry E. Finger
AMERICANS #59; LINES 74 [71]

99. *The Americans.* 1955/56
Printed 1970s
[projection proofs including tuba, covered car]
Private collection

100. *The Americans.* 1955/56
Printed 1970s
[projection proofs including New Orleans trolley, Canal Street]
Private collection

101. *The Americans.* 1955/56
[projection proofs including flag and children, waitress and Santa Claus]
Printed 1970s
Private collection

102. *10th St., New York.* 1956
[Wanamakers fire onlookers]
Printed 1985
Lent by Robert Frank, courtesy of Pace/MacGill Gallery, New York

103. *Fourth of July, Coney Island.* 1958
[sleeper under white blanket, parachute jump]
Printed 1975
Collection of Canadian Museum of Contemporary Photography, Ottawa
LINES [97]

104. *Fourth of July, Coney Island.* 1958
[man asleep]
Collection of the Museum of Modern Art, New York; Purchase
LINES [95]

105. *Fourth of July, Coney Island.* 1958
[couple walking at water's edge]
Lent by Robert Frank, courtesy of Pace/MacGill Gallery, New York
LINES [98]

106. *Fourth of July, Coney Island.* 1958
[couple asleep]
Collection of Evelyn Coutellier, Moncton, New Brunswick, Canada
LINES 94 [96]

107. *Florida.* 1958
[light pole]
Printed 1970s
Courtesy of Pace/MacGill Gallery, New York
TODOLI 136

108. *Florida.* 1958
[woman asleep between cars on beach]
Private collection

109. *Daytona Beach.* 1958
[motorcyclist]
Collection of the Southland Corporation, Dallas
LINES 77 [74]

110. *Times Square.* 1959
[boys in convertible]
Printed 1970s
Collection of Stanford University Museum of Art; Gift of Bowen H. McCoy

111. *Chicago.* c. 1959
[Cadillac de Ville with fins on rooftop]
Courtesy of Pace/MacGill Gallery, New York

112. *New York.* 1961
[palm frond dropped from hearse]
Printed 1980s
Private collection
PANTHEON 13

113. *New York City.* 1961
[woman holding book *Listen to God*]
Courtesy of G.H. Dalsheimer Gallery, Baltimore
LINES 65 [62]; TODOLI 76

114. *Platt River, Tennessee.* 1961
[man and cow at riverside]
Printed 1970s
Courtesy of Benteler Galleries, Inc., Houston
LINES 79 [76]; TODOLI 134

115. *Teardrops, Brunswick, New Jersey.* 1964
Printed 1980s
Lent by Robert Frank, courtesy of Pace/MacGill Gallery, New York
PANTHEON 14; TODOLI 123

116. *Mary with Pablo.* 1951
[nursing]
Lent by Robert Frank
B/W/T 13 (White)

117. *Meyer Schapiro and Pablo, 23rd St., New York City.* c. 1953
Printed 1970s
Collection of Pablo Frank, New York

118. *Mary and Pablo,* c. 1953
[Mary holding Pablo]
Collection of Andrew Szegedy-Maszak, Middletown, Connecticut

*119. *Mary and Andrea, Third Ave., New York City.* 1956
Collection of the Museum of Fine Arts, Houston; Gift of P/K Associates

120. *New York City.* 1954
[old man and Pablo]
Printed 1970s
Collection of Pablo Frank, New York
LINES 56 [55]; PANTHEON 21; TODOLI 82

121. *Mary and Andrea, Long Island.* 1954
[viewing Italian statue]
Lent by Robert Frank, courtesy of Pace/MacGill Gallery, New York
LINES 56 [55]

122. *Mary, Provincetown.* 1958
[shadow across face]
Collection of Andrew Szegedy-Maszak, Middletown, Connecticut
LINES 57 [56]

123. *Pablo Sleeping.* c. 1958
Collection of Stanford University Museum of Art; Gift of Bowen H. McCoy

124. *Cape Cod.* 1962
[Pablo, flag, "Marilyn Dead"]
Courtesy of G.H. Dalsheimer Gallery, Baltimore
LINES 97; TODOLI 121

125. *Pablo.* March 1979
Collection of Pablo Frank, New York

126. *Allen Ginsberg.* c. 1956
Printed 1985
Lent by Robert Frank, courtesy of Pace/MacGill Gallery, New York

127. *Norman Mailer.* 1956/58
Printed c. 1970
Lent by Robert Frank
LINES 78 [75]

128. *Willem de Kooning.* c. 1961
Printed 1970s
Collection of the Museum of Fine Arts, Houston; Gift of P/K Associates
LINES 55 [54]

*129. *10th St. Painters.* 1950-60/1985
Collage: gelatin silver photographs and handwritten text
Private collection

130. *Delon and Monica Vitti, Rome.* 1961
Printed 1970s
Collection of Stanford University Museum of Art; Gift of Bowen H. McCoy

131. *Jack Kerouac in N.Y.C.* 1962
Courtesy of Timothy Baum, New York

*132. *Jack Kerouac.* c. 1962
Printed 1985
Lent by Robert Frank, courtesy of Pace/MacGill Gallery, New York

133. *Venice Film Festival.* 1962
[Japanese actor Toshiro Mifune]
Printed 1970s
Collection of The Museum of Fine Arts, Houston; Gift of P/K Associates
LINES 92 [93]; TODOLI 132

134. *Marvin Israel and Raoul Hague near Woodstock, New York.* 1964
Printed 1980s
Lent by Robert Frank, courtesy of Pace/MacGill Gallery, New York

135. *Giles Groulx: summer 1976; Sentimental Souvenir, May 1978.*
Collage: gelatin silver and Lurecamera photographs, handwritten text; assembled 1985
Lent by Robert Frank, courtesy of Pace/MacGill Gallery, New York

136. *Self-portrait in Mabou.* August 1979
Vertical triptych
Courtesy of G.H. Dalsheimer Gallery, Baltimore
TODOLI 162

137. Untitled from *Bus* series. 1959
[man crossing street between two buses]
Courtesy of G.H. Dalsheimer Gallery, Baltimore
LINES 101 [104]; TODOLI 141

138. Untitled from *Bus* series. 1959
[hand out of window]
Courtesy of G.H. Dalsheimer Gallery, Baltimore
LINES 98 [101]

139. Untitled from *Bus* series. 1959
[sidewalk vendor with toys]
Courtesy of G.H. Dalsheimer Gallery, Baltimore
LINES 98 [101]; TODOLI 143

140. Untitled from *Bus* series. 1959
[mother and two children]
Courtesy of G.H. Dalsheimer Gallery, Baltimore
LINES 99; TODOLI 14

141. Untitled from *Bus* series. 1959
[man in back of truck]
Courtesy of G.H. Dalsheimer Gallery, Baltimore
LINES 99 [102]; TODOLI 144

142. Untitled from *Bus* series. 1959
[couple in exaggerated greeting]
Courtesy of G.H. Dalsheimer Gallery, Baltimore

143. Untitled from *Bus* series. 1959
[hand to head, inside bus; figure on sidewalk]
Collection of Stanford University Museum of Art; Gift of Raymond B. Gary

144. *Pull My Daisy.* 1959
Vertical diptych
Lent by Robert Frank
PANTHEON 46

145. *Pull My Daisy.* 1959
Seven film strips, with inscription
Printed 1980s
Lent by Robert Frank, courtesy of Pace/MacGill Gallery, New York
AMERICANS 1969 edition, unpaginated; LINES 104-05 [106]; TODOLI 146-47

146. *The Sin of Jesus.* 1960
Nine film strips
Printed 1969
Collection of the Museum of Fine Arts, Houston; The Target Collection of American Photography
AMERICANS 1969 edition, variant, unpaginated

147. *Me and My Brother.* 1965-1968
Five film strips, printed c. 1969
Collection of Philadelphia Museum of Art; Purchased with funds provided by Dorothy Norman
PANTHEON 48

148. *Cocksucker Blues.* 1972
Vertical triptych
[Mick Jagger and Keith Richards]
Lent by Robert Frank, courtesy of Pace/MacGill Gallery, New York
PANTHEON 49; TODOLI 151

149. *Exile on Main Street.* 1971
Collage: gelatin silver photographs, paint
Collection of Canadian Museum of Contemporary Photography, Ottawa

150. *Exile on Main Street.* 1972
Letterpress and offset record cover
Collection of the Museum of Fine Arts, Houston; Museum purchase

151. *Good bye Mr. Brodovitch, I am Leaving New York.* December 23, 1971
Sixteen film strips
Collection of Canadian Museum of Contemporary Photography, Ottawa
TODOLI 152

(b). *Isn't it Wonderful Just To Be Alive.* 1971
Collage: gelatin silver photographs, masking tape, handwritten text
Collection of Canadian Museum of Contemporary Photography, Ottawa
[Houston showing only]
LINES 112-13; TODOLI 155

152. *Mabou.* 1974
Collage: Ektacolor photographs, roofing paper, press board
Lent by Robert Frank, courtesy of Pace/MacGill Gallery, New York

(c). *Andrea.* 1975
Collage: Ektacolor photographs, handwritten text, paint
Lent by Robert Frank
[Houston showing only]

(d). *Mabou Coal Mines, Landscape.* Winter 1976
In collaboration with June Leaf
Collage: Ektacolor, Lurecamera photographs, printed text, paint
Collection of Canadian Museum of Contemporary Photography, Ottawa
[Houston showing only]

(e). *A Monument to Electricity + Photography.* 1976
Collage: Ektacolor photographs
Collection of Canadian Museum of Contemporary Photography, Ottawa
[Houston showing only]

(f). *In Mabou / Wonderful Time / with June.* Summer 1977
Collage: Ektacolor, Lurecamera photographs, handwritten text
Collection of Canadian Museum of Contemporary Photography, Ottawa
[Houston showing only]

153. Guide print for *The Fire Below,* c. 1978
Collage: Black-and-white Polaroid photographs, paint, tape, ink
Lent by Robert Frank, courtesy of Pace/MacGill Gallery, New York

(g). *For Andrea Who Died 1954-1974.* 1977
Collage: Black-and-white Polaroid photographs, handwritten text
Lent by Robert Frank
[Houston showing only]

154. *Words, Nova Scotia.* 1977
Collection of Canadian Museum of Contemporary Photography, Ottawa
Variants: TODOLI 157; MFA, H 3

155. *Mabou Winter Footage.* 1977
Lent by Robert Frank, courtesy of Pace/MacGill Gallery, New York
PANTHEON 52

156. *Bad Dream, Venice + Los Angeles, California.* March 28, 1978
Lent by Robert Frank, courtesy of Pace/MacGill Gallery, New York
PANTHEON 57; TODOLI 160

*157. *Sick of Goodbys.* November 1978
Collection of the Museum of Fine Arts, Houston; Gift of the photographer
PANTHEON 56; TODOLI 156

*158. *Halifax Infirmary.* 1978
Photograph with text, paint
Courtesy of G.H. Dalsheimer Gallery, Baltimore

159. *4 am Make Love to Me, Brattleboro, Vermont.* 1979
Lent by Robert Frank, courtesy of Pace/MacGill Gallery, New York
PANTHEON 60

160. *Amherst - Brattleboro.* 1979
Lent by Robert Frank, courtesy of Pace/MacGill Gallery, New York
TODOLI 161

161. *Lookout for Hope, New York - Mabou.* 1979
Lent by Robert Frank, courtesy of Pace/MacGill Gallery, New York
PANTHEON 58

162. *Be Happy, Mabou.* New Year's Day, 1981
Lent by Robert Frank, courtesy of Pace/MacGill Gallery, New York
PANTHEON 63; TODOLI 163

163. *Mabou Storm.* New Year's Day, 1981
Collection of Jo C. Tartt, Jr., Washington, D.C.
PANTHEON 53; TODOLI 165

164. *Blind Love Faith.* Mabou, 1981
Lent by Robert Frank, courtesy of Pace/MacGill Gallery, New York

*165. *Home Improvements.*
Video: November 1983-February 1984
Negatives: March 1985; assembled 1985
Five 20 x 24 Polaroid photographs, handwritten text
Private collection

Books

166. *40 Fotos.* 1943-47
Book of original photographs, constructed 1947
Lent by Robert Frank

167. *Peru.* 1948
Book of original photographs, dedicated to Mr. Brodovitch
Lent by Joel Meyerowitz, New York; Courtesy of the Museum of Modern Art, New York

168. *Black, White and Things.* 1947-52
Book of original photographs, constructed 1952
Dedicated to Mr. Steichen
Collection of the Museum of Modern Art, New York; Gift of Edward Steichen

169. *Paris.* 1949
Book of original photographs and text
Lent by Mary Frank

170. *Indiens Pas Morts.*
Photographs by Werner Bischof, Robert Frank, and Pierre Verger.
Text by Georges Arnaud.
Paris: Robert Delpire, 1956.
Collection of Evelyn Coutellier, Moncton, New Brunswick, Canada

171. *The Americans.* c. 1957
Original maquette
Collection of the Museum of Fine Arts, Houston; The Target Collection of American Photography

172. *Les Américains*
Edited by Alain Bosquet
Paris: Robert Delpire, 1958
Collection of Evelyn Coutellier, Moncton, New Brunswick, Canada

173. *The Americans*
Introduction by Jack Kerouac
Millerton, New York: An Aperture Book, Grossman Publishers, 1969
Private collection

174. *Zero Mostel Reads a Book*
New York: The New York Times, Inc., 1963
Collection of Evelyn Coutellier, Moncton, New Brunswick, Canada

*175. *Me and My Brother*
1965-66
Script with original photographs, constructed c. 1968
Lent by Robert Frank

176. *The Lines of My Hand.* c. 1970
Original maquette
Lent by Robert Frank

177. *The Lines of My Hand*
Tokyo: Yugensha, Kazuhiko Motomura, 1972
Private collection

178. *The Lines of My Hand*
New York: Lustrum Press, distributed by Light Impressions, Rochester, New York, 1972
Private Collection

Films

179. *Pull My Daisy*
G-String Productions, 1959
16mm, black and white, 28 minutes
Adapted, photographed, and directed: Robert Frank, Alfred Leslie
Script: based on the third act of the play, *The Beat Generation,* by Jack Kerouac
Narration, written and improvised: Jack Kerouac
Editors: Leon Prochnik, Robert Frank, Alfred Leslie
Music, composed and conducted: David Amram
Musicians: David Amram, Sahib Shahab, Arthur Phipps, Babs Gonzales, Jane Taylor, Al Harewood, Midhat Serbagi, Ronnie Roseman
Song: "The Crazy Daisy," lyrics by Allen Ginsberg, Jack Kerouac; sung by Anita Ellis
Still photographer: John Cohen
Cast: Richard Bellamy (Bishop); Allen Ginsberg and Peter Orlovsky (themselves); Gregory Corso (Jack Kerouac); Larry Rivers (Milo); Delphine Seyrig (Beltiane, Milo's wife); David Amram (Mez McGillicuddy); Alice Neel (Bishop's mother); Sally Gross (Bishop's sister); Denise Parker (girl in bed); Pablo Frank (little boy)
Collection of the Museum of Fine Arts, Houston

(h). *The Sin of Jesus*
An Off-Broadway Production, 1961
35mm, black and white, 40 minutes
Director: Robert Frank
Producer: Walter Gutman
Camera: Gert Berliner
Script: based on the story by Isaac Babel
Editors: Robert Frank, Ken Collins
Music: Morton Feldman
Cast: Julie Bovasso, John Coe, Roberts Blossom, St. George Brian, Telly Savalas
Lent by Robert Frank
[Houston showing only]

(i). *O.K. End Here*
September 20 Productions, 1963
35mm, black and white, 30 minutes
Director: Robert Frank
Producer: Edwin Gregson
Camera: Gert Berliner
Script: Marion Magid
Editor: Aram Avakian
Cast: Martino La Salle (man); Sue Ungaro (woman); Sudie Bond (woman in restaurant); Anita Ellis (former mistress); Joseph Bird (her husband)
Lent by Robert Frank
[Houston showing only]

180. *Me and My Brother*
Two Faces Company, 1965-68
35mm, black and white and color, 91 minutes
Director: Robert Frank
Producer: Helen Silverstein
Script: Robert Frank, Sam Shepard
Photography: Robert Frank
Editors: Robert Frank, Helen Silverstein, Bob Easton, Lynn Ratener
Cast: Julius Orlovsky (himself); Joseph Chaikin (Julius Orlovsky); John Coe (psychiatrist); Allen Ginsberg and Peter Orlovsky (themselves); Virginia Kiser (social worker); Nancy Fish (herself); Cynthia McAdams (actress); Roscoe Lee Browne (photographer); Seth Allen, Maria Tucci, Jack Greenbaum, Christopher Walken, Beth Porter, Fred Ainsworth, Richard Orzel, Philippe LaPrelle, Otis Young, Gregory Corso, Sully Boyar, Joel Press, Louis Waldon
Collection of the Museum of Fine Arts, Houston

181. *Conversations in Vermont*
Dilexi Foundation, 1969
16mm, black and white, 26 minutes
Producer, director, editor, sound, and script: Robert Frank
Camera: Ralph Gibson
Funded by Dilexi Foundation
Cast: Robert Frank, Andrea Frank, Pablo Frank, and students at school in Vermont
Collection of the Museum of Fine Arts, Houston

182. *Life-raft Earth*
Portola Institute, 1969
16mm, black and white, 37 minutes
Documentary made by Robert Frank, assisted by Danny Lyon
Producers: Hugh Romney, Stewart Brand
A documentary of an event called the Hunger Show that took place October 11-18, 1969 in a Hayward, California parking lot
Collection of the Museum of Fine Arts, Houston

183. *About Me: A Musical.* 1971
16mm, black and white, 35 minutes
Writer, producer, director: Robert Frank
Picture: Danny Seymour
Sound: Robert McNamara
Assistants: Rhetta Barron, Danny Lyon, Ralph Gibson
Cast: Lynn Reyner, Jaime deCarlo Lotts, Robert Schlee, Sheila Pavlo, Bill Hart, Vera Cochran, Sidney Kaplan, June Leaf, Allen Ginsberg, and others
Collection of the Museum of Fine Arts, Houston

(j). *Cocksucker Blues*
A Rolling Stones Presentation, 1972
16mm, black and white and color, 90 minutes
Director: Robert Frank
Producer: Marshall Chess
Camera: Robert Frank, Danny Seymour
Editors: Robert Frank, Paul Justman, Susan Steinberg
Sound: Danny Seymour, "Flex"
Financed by the Rolling Stones
Lent by Robert Frank
[Houston showing only]

184. *Keep Busy.* 1975
16mm, black and white, 38 minutes
Director, camera: Robert Frank
Script: Rudy Wurlitzer
Sound: Charles Dean
Cast: June Leaf, Joan Jonas, Richard Serra, Joanne Akolitis
Collection of the Museum of Fine Arts, Houston

185. *Life Dances On....* 1980
16mm, black and white and color, 30 minutes
Producer, director: Robert Frank
Films and recorded: Gary Hill, Danny Seymour, Robert Frank
Editor: Gary Hill
Cast: Pablo Frank, Sandy Strawbridge, Marty Greenbaum, Billy, Finley Fryer, and others
Collection of the Museum of Fine Arts, Houston

186. *Energy and How to Get It*
Robert Frank, Gary Hill, Rudy Wurlitzer, 1981
16mm, black and white, 28 minutes
Producer, director: Robert Frank
Script: Rudy Wurlitzer
Camera: Robert Frank, Gary Hill
Sound: Leanne Ungeer, John Knoop
Production Assistants: Betsy Green, Adrian Poulis
Editor: Gary Hill
Cast: William Burroughs, R. Dowdney, Rudy Wurlitzer, Robert Golka, Agnes Moon, John Giorno, Lynne Adams, Alan Moyle, Dr. John, Libby Titus
Funded by the Corporation for Public Broadcasting as part of its Independent Anthropology Film Series
Collection of the Museum of Fine Arts, Houston

187. *This Song for Jack.* 1983
16mm, black and white, 30 minutes
A film by Robert Frank, based on footage Frank shot at "On the Road: The Jack Kerouac Conference," held at Naropa Institute, Boulder, Colorado, July 23 - August 1, 1982
Collection of the Museum of Fine Arts, Houston

188. *Home Improvements.* 1984-85
1/2-inch video by Robert Frank taped in New York and Nova Scotia, 29 minutes, 20 seconds
Footage shot November 1983 - March 1984; final editing March 1985
Lent by Robert Frank

SELECTED BIBLIOGRAPHY

by Stuart Alexander

Articles published in this catalogue and unique books included in the checklist are not cited here. For more complete bibliographic information, refer to *Robert Frank: A Bibliography, Filmography, and Exhibition Chronology, 1946-1985*, by Stuart Alexander. To be copublished by the Center for Creative Photography, Tucson, Arizona and the Museum of Fine Arts, Houston. The bibliography contains more than 2,200 references, with annotations, quotations, and excerpts.

BOOKS

Indiens pas morts. Photographies de Werner Bischof, Robert Frank, et Pierre Verger. Texte de Georges Arnaud. Légendes de Manuel Tuñon de Lara. Paris: Robert Delpire, 1956. [172 pp. 14 b&w by Frank, 13 b&w by Bischof, and 50 b&w by Verger] Also published as *From Incas to Indios*. New York: Universe Books, 1956; *Incas to Indians*. London: Photography Magazine, 1956; *Indios*. Zurich: Manesse, 1956; *Dagli Incas agli Indios*. Milan: Feltrinelli, 1957; *Alto Peru, El gran Imperio de los Incas*. Barcelona: Artco, Ediciones de Arte y Color, 1959.

Les Américains. Photographies de Robert Frank. Textes Réunis et Présentés par Alain Bosquet. Encyclopédie Essentielle, no. 5, Série Histoire, no. 3. Paris: Robert Delpire, 1958. [175 pp. 83 b&w]

Gli Americani. Testi raccolti e presentati da Alain Bosquet e Raffaele Crovi. Fotografie di Robert Frank. Specchio del mondo 5. Sezione storia no. 3, Milan: Il Saggiatore, 1959. [181 pp. 83 b&w]

The Americans. Photographs by Robert Frank. Introduction by Jack Kerouac. New York: Grove Press, 1959. [178 pp. 83 b&w]

New York Is. Photographs by Robert Frank. Introduction by Gilbert Millstein. New York: The New York Times, ca. 1959. [56 pp. 24 b&w]

Pull My Daisy. Text ad-libbed by Jack Kerouac for the film by Robert Frank and Alfred Leslie. Introduction by Jerry Tallmer. New York: Grove Press, 1961. [72 pp. Based on the film *Pull My Daisy*. 49 b&w frame enlargements from the film. 7 b&w by John Cohen made during filming of the movie.]

Zero Mostel Reads a Book. Photographs by Robert Frank. New York: The New York Times, Inc., 1963. [44 pp. 37 b&w]

The Americans. Photographs by Robert Frank. Introduction by Jack Kerouac. Revised and enlarged edition. New York: An Aperture Book, Museum of Modern Art Edition, 1968. [188 pp. 83 b&w. Also: New York: An Aperture Book, Grossman Publishers, 1969. Identical to above.]

Frank, Robert. *The Lines of My Hand*. Tokyo: Yugensha, Kazuhiko Motomura, 1972. [119 pp. plus 30 pp. booklet insert in Japanese. 128 b&w]

Frank, Robert. *The Lines of My Hand*. New York: Lustrum Press. Distributed by Light Impressions, Rochester, N.Y., 1972. [112 pp. 113 b&w]

Robert Frank. Introduction by Rudolph Wurlitzer. The Aperture History of Photography Series, no. 2. Millerton, N.Y.: Aperture, 1976. [96 pp. 45 b&w. Published simultaneously in London by Gordon Fraser Gallery, Ltd. and in French translation in Paris by Nouvel Observateur/ Delpire.]

The Americans. Photographs by Robert Frank. Introduction by Jack Kerouac. Revised edition Millerton, N.Y.: An Aperture Monograph, and London: Gordon Fraser Gallery, Ltd., 1978. [181 pp. 84 b&w]

Robert Frank. Textes de Robert Frank et Rudolph Wurlitzer. Collection Photo Poche, no. 10. Paris: Centre National de la Photographie avec le concours du Ministère de la Culture, 1983. [142 pp. 63 b&w] Also published by Pantheon Photo Library. New York: Pantheon, 1985.

BOOK REVIEWS

LES AMÉRICAINS/THE AMERICANS, 1958 and 1959 editions

G[asser], M[anuel]. "Kritisches zu zwolf neuen Photobüchern: Reportagen." *Du* 19:3 (March 1959), pp. 80, 82.

[White, Minor]. "Book Reviews: Les Américains." *Aperture* 7:3 (1959 [actually issued 1960]), p. 127.

Millstein, Gilbert. "In Each a Self-Portrait." *The New York Times Book Review*, January 17, 1960, p. 7.

Caulfield, Patricia. "New Photo Books: The Americans." *Modern Photography* 24:6 (June 1960), pp. 32-33.

Lambeth, Michel. "Books Reviewed: The Americans." *Canadian Forum* 40:475 (August 1960), p. 120.

Gutierrez, Donald. "Books: The Unhappy Many." *Dissent* 8:4 (Autumn 1961), pp. 515-16.

THE AMERICANS, 1968 and 1969 editions

Coleman, A.D. "Latent Image: Robert Frank." *Village Voice* 14:29, May 1, 1969, p. 13.

Richard, Paul. "Americans—Without Tricks." *The Washington Post*, May 19, 1969, sec. B, p. 5.

Scarborough, John. "From Nature in the Raw to Life in the Raw." *Houston Chronicle*, June 8, 1969, "Zest" sec., p. 11.

Crane, Arnold H. "For the Photography Collector." *Chicago Daily News*, July 12, 1969, "Panorama" sec., p. 9.

Gibson, Ralph. "Books: The Americans." *Artforum* 8:9 (May 1970), p. 92.

THE LINES OF MY HAND, 1972

Coleman, A.D. "Latent Image: Where Death Is at Home." *Village Voice* 17:32, August 10, 1972, p. 21.

Thornton, Gene. "Photography: Robert Frank's Dilemma." *The New York Times*, August 20, 1972, sec. 2, p. 13.

Schwartz, Sanford. "Still, Photography." *The New York Times Book Review*, December 3, 1972, pp. 4-5, 16, 20, 24.

Kernan, Margot. "Writing with Light." *The Washington Post Book World*, December 3, 1972, pp. 6-7.

S[cully], J[ulia]. "Books in Review." *Modern Photography* 37:1 (January 1973), p. 46.

Hagen, Charles. "Robert Frank: Seeing Through the Pain." *Afterimage* 1:5 (February 1973), pp. 1, 4-5.

Jeffrey, Ian. "Robert Frank: An Appreciation." *The Photographic Journal* 113:7 (July 1973), pp. 347, 349.

THE AMERICANS, 1978

Davis, Douglas. "Photography: Return of a Classic." *Newsweek* 92:23 (December 4, 1978), pp. 104, 109.

Goldberg, Vicki. "Book Bits." *American Photographer* 2:4 (April 1979), p. 82.

Schofield, Jack. "Book Reviews." *The Photographic Journal* 119:7 (November 1979), p. 352.

ROBERT FRANK, 1983

Roegiers, Patrick. "Robert Frank: L'Observateur Solidaire." *Révolution* (Paris), no. 202 (January 13-19, 1984), pp. 28-31.

B[oone], D[aniele]. "Robert Frank." *Le Journal des Cahiers du Cinéma*, no. 40, on p. 13 of this insert between pp. 34 and 35 of *Cahiers du Cinéma*, no. 356 (February 1984).

BOOKS THAT INCLUDE FRANK

"Robert Frank: Story of a Welsh Miner." *U.S. Camera 1955*. Edited by Tom Maloney. New York: U.S. Camera, 1954. [Photographic essay by Frank on pp. 82-93.]

The Family of Man. Edited and with an introduction by Edward Steichen. Prologue by Carl Sandburg. New York: Maco Magazine Corporation for the Museum of Modern Art, 1955. [7 b&w, pp. 20, 21, 91, 143, 145, 151, 155]

Photographers on Photography: A Critical Anthology. Edited by Nathan Lyons. Englewood Cliffs, N.J.: Prentice-Hall in collaboration with the George Eastman House, Rochester, N.Y., 1966, pp. 66-67, 182.

Evans, Walker. "Photography." *Quality: Its Image in the Arts*, edited by Louis Kronenberger. Conceived and produced by Marshall Lee. New York: Balance House, Atheneum, 1969, pp. 169-211.

Film Culture Reader. Edited with an introduction by P. Adams Sitney. New York: Praeger Publishers, 1970. [Frank mentioned throughout.]

"Walker Evans on Robert Frank/Robert Frank on Walker Evans." *Still/3.* New Haven: Yale University, 1971, pp. 2-6.

Robert Frank: "The Lines of My Hand," on pp. 130-38 and Kernan, Sean. "Uneasy Words While Waiting: Robert Frank," on pp. 139-45. *U. S. Camera/Camera 35 Annual: America: Photographic Statements.* Edited by Jim Hughes. New York: the American Express Publishing Corp., 1972.

Mekas, Jonas. *Movie Journal: The Rise of the New American Cinema, 1959-1971.* New York: Macmillan, 1972. Also published in paperbound edition by Collier Books, New York, 1972, with identical pagination.

Greenfield, Robert. *S.T.P.: A Journey Through America with the Rolling Stones.* New York: Saturday Review Press/E.P. Dutton & Co., 1974.

The Snapshot. Edited with an introduction by Jonathan Green. Millerton, New York: Aperture, 1974, pp. 120-23.[Also published as special issue of Aperture.]

"Robert Frank: Photographs from London and Wales, 1951." [Portfolio of prints reproduced] *Creative Camera International Yearbook 1975.* Edited by Colin Osman and Peter Turner. London: Coo Press Ltd., 1974.

Photography Within the Humanities. Edited by Eugenia Parry Janis and Wendy MacNeil. Danbury, N.H.: Addison House Publishers and Wellesley, Mass.: Art Department, Jewett Arts Center, Wellesley College, 1977, pp. 52-65.

Autobiography: Film/Video/Photography. Edited by John Stuart Katz. Toronto: Art Gallery of Ontario, 1978, pp. 13, 20-28, 46-47.

Photography: Current Perspectives. Edited by Jerome Liebling. Rochester, N.Y.: The Massachusetts Review, Inc. and Light Impressions Corp., 1978, pp. 10, 138-45, 224-28, 253. Also published as special issue of *The Massachusetts Review* with different pagination.

EXHIBITION CATALOGUES

Robert Frank: Werkverzeichnis. Texts by Willy Rotzler and Robert Frank. Zurich: Stiftung für die Photographie im Kunsthaus Zurich, 1976. [20 pp.]

Szarkowski, John. *Mirrors and Windows: American Photography since 1960.* New York: The Museum of Modern Art. Distributed by New York Graphic Society, Boston, 1978. [Frank discussed pp. 16-20, 23 although not included in exhibition]

Robert Frank: An Exhibition of Photography and Films, 1945-1977. Introduction by Philip Brookman. Santa Cruz, Calif.: Mary Porter Sesnon Art Gallery, College V, University of California, Santa Cruz, 1978. [20 pp.]

Brookman, Philip. *Robert Frank: Photographer/Film-Maker, Works from 1945-1979.* Preface and acknowledgments by Nancy Drew and Russell J. Moore. Essay by Philip Brookman. Long Beach, Calif.: Long Beach Museum of Art, 1979. [12 pp.]

Gee, Helen. *Photography of the Fifties: An American Perspective.* Foreword by James L. Enyeart. Tucson, Arizona: Center for Creative Photography, University of Arizona, 1980. [pp. 18-19, 156-61; reprinted in hardcover in 1983]

Robert Frank: Photographs. Essay by Peter Turner. London: Institute of Contemporary Art, 1980. [4 pp.]

Papageorge, Tod. *Walker Evans and Robert Frank: An Essay on Influence.* New Haven, Conn.: Yale University Art Gallery, 1981. [62 pp.]

Robert Frank: Fotografias/Films, 1948-1984. Essays by Vicent Todoli, Jno Cook, and Martin Schaub. Collecion Imagen, no. 2. Valencia, Spain: Sala Parpallo/Institucio Alfons el Magnanim, 1985. [175 pp.]

Robert Frank: Sobre Valencia, 1950. Valencia, Spain: Sala Parpallo/Institucio Alfons el Magnanim, 1985. [36 pp.]

Robert Frank and American Politics. Introduction by Barbara Tannenbaum. Essay by David B. Cooper. Akron, Ohio: Akron Art Museum, 1985. [16 b&w, 28 pp.]

FILM REVIEWS

PULL MY DAISY

Selz, Thalia. "Film Reviews: The Beat Generation." *Film Quarterly* 13:1 (Fall 1959), pp. 54-56.

"Show Business: Endsville: Zen-Hur." *Time* 74:24 (December 14, 1959), p. 66.

MacDonald, Dwight. "Films: Amateurs and Pros." *Esquire* 53:4 (April 1960), pp. 26, 28, 32.

Knight, Arthur. "The Far Out Films." *Playboy* 7:4 (April 1960), pp. 42-44, 46, 50, 58, 85.

Crowther, Bosley. "Our Own 'New Wave': Local Film Makers Give Promise of More." *The New York Times*, April 10, 1960, sec. 2, p. 1.

Mekas, Jonas. "Cinema of the New Generation." *Film Culture*, no. 21 (Summer 1960), pp. 1-20.

Tyler, Parker. "For 'Shadows' Against 'Pull My Daisy.'" *Film Culture*, no. 24 (Spring 1962), pp. 28-33.

Leslie, Alfred. "'Daisy': 10 Years Later." *Village Voice* 14:7, November 28, 1968, p. 54.

THE SIN OF JESUS

Miller, Jonathan. "The Sin of Jesus." *Sight & Sound* 30:4 (Autumn 1961), p. 198.

Macdonald, Dwight. "Films: Re-viewing and Reviewing, Two of Yesterday's and Two of the Day's." *Esquire* 56:5 (November 1961), pp. 56, 58, 62-63.

Loetscher, Hugo. "Die Filme Robert Franks." *Du* 22:1 (January 1962), pp. 33-36.

Sitney, P. Adams. "'The Sin of Jesus' & 'The Flower Thief.'" *Film Culture*, no. 25 (Summer 1962), pp. 30-33.

CHAPPAQUA

Frank, Robert. "Films: Entertainment Shacked up with Art." *Artsmagazine* 41:5 (March 1967), p. 23.

Shainberg, Lawrence. "Notes from the Underground." *Evergreen Review*, no. 50 (December 1967), pp. 22-25, 105-12.

ME AND MY BROTHER

Werb. "Films Caught at Venice Fest: Me and My Brother." *Variety* 252:4 (September 11, 1968), p. 106.

Weiler, A.H. "Screen: 'Me and My Brother' Opens: Film by Robert Frank Is at New Yorker." *The New York Times*, February 3, 1969, sec. 1, p. 31.

LIFE-RAFT EARTH

Albright, Thomas. "One Man's End to Cynicism." *San Francisco Chronicle* (October 15, 1969), p. 41.

COCKSUCKER BLUES

Marcus, Greil. "The Stones Movie You'll Never See." *Village Voice* 20:23, June 9, 1975, p. 126.

Cosgrove, Gillian. "The Rolling Stones On Tour—The Film That Can't Be Shown." *The Montreal Star*, September 10, 1977, sec. D, pp. 1,6.

Cosgrove, Gillian. "On the Road With the Rolling Stones: The Film That Can't Be Shown." *The Montreal Star*, September 12, 1977, sec. C, p. 2.

[Mac]Cart[hy, T]. "Film Reviews: CS Blues." *Variety* 294:13 (May 2, 1979), pp. 27, 46.

Hoberman, J. "Robert Frank: Exile from Main Street." *Village Voice* 25:38, September 17-23, 1980, pp. 44, 59.

FILM RETROSPECTIVE REVIEWS

Sturken, Marita. "Frank Films On." *Afterimage* 8:5 (December 1980), pp. 18-19.

Albera, François. "Robert Frank: le mouvement perpetuel." *Les Cahiers de la Photographie*, no. 11/12 and numéro special 3 (4th trimester 1983), pp. 111-20.

Schaub, Martin. "FotoFilmFotoFilm eine Spirale: Robert Franks Suche nach den Augenblicken der wahren Empfindung." *Cinema: unabhangige Schweizer Filmzeitschrift* [Zurich] 30 Jg. (1984), pp. 75-94.

PERIODICALS

Shortly after Frank's arrival in New York in March 1947, he was hired by the art director Alexey Brodovitch to make photographs for *Junior Bazaar* and *Harper's Bazaar*. Beginning in July 1947, Frank's photographs began to appear in *Harper's Bazaar* and continued nearly every month until October 1951. Other commercial assignments for magazines appeared in *Time* (1951), *Life* (1953,1955), *Look* (1953), and *McCall's* (1953-1954). By this time Frank had found his own niche, and he was hired by magazines that wanted the particular style of picture that he was noted for. His assignments continued to appear in the following magazines: *Vogue* (1953-54), *Fortune* (1955), *House and Garden* (1958), *Esquire* (1959), *Show* (1961-62), *Glamour* 1962), and *Harper's Bazaar* again in 1962 and 1963. Frank worked steadily making advertising photographs for *The New York Times* that appeared in the newspaper and in trade journals from 1958-63. Some of the more significant assignments are included below.

"Winter Picture Angles." *U.S. Camera* 12:1 (January 1949), pp. 42-43.

L[aubli, Walter], "Robert Frank." *Camera* 28:12 (December 1949), pp. 358-71.

"Speaking of Pictures: A Photographer in Paris Finds Chairs Everywhere." *Life* 30:21 (May 2l, 1951), pp. 26-28.

"*Life* Announces the Winners of the Young Photographers Contest." *Life* 31:22 (November 26, 1951), pp. 15-21,30.

[Dobell, Byron?]. "Robert Frank: Swiss Mister." *Photo Arts* (New York) 1:10 (December 1951), pp. 594-99.

"Der Photograph Robert Frank." *Das Wochenende* in *Neue Zurcher Zeitung* (November 1, 1952), Morgenausgabe no. 2411, Blatt 3, Wochenende 45, p. 1 [4 b&w. Also published in same newspaper's foreign edition: November 2, 1952, Blatt 5, p. 1, Fernausgabe no. 302, Wochenende 45.]

"Indiens des Hauts-Plateaux, photographies de Robert Frank, texte de Georges Arnaud." *Neuf*, no. 8, consacré à Robert Frank (December 1952), pp. 1-36.

"Feature Pictures: Robert Frank. . .The Photographer as Poet." Edited by Byron Dobell. *U.S. Camera* 17:9 (September 1954), pp. 77-84.

"The Congressional." Photographs by Robert Frank, text by Walker Evans. *Fortune* 52:5 (November 1955), pp. 118-22.

Schuh, Gotthard. "Robert Frank." *Camera* 36:8 (August 1957), pp. 339-56.

"New York is a Cocktail Party." *Advertising Age* 29:3 (January 20, 1958), p. 7. [New York is . . . advertisement for *The New York Times*. This is the first in a series of advertisements that appear intermittently in this journal until June 1960. Other advertisements appear in *The New York Times* until September 1963.]

" A Pageant Portfolio: One Man's U.S.A." Photographs by Robert Frank. *Pageant* 13:10 (April 1958), pp. 24-35, inside back cover.

"A Hard Look at the New Hollywood." Photographs by Robert Frank. *Esquire* 51:3 (March 1959), pp. 51-65.

"Robert Frank." *Aperture* 9:1 (1961), pp. 4-19.

Bennett, Edna. "Black and White Are the Colors of Robert Frank." *Aperture* 9:1 (1961), pp. 20-22.

Vanderbeek, Stan. "The Cinema Delimina—Film from the Underground." *Film Quarterly* 14:4 (Summer 1961), pp. 5-15.

Talese, Gay. "42nd Street—How It Got That Way." Photographs by Robert Frank. *Show* 1:3 (December 1961), pp. 62-71.

"Photographs by Robert Frank." *Choice: A Magazine for Poetry and Photography*, no. 2 (1962), pp. 97-112.

Rotzler, Willy. "Robert Frank." *Du* 22:1 (January 1962), pp. 1-32.

Deschin, Jacob. "Two-Man Exhibit: Photographs by Callahan and Frank at Museum of Modern Art." *The New York Times*, February 4, 1962, sec. 2, p. 21.

"The Venice Film Festival." Photographs by Robert Frank. *Show* 2:5 (May 1962), pp. 60-65.

"Edgar Varese, Willem de Kooning." *Harper's Bazaar*, no. 3012 (November 1962), pp. 166-69.

"Portfolio: Robert Frank: 5 Photographs." *The Second Coming Magazine* 1:6 (January 1965), pp. 57-62.

Porter, Allan. "Robert Frank: A Bus Ride Through New York." *Camera* 45:1 (January 1966), pp. 32-35.

Swanberg, Lasse. "Robert Frank." In *Fotografisk Arsbok 1968*. Stockholm: Nordisk Rotogravyrs Forlag/P.A. Norstedt & Soner, 1967, pp. 56-61.

Frank, Robert and Wyss, Max. "Gotthard Schuh: The Irretrievable Instant." *Camera* 47:3 (March 1968), pp. 4-17.

"Robert Frank: The Americans." *Creative Camera*, no. 55 (January 1969), pp. 22-31.

Porter, Allan. 'The Street,' 1: R. Frank." *Camera* 48:3 (March 1969), pp. 5-13.

"Photograph by Robert Frank." *Creative Camera*, no. 65 (November 1969), p. 377.

"Coney Island: Robert Frank." *Camera* (England) 50:3 (March 1971), pp. 18-25.

Stott, William. "Walker Evans, Robert Frank and the Landscape of Dissociation." *Artscanada*, no. 192/193/194/195 (December 1974), pp. 83-89.

Mann, Margery. "West: The Americans Revisited." *Camera 35* 18:10 (January 1975), pp. 14, 74-75. [Long discussion of *The Americans*.]

Hellman, Roberta, and Hoshino, Marvin. "What Frank Saw." *Village Voice*, February 3, 1975, p. 98.

Loetscher, Hugo. "Robert Frank, Photograph." *Das Wochenende* in *Neue Zurcher Zeitung*. vol. 197, no. 43, February 21/22, 1976, pp. 61-64.

Bunnell, Peter C. "Certain of Robert Frank's Photographs. . . ." *The Print Collector's Newsletter* 7:3 (July/August 1976), p. 81.

Wheeler, Dennis. "Robert Frank Interviewed." *Criteria* 3:2 (June 1977), pp. 1, 4-7, 24.

Claass, Arnaud. "Robert Frank et les Avant-Gardes." *Contrejour* [Paris] no. 13 (October/November 1977), pp. 22-25.

Cousineau, Penny. "Robert Frank's Postcards from Everywhere." *Afterimage* 5:8 (February 1978), pp. 6-8.

Rubinfien, Leo. "Photography: Robert Frank in Ottawa." *Art in America* 66:3 (May/June 1978), pp. 52-55.

Scully, Julia, and Grundberg, Andy. "Currents: American Photography Today: Robert Frank's iconoclastic, outsider's view of America in the '50s provided both form and substance for the next generation." *Modern Photography* 42:10 (October 1978), pp. 94-97, 196, 198, 200.

Cousineau, Penny. "New Work by Robert Frank." *Artscanada*, no. 224/225 (December 1978/January 1979), pp. 58-59.

Thornton, Gene. "Photography View: Catching America on the Wing." *The New York Times*, February 18, 1979, sec. 2, p. 33.

Lifson, Ben. "Robert Frank and the Realm of Method." *Village Voice* 24:8 (February 19, 1979), p. 75.

Stettner, Lou. "Speaking Out: Robert Frank and Burk Uzzle." *Camera 35* 24:5 (May 1979), pp. 12-13,80.

Stevens, Nancy. "The Americans Revisited: Photographs by Robert Frank, Text by Jack Kerouac." *American Photographer* 2:6 (June 1979), pp. 38-49.

Hellman, Roberta and Hoshino, Marvin. "Robert Frank." *Artsmagazine* 54:1 (September 1979), p. 18.

Messer, William. "Destiny into Awareness: Viewed: Robert Frank at the ICA." *British Journal of Photography* 127:21 (May 23, 1980), pp. 496-97.

Brumfield, John. "'The Americans' and the Americans." *Afterimage* 8:1/2 (Summer 1980), pp. 8-15.

Mitchell, Michael. "Commentaries/Reviews: Around and Around the Telephone Pole." *Parachute* (Summer 1980), pp. 46-47.

Hinderaker, Mark. "*The Family of Man* and *The Americans*." *Photographer's Forum* 2:4 (September 1980), pp. 22-28.

Baier, Leslie [sic., Lesley]. "Visions of Fascination and Despair: The Relationship Between Walker Evans and Robert Frank." *Art Journal* 41:1 (Spring 1981), pp. 55-63.

"Robert Frank Returns to Still Photography." *CoEvolution Quarterly*, no. 29 (Spring 1981), front and back covers and p. 2.

"Energy and How to Get It: Proposal by Gary Hill for a film by Robert Frank, Gary Hill, and Rudy Wurlitzer." *CoEvolution Quarterly*, no. 29 (Spring 1981), pp. 46-47.

Cassell, James. "Robert Frank's *The Americans*: An Original Vision Despite Tod Papageorge's Challenge." *New Art Examiner* 8:10 (Summer 1981), pp. 1, 8.

Westerbeck, Colin L., Jr. "Reviews: New York: Tod Papageorge." *Artforum* 20:1 (September 1981), pp. 75-76.

Cook, Jno. "Robert Frank's America." *Afterimage* 9:8 (March 1982), pp. 9-14.

Ennis, Michael. "The Roadside Eye." *Texas Monthly* 11:11 (November 1983), p. 180-83.

"Robert Frank, la photographie, enfin." *Les Cahiers de la Photographie*, no. 11/12 and numéro spécial 3 (4th trimester 1983), pp. 1-125. [Special issue edited by Gilles Mora devoted entirely to Frank. Includes texts by Gilles Mora, Walker Evans, Robert Frank, Alain Bergala, Denis Roche, Stuart Alexander, Arnaud Claass, Gabriel Bauret, Jean Kempf, Jean Arrouye, Alain Fleig, Anne-Marie Faux, Francois Albera, and Robert Delpire.]

Johnson, William S. "Public Statements/Private Views: Shifting the Ground in the 1950s." *Untitled*, no. 35 (1984), pp. 81-92. [Issue titled *Observations: Essays on Documentary Photography*.]

Cook, Jno. "Photography: Robert Frank's Parody." *Nit & Wit: Chicago's Arts Magazine* 6:3 (May/June 1984), pp. 40-43.

Frank, Robert. "Three groups of photographs taken 1955/56 on a trip across the USA." *C Magazine* (Toronto), no. 3 (Fall 1984), pp. 66-70.

"Portfolio by Robert Frank, July 16-19, 1984." *California* 9:9 (September 1984), pp. 123-33.

Schiffman, Amy M. "Politics as Unusual: Robert Frank." *American Photographer* 13:5 (November 1984), pp. 52-57.

Cotkin, George. "The Photographer in the Beat-Hipster Idiom: Robert Frank's *The Americans*." *American Studies* 26:1 (Spring 1985), pp. 19-33.

Schmid, Joachim. "Ein Interview mit Robert Frank." *Fotokritik* (Berlin), no. 14 (June 1985), pp. 16-21.

OTHER

The New Lost City Ramblers: Vol. 2. Folkways Record FA 2397, Folkways Records and Service Corp., New York, 1959. [12-inch record, 33 1/3 r.p.m.]

Readings by Jack Kerouac on the Beat Generation. Verve Records. MG V-15005, 1959. [12 inch monaural record, 33 1/3 r.p.m.]

Frank has also done photographs for several other album covers and liners: two New Lost City Ramblers covers in 1961, one in mid sixties, one in 1968, one in 1973, and another in 1978. He also did photographs for Rolling Stones, *Exile on Main Street*, 1972; Allen Ginsberg, *First Blues*, 1982; J. Geils Band, *You're Getting Even While I'm Getting Odd*, 1984; and Tom Waits, *Rain Dogs*, 1985.